Artists in Glass

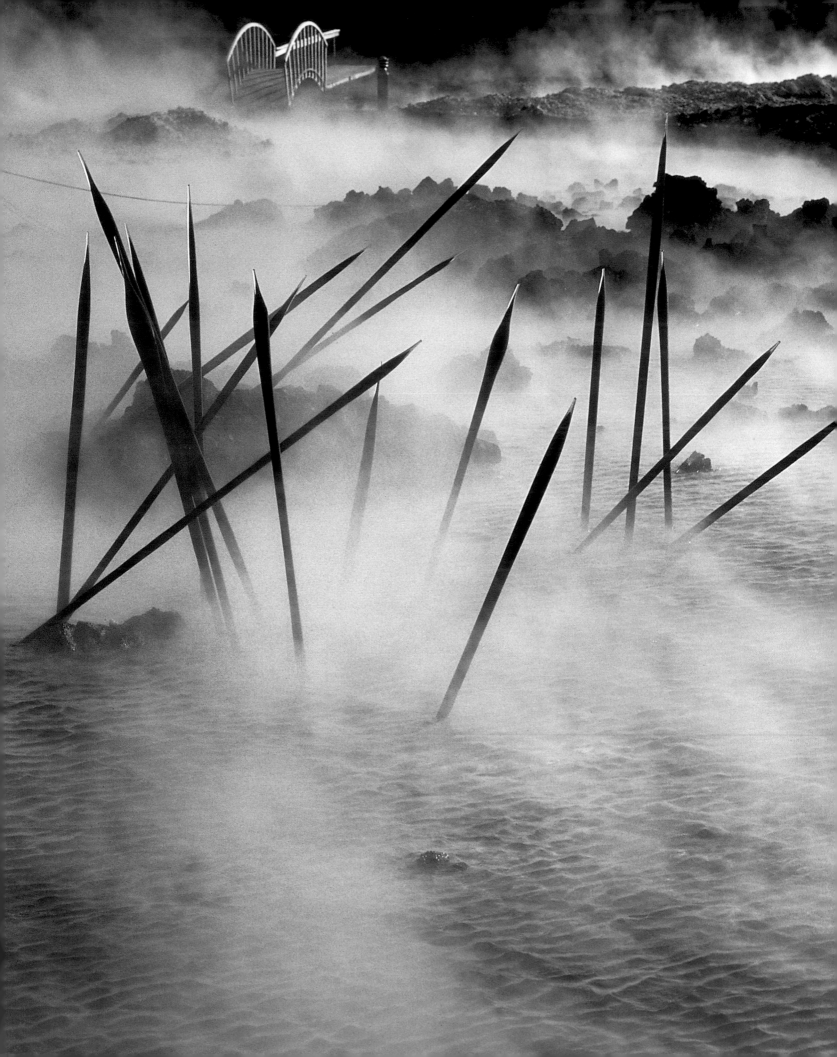

MITCHELL BEAZLEY

Artists in Glass

Late Twentieth Century Masters in Glass

DAN KLEIN

Artists in Glass

DAN KLEIN

First published in Great Britain in 2001 by Mitchell Beazley,
an imprint of Octopus Publishing Group Ltd,
2–4 Heron Quays, Docklands, London E14 4JP

Executive Editor Mark Fletcher
Art Director Geoff Borin
Project Editor Emily Asquith
Designer Colin Goody
Editor Kirsty Seymour-Ure
Production Catherine Lay, Alex Wiltshire
Picture Research Alan Poole
Proof Reader Jane Donovan
Indexer Christine Shuttleworth

A CIP catalogue record for this book is available from the British Library

ISBN 1 84000 340 5

Set in Helvetica Neue
Produced by Toppan Printing Co., (HK) Ltd.
Printed and bound in China

Key to caption abbreviations
h height
w width
d depth
l length
diam. diameter
circ. circumference
Dimensions of pieces are given
to the nearest half cm

Page 2 "Red Spears". Dale Chihuly, 2000.
l 1,000 cm (394 in). Blown glass and mist.
Photography and film or video records of Chihuly's
work are an important element of his concept as a
whole. He bears the potential of those media in mind
during the process of artistic creation in glass.

Contents

Introduction

Attitudes to glass have changed dramatically since the 1960s. Until then glass, whether for utilitarian or artistic purposes, had been produced in a factory environment. Throughout its 5,000-year history glass has always been exploited for its decorative potential, but its status as an industrial material was never challenged until the 1960s when Harvey Littleton questioned whether it was possible to melt glass in a more private way.

Littleton's curiosity as to the possibilities of glass as an artist's material eventually took over his whole life, and the originality of his early investigations revolutionized thinking about the artistic potential of glass. In March 1962, in a garage made

available on the grounds of the Toledo Museum of Art, Ohio, by Otto Wittman (who was museum director at the time), Littleton organized a workshop, where a primitive home-made pot furnace was used to melt glass. The glass behaved badly and the attempts at forming it were basic. Misshapen bubbles emerged from the workshop, expressing artistic and technical frustration and described as "garage art". But the excitement generated by the experience was tremendous and there was a consensus that the possibilities for artistic expression were endless if the technicalities could be got right.

More by coincidence than by design two people assisted with that first seminar in Toledo, who were able to direct the artistic endeavours of those gathered there (mainly potters curious about glass) along the right lines technically. One was Dominic Labino, who had spent 30 years developing glass fibre for use in space missions and space shuttles and had invented a type of glass marble (referred to as #475 fibreglass marbles) that were easy to handle and easy to melt. The other was Harvey Leafgreen, a retired Toledo glass-blower, who attended the conference because he happened to read about it in a local newspaper, but was delighted that his years of experience could be put to good use. A second, more successful seminar, with a better-designed tank furnace constructed by Labino, was held at Toledo in June of 1962. The seminars had generated a new kind of interest in glass and in 1963 Littleton introduced a class in creative glass-blowing to the academic curriculum of the University of Wisconsin at Madison, where he was teaching.

Left *"Imploded Form". Harvey Littleton, 1966.*
h 32.5 cm (12¾ in), w 15 cm (6 in), d 15 cm (6 in).
Blown blue barium/potash glass vase that, as the piece was being blown, had the air sucked back out from it. Marks of human intervention on glass had symbolic significance in the early years of the studio glass movement. Littleton's quip, "Technique is cheap", put a new perspective on the art form.

By 1964 Littleton had been appointed chairman of the Art Department at the University of Wisconsin, having established an undergraduate glass course, the first of its kind in the United States. In the same year his first graduate student, Marvin Lipofsky, was hired to start a glass programme at the University of Berkeley in California. Since the 1950s a group of Californian potters led by Peter Voulkos at the University of California had been applying some of the emotive principles of Abstract Expressionist art to clay. Their sculptural work had

Below "Jungbrunnen: Fountain of Youth". Erwin Eisch, 1969. 3,000 sq cm (465 sq in).
Mixed media "bathroom" installation (no longer in existence) from the Bundesgartenschau, Munich. Glass was part of Eisch's family environment, but a fine art education at the Munich Academy of Art had a liberating effect on him and, through his influence, on a generation of glass creation.

a liberating influence on the decorative arts in general. Glass was added to many American art school curricula during the 1960s and was a hot topic for debate and discussion at gatherings such as the First International Craft Congress held at Columbia University in 1964. Erwin Eisch was invited to be a panel member on that occasion. Littleton had met Eisch two years earlier when travelling in Germany, a meeting of minds characteristic of the international exchange of information and ideas that contributed so much to global changes in attitude.

The United States had little to offer in the way of glass history and the appetite of Americans to travel and learn from others was infectious. National and international conferences and exhibitions were the breeding ground for new ideas in glass. Many friendships destined to last a lifetime were forged during

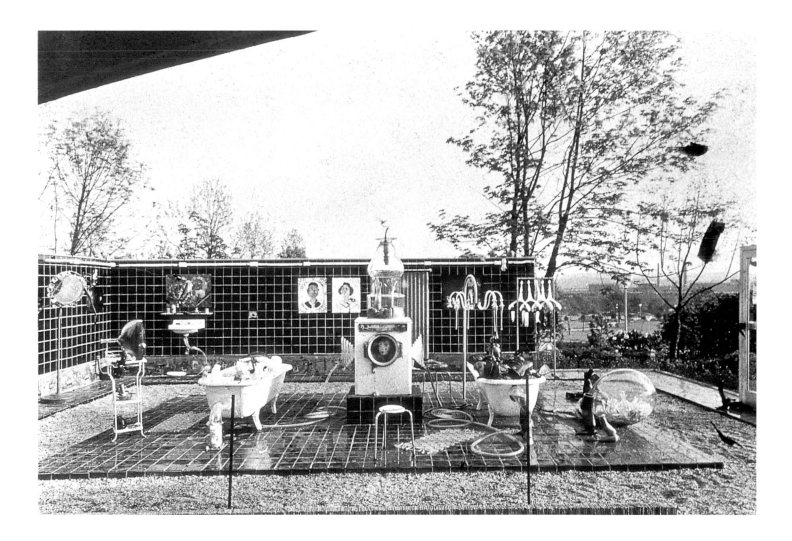

this first decade of adventure into the possibilities of direct self expression in glass. In 1964 Sam Herman, another Littleton student, arrived in Britain and by 1967 he headed the first short courses in glass-making at the Royal College of Art in London. Also in 1964 what was referred to as a "Dominic Labino style" furnace had been built at the Rietveld Akademie in Amsterdam, where, in 1966, the Swedish glass artist Åsa Brandt was to be the first full-time glass student. In 1967 Dale Chihuly, a student of Littleton's at the time and later to become the most celebrated glass artist in the world, visited the World Expo in Montreal, where he met Stanislav Libenský and Jaroslava Brychtová from Czechoslovakia for the first time. His

first exposure to the Czech tradition of monumental casting in glass opened up a whole new world. At the time the work of Czech glass artists was virtually unknown to the glass community in the West, even though important pieces had been exhibited at numerous world fairs, including Expo in Brussels in 1958 and the Milan Triennials in 1957 and 1960.

For followers of Littleton the emphasis during the 1960s was on blown glass. Littleton and the first generation of his students were committed to the idea of establishing a direct relationship with glass in ways that had never previously been explored. They underestimated the importance of technique. In his seminal treatise *Glass Blowing – A Search for Form*, published in 1971, Littleton had written "Technique is cheap". The resultant body of work that emerged during the 1960s in the United States under the influence of Littleton was a series of freely conceived shapes limited by a lack of technical ability, commonly referred to as "dip and blow" style. It was not long, however, before the first generation of American students found their way to countries such as Italy, Czechoslovakia, and Sweden, where they learned that technique and teamwork were key to creation in glass.

In 1969 Dale Chihuly took a trip to Venice, having completed his studies under Littleton and gone on to do a postgraduate course at Rhode Island School of Design. First for Chihuly and then for numerous other Americans, the discovery of Venetian-style teamwork in hot glass was a revelation. Chihuly came back to the United States to head the glass programme at

Left *"Dale Chihuly Portrait with Ikebana".*
Through his teaching, his work as an artist, his flare for branding new ideas in art, and a colourful personality, Chihuly has had the single greatest influence on the state of glass art since the late 1960s.

Right *"Feomina", Lino Tagliapietra, 1997.*
h 42 cm (16½ in), w 35.5 cm (14 in), d 20 cm (7¾ in).
Free-blown red glass with red canes, cold-worked on the surface.
Titles sometimes suggest themselves during the making process, as a form or colour emerges: for Tagliapietra, an idea that originates in this way can lead to a whole series of work.

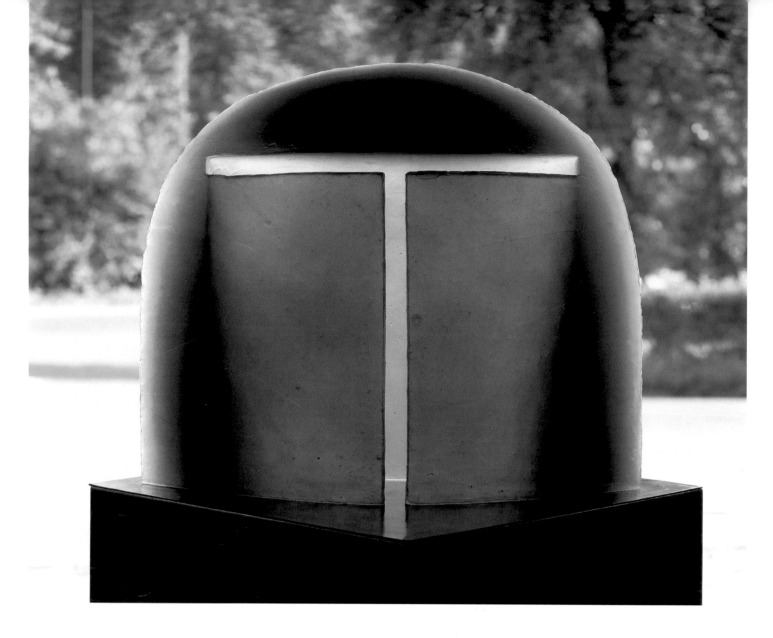

Rhode Island School of Design. The 1970s was a decade of technical exploration, with technical and artistic exchanges worldwide that would have been tantamount to industrial espionage between factories, but happened as a matter of course in an artistic environment. In his teaching Chihuly encouraged research into established techniques as much as he encouraged freedom of thought aimed at expanding artistic horizons. Vessel form, which throughout its history had defined the parameters of glass art, either tended towards the sculptural or was abandoned completely in favour of sculpture during the 1970s. Old techniques were reinvented and expanded beyond recognition by artists working in glass without any of the industrial constraints to which glass had been traditionally subject. In the past studio glass designers

Above "Head T: T Space". Stanislav Libenský & Jaroslava Brychtová, 1996–7. h 90 cm (35½ in) , w 106 cm (41¾ in), d 36 cm (14 in). Mould-cast grey glass. The monumental casting techniques developed by Libenský and Brychtová have been responsible for an entirely new sculptural language that has been adopted by artists in glass the world over.

had entrusted their designs to glass-workers. For a new generation of glass artists technique was part of the creative process, a way of unlocking artistic ideas.

In the United States during the 1970s and 1980s new ideas came mainly from those who taught at or attended the many newly-created university glass courses. The founding of Pilchuck School near Seattle by Dale Chihuly in 1971 was an important

landmark and the exchange of ideas there in later years had a marked influence on glass internationally as famous glass practitioners from all over the world held master-classes in which they shared their ideas with others. In 1971 the Glass Art Society was founded and had its first meeting at Penland School of Crafts in North Carolina. In 1972 the Japan Glass Art Society was founded, and in 1976 B.A.G. (British Artists in Glass) was formed with 13 full members. During the same year a hot-glass conference, "Working with Hot Glass", was organized at the Royal College of Art in London. International participants included Stanislav Libenský, whose talk about glass-casting was met with a standing ovation. In 1978 the first Australian glass conference took place. In 1982 the first of a series of international symposia was held in Nový Bor in Czechoslovakia. In 1983 C.I.R.V.A. (Centre International de Recherche sur le Verre et les Arts Plastiques) was founded in Aix-en-Provence, moving to Marseilles in 1987.

As the interest grew among practitioners and among the public, specialist galleries opened up. In England the Glasshouse, a cooperative of artists in central London that doubled up as a gallery, led the way in 1969. In the United States the Contemporary Art Glass Group (later Heller Gallery) in New York and Habatat Galleries in Lathrup Village, Michigan, started flourishing businesses in 1971; both are still going strong. More galleries opened around the world. Museum curators showed an early interest in contemporary glass and staged exhibitions, often accompanied by catalogues. Among the most important were *Glas Heute – Kunst oder Handwerk* (Glass Today – Art or Craft) in 1972 at the Kunstgewerbemuseum Bellerive, Zurich, and *New Glass: A Worldwide Survey*, a travelling exhibition organized by the Corning Museum of Glass, New York State. In Europe there were two important juried exhibitions in Coburg, the first in 1977, the second in 1985, both in the form of competitions for artists in Europe (both Eastern and Western) with significant prizes awarded. New glass publications made information more available; 1976 saw the appearance of the *Glass Art Magazine* (later renamed *Glass*); from 1977 onward

the *Corning Glass Review*, published annually, illustrated 100 significant new works in glass chosen from slides submitted to a jury; while in 1980 *Neues Glas*, a magazine devoted to contemporary glass worldwide, first appeared. Many magazines about crafts, in the United States, Europe, and Australia, devoted considerable space to articles about glass.

The dissemination and exchange of information brought with it a host of new ideas. Better materials and more sophisticated equipment led to more interesting work, and throughout the 1970s and 1980s undergraduate and graduate students, and young professionals starting out on a career in glass, showed an exciting range of new artistic possibilities in the medium. Chihuly in America and Libenský and Brychtová in Czechoslovakia were an inspiration to their students because of the way in which they transformed traditional glass disciplines. Inspired teaching has been at the heart of the contemporary glass movement, with many of the greatest artists devoting considerable time to it. The handing on of information in a university environment has been the single most important factor in the changes that have taken place in glass.

In Chihuly's case a colourful theatrical environment for blowing glass replaced the more prosaic factory floor. Glass-blowing has always involved a degree of showmanship, which Chihuly exploits to the full, turning it from industrial process into performance art. He challenges the blowpipe as a virtuoso trumpeter might challenge his instrument, and is also a master at bringing out the talents of others. Chihuly is composer, conductor, and performer all in one. In this new artistic environment time became less of a consideration, allowing ideas to develop more freely and experiments to happen more frequently. Chihuly set the mood for creation in glass in the 1970s in the United States, a mood that affected glass-making all over the world: and there was no looking back.

In contrast to the United States there was already a firmly established glass curriculum in Czechoslovakia, where a thorough grounding in glass takes up to eight years of study.

Libenský and Brychtová's innovative ideas about large-scale glass-casting have been the single greatest influence in Czechoslovakia. The atmosphere in Libenský's studio and his inspirational style of teaching at the Prague Academy of Applied Arts have been intimate, but no less influential than Chihuly's more extrovert performance. This was largely due to the political situation in Czechoslovakia under the Communist régime. Until the fall of the Berlin Wall at the end of the 1980s Czech artists worked in great isolation. Glass played a non-political yet important role in Communist culture. It was used by government officials to impress at world exhibitions and world fairs, and some Czech glass artists benefited as a result by being allowed to travel more frequently than most of their compatriots to attend them. In this way they met artists from all over the world and invited them to Czechoslovakia. It encouraged Libenský to allow his students even more free-dom. The combination of comparative isolation and Libenský's influence has spawned a distinctive national (mainly sculptural) style in cast glass. The other great Czech teacher has been Václav Cigler, who taught in Bratislava and whose exploration into the artistic possibilities of optically cut glass set another Czech fashion, particularly prevalent during the 1980s.

By the beginning of the 1990s glass education was well developed in all countries where the subject was deemed of interest. Various Australians returning home from trips abroad as well as established artists from Britain and the United States had introduced new ideas in contemporary glass to Australia, where there is a lively decorative arts scene. In 1983 Klaus Moje arrived in Australia from Germany and at the Canberra School of Art, a part of the Australian National University, established what is now one of the most sophisticated glass departments anywhere. In Japan there are now at least two choices for students interested in glass, the older Tokyo Glass Art Institute, and the Toyama City Institute of Glass Art (founded in 1991), where there is an advanced course and an international teaching staff. A whole new artistic language with its own grammar and technical vocabulary had been established in most areas of glass-making by the beginning of the 1990s. Chihuly's and Libenský's and Brychtová's contributions to blowing and casting has already been mentioned. Many others added their own ideas in these areas, while yet others explored different avenues technically. Techniques such as *pâte de verre*, kiln-forming, lost-wax casting, electroforming, lampwork, sand-casting, engraving, optical cutting, enamel-painting, and fusing had been more or less reinvented, thanks to better equipment and to the unprecedented degree of artistic imagination that had been expended on working with glass since the 1960s. Some brand new ideas emerged, such as Mary Ann Toots Zynsky's technique of working with glass threads or Mary van Cline's use of photographs printed on photosensitive glass.

If there was one predominant influence during the last decade of the 20th century, it was that of the Italian glass-makers and their techniques. In the early 1970s many Americans had visited Venice in an attempt to learn what the Venetians deemed to be privileged information. Until Ludovico de Santillana at Venini encouraged open exchange, visiting artists were considered to be engaging in industrial espionage. The great change came with Lino Tagliapietra's master-class at Pilchuck in 1979, the first of many that he gave there over a period of more than 20 years. During that time the Italian way of glass-making was taught to students from across the globe and has become one of the principal techniques used by contemporary glass-makers. Tagliapietra has been at the centre of its growing popularity, both as a teacher and as a collaborator interpreting the ideas of others. In 1988 he began his collaboration with Dale Chihuly, working on a series called "Venetians". He has travelled the world teaching and making glass with others, while also finding the time to make a considerable body of his own work, and becoming an artist of great stature in the process. International collaboration involving artists from Italy, the United States, and Australia has also led to the development of new kinds of coloured glass at Bullseye in Portland, Oregon, allowing for a greater degree of colour compatibility and enabling blowing and kiln-forming techniques to be combined for the first time.

The American craze for glass has led to Seattle's becoming known as the "Venice of the West", with a second generation of home-grown artists blowing glass as if they had been born on Murano. A previous generation, including Billy Morris, Benjamin Moore, Richard Marquis, and of course Dale Chihuly, had been won over by going to Venice themselves. Among the next generation Dante Marioni has emerged as a leading light, inspiring other young artists to follow his examples, whether they be American, European, or Australian. During the 1990s Venice once again found itself at the centre of contemporary glass with two large survey exhibitions, one in 1996, the other in 1998, both called *Venezia Aperto Vetro*. These were the first in what is intended as an ongoing series of glass biennials in Venice. In 1996 the exhibition included work by artists from all over the world, and Chihuly's contribution "Chihuly Over Venice" created a sensation. In 1998 the exhibition, again an international survey, was intended as a celebration of the Italian way of making glass.

The 1990s were marked by a number of other major glass exhibitions, in Denmark, Japan, and the United States. In Japan since the 1980s there have been regular international glass prizes and touring glass exhibitions organized either by the Kanazawa Chamber of Commerce and Industry or by Hokkaido Museum of Modern Art in Sapporo. An exhibition in Denmark, *Young Glass 1997*, was held at the museum in Ebeltoft. Built around a competition for which entries were submitted from all over the world, it aimed at encouraging and promoting young glass artists. Two exhibitions in particular marked an important departure from the customary survey shows. One was *The Glass Skin* (1997–1998), a travelling exhibition seen in Japan, Germany, and the United States and curated by three museum curators, one from each of those countries. The thematic concept of glass as skin created a new context in which to evaluate the art form. The Libenský Brychtová retrospective exhibition at the Corning Museum of Glass in 1994 encapsulated perhaps more than any previous exhibition the growth in stature of the art form. It also put the Libenskýs' tremendous lifetime achievement in perspective.

Stanislav Libenský and Jaroslava Brychtová in the Czech Republic, Dale Chihuly in the United States, Lino Tagliapietra in Italy, and Bertil Vallien in Sweden have demonstrated how artistically fulfilling a life in glass can be. If glass is now accepted as a legitimate medium for artistic expression and deemed capable of expressing the full range of human emotion, whether as sculpture or in vessel form, it is largely owing to the tremendous leap of faith by giants such as these. Their total commitment to the medium has been a transforming factor, changing the role of glass in the modern world and inspiring others to follow their example. Vast new horizons have opened up, thanks to the work of these artists and many others, only some of whose work it has been possible to document in this book.

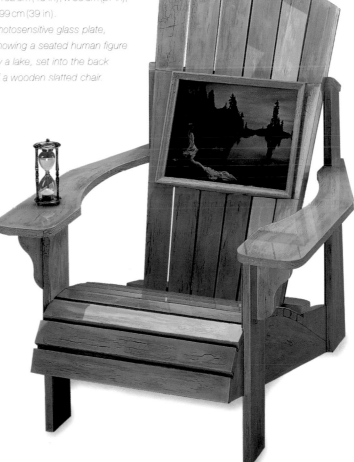

Below *"The Nature of Time"*
Mary van Cline, 1990.
h 102 cm (40 in), w 69 cm (27 in),
d 99 cm (39 in).
Photosensitive glass plate,
showing a seated human figure
by a lake, set into the back
of a wooden slatted chair.

The Artists

Hank Murta Adams

BORN 1956, PHILADELPHIA, PENNSYLVANIA, USA NATIONALITY AMERICAN

Below *"Clacker"*, *1998.*
h 50 cm (19⅜ in), w 30 cm (11⅞ in),
d 85 cm (34 in). Cast glass and copper.
The rough but brittle texture of
crushed glass fashioned into a
half-human, half-monster head of
melting or decaying flesh conveys
danger, pain, and sensitivity.

Hank Adams came to glass from a fine art background, having studied painting at Rhode Island School of Design, an art school where during the 1970s glass was treated like a fine art and therefore interested many students other than those in the glass department. Like many of his contemporaries Adams has done a fair amount of teaching, while from 1988 to 1994 he was principal designer at the Blenko Glass Co., one of only a few glass companies in Milton, West Virginia.

Cast glass and metal (often copper) are the materials from which Hank Murta Adams' glass sculptures are made. His art is that of the grotesque, the sinister. His head-and-shoulder portraits of a cast of imagined characters are at the same time frightening and beguiling. Their eyes, often of copper, have the same fixed stare as dolls' eyes. Their flesh seems torn apart and raw. Part monster, part human, confrontational in character, the figures demand a reaction from the viewer in a way that pretty things do not: they have a sense of importance and a presence about them that is arresting.

The glass mass of which the figures are made is extremely heavy and the pieces are large in scale, often standing up to a metre high. Work of such dimensions is difficult to put together, difficult to control, and a long time in the making. It also requires considerable physical strength. The heads and bodies are made of glass that is crushed and densely packed into a mould, then fired over several days to allow time for the process of fusion and cooling to take place.

Everything about the work, from the thought processes from which it springs to the physical processes that bring it to life, is time-consuming and complex. It is difficult to say what these figures with their patinated metallic incrustations are about. Are the metallic contraptions that sprout from them connectors to some hidden world? Adams is concerned with death and the life it takes away. His mother has multiple sclerosis and her illness has made him focus on the illness that some of his peers have died from or been forced to endure. He says: "HIV, among the most important things that's happened in the 20th century, connected us,

Right "Hovering", 1984.
w 40 cm (15½ in), d 12.5 cm (5 in).
*Cast and blown glass and copper.
An imaginary crowd of agitated
human forms reacts to the
strange meteorite that hangs
above it, in a scenario typical
of the artist's concern with life's
unwanted dangers.*

Below "Head with Prop", 1998.
h 45 cm (17¾ in), w 35 cm (13¾ in),
d 37.5 cm (14¾ in).
*Cast glass and copper. Staring
eyes, blue hair, and a propeller
nose give this portrait head
the haunting character that
has become a trademark of
Adams' sculpture.*

made us more aware of sharing flesh, aware of the old adage that if you have your health you have everything." The faces and bodies in his work seem eaten away with the diseases that plague his thoughts.

In the last decade Adams has explored different kinds of metal and glass compositions. Smaller, more intimate glass elements, figural or abstract, are held together within a loose wire framework of cellular pattern. The pieces have titles such as "Map" or "Cell". The wire cagework becomes a molecular device in which the glass elements act as focal points. An eye or a face here, a suggested shape there, serve to focus our minds and give more than abstract significance to the work. "Cell" (1996) is a large installation piece measuring 146 x 284 cm (57 x 112 in), made of sand-cast glass discs, each attached by copper wire to an electroplated steel frame. The effect is that of a living organism that might be seen through a microscope. It is fragile, sinister, fetishistic, a kind of *memento mori*.

Baldwin & Guggisberg

PHILIP BALDWIN BORN 1947, NEW YORK, USA NATIONALITY AMERICAN

MONICA GUGGISBERG, BORN 1955, BERN, SWITZERLAND NATIONALITY SWISS

Philip Baldwin and Monica Guggisberg, husband and wife, work together in Nonfoux in the French-speaking part of Switzerland, where they have created an impressive glass studio near their home. The setting is rural and there is little to divert attention away from their life of making glass. The couple began working together in 1979, shortly after they met at the Orrefors Glass School in Sweden. Different paths had led them to Orrefors: Guggisberg had experimented with flameworking and worked in that technique in the glass studio she opened in 1978, while Baldwin had taken a BA course at the American University in Washington, DC. From 1979 to 1981 the pair were assistants to Wilke Adolfsson and Ann Wolff at Transjö in the heart of Sweden's glass-making area. That too is a rural environment, and when they set up their own studio at Nonfoux in 1982, they took with them both the traditions of Swedish glass-making and the quiet lifestyle that they had experienced there.

Both are expert glass-blowers and practise in the Swedish manner. In an artist's statement they explain: "[The pieces] are blown using the Swedish

Above "Celestial Convergence", 1993 h 53 cm (20⅞ in).
Three disks blown in double underlay and assembled to form a pattern of intersecting circles suggesting the interaction of planets. Presented on a metal stand, the piece takes on a sculptural presence.

Right "Centered Square", 1986. diam. 44 cm (17¼ in).
An early unique piece blown using the double underlay technique. The piece is sandblasted with a linear pattern typical of the clear visual geometry preferred by these artists.

under- and overlay technique, which allows for a very thin layer of strong colour on the outer surface, thus permitting very delicate cutting to expose contrasting colour on the inside of the glass. This treatment allows for a wonderful exploration of colour, texture, pattern and tactile sensibility in each piece." The body of Swedish blown glass is heavier than in Italian blown glass, in which the layers of glass are more or less of the same thickness. In Swedish glass the first bubble is blown with a denser gather of glass than in Italy and to this much thinner layers are added. The glass can then be worked more elaborately when cold since the base material can withstand more pressure from cutting and grinding.

The fruits of Baldwin and Guggisberg's first artistic collaboration embodied many of the characteristics of Scandinavian glass. They worked mainly decorating large circular plates or bowls with clean geometric patterns cut into the outer layers of glass. These pieces are bright and decorative, midway between production work and unique work. The two kinds of work have been combined since the 1920s in Sweden; designers for the Swedish glass industry have always been expected to produce basic good design for mass-produced tableware and decorative objects. Over the years, demand for Baldwin and Guggisberg's artistic work has grown, although their studio is run on essentially unchanging lines, with both of them sharing hot and cold work equally, and with the help of assistants.

Below "Red Night In Blue, III & IV, 1994. h 10 & 12 cm (4 & 4¾ in), diam. 28 & 30 cm (11 & 11⅝ in). These perfectly executed bowl forms are unique pieces made using industrial techniques and functional forms to create the balanced visual aesthetics typical of Swedish studio glass.

In 1981 Baldwin and Guggisberg made their first trip to Venice, with Wilke Adolfsson, the master glass-blower to whom they had been assistants in Sweden. This was the first of many journeys to Venice, and the beginning of a dialogue between Swedish and Italian glass techniques (Swedish hot-glass processes and Italian cold-cutting techniques) that would develop over two decades. What has evolved is a look very recognizably their own, with the fusion of cultures allowing them to explore a new world of pattern in glass. On their visits to Venice Guggisberg and Baldwin discovered the possibilities of using Italian cold-working techniques on their blown forms, in particular the *battuto* (beaten or hammered) and *inciso* (incised) techniques. In Italian glass these cold-working methods were developed mainly at Venini during the 1950s to mark monochrome pieces with a variety of cellular or linear patterns. In a process related to glass engraving, the patterns are created by hammering or chiselling the surface of the glass, using a variety of differently shaped tools.

Guggisberg and Baldwin take their blown vessel forms from Nonfoux to Venice, and on Murano work with masters of the *battuto* technique who follow their drawn instructions; by now they are virtually a part of the Venetian glass community. They have become increasingly fascinated by Italian techniques both hot and cold and have worked with a number of Venetian glass artists, using Venetian techniques to explore their own

Above "Faceted Plains In Red & In Grey", 1999. h 51 & 44 cm (20 & 17¼ in), diam. 10 & 12.5 cm (4 & 5 in) Blown in over- and underlay, surface pattern cut with stone and diamond wheels.

Right "Red & Blue Spin Tops", 1997. h 25 & 47 cm (9⅞ & 18½ in), diam. 13.5 & 20 cm (5¼ & 7⅞ in). Blown in over- and underlay, surface pattern cut with stone and diamond wheels.

Opposite "Cortigiana Arancia e Guardiano a Sguardi di Traverso" (Orange Courtesan and Guardian with Sideways Glance), 2000. h 85 & 105 cm (33⅜ & 41¼ in), diam. 12 & 13.5 cm (4¾ & 5¼ in). Blown in over- and underlay, surface pattern cut with stone and diamond wheels.

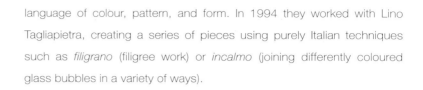

language of colour, pattern, and form. In 1994 they worked with Lino Tagliapietra, creating a series of pieces using purely Italian techniques such as *filigrano* (filigree work) or *incalmo* (joining differently coloured glass bubbles in a variety of ways).

In essence Guggisberg and Baldwin are vessel-makers. They have an innate understanding of form with a marked preference for symmetry and balance in their chosen shapes. The forms are pleasing and harmonious, as is their overall aesthetic. Colour and pattern in their work is always well behaved, always tasteful. Although they do not adventure beyond the pleasures of simple geometry and conventional colour, they find enough within those confines to make their work interesting and appealing. Often the patterns they use are cellular, in that a basic cell pattern is used which·acts as the theme while endless groupings or patterns form the variations. The decorative schemes made to this formula are rhythmic and lively. Guggisberg and Baldwin know how to make a glass surface vibrate and how to exploit all the seductive qualities of glass, above all where colour and pattern are concerned. They are superb craftspeople and understand the important role that technical excellence plays in the aesthetics of glass. Their work is tightly controlled and there is little room for the kind of accident that characterizes some contemporary glass.

To personalize their vessel forms and give them character Guggisberg and Baldwin have invented characters for them – "Sentinels", "Watchers", "Guardians" and "Courtesans". The Courtesans, presented singly or in groups, take them farthest away from what they were creating until the mid-1990s. The glass forms, suggesting heads and slender elegant bodies, are supported on long metal rods rising from metal plinths. Head and body are separately blown forms, joined together in the Italian *incalmo* manner; often the head has a cold-worked pattern. Individual pieces are designed, when grouped together, to strike up a relationship with their neighbours, leaning in towards one another as if exchanging a confidence, or in casual groups suggesting a kind of camaraderie. Guggisberg and Baldwin say of their *Cortigiane*: "These standing figures represent a leap in which we stretch and expand our usually strict notion of form. Their bodies are exaggerations of those same forms, elaborated with slightly asymmetrical flourishes. They are not meant to be a dramatic departure, but rather companions, fellow travellers with a different perspective. For sober-minded folk like us, they poke a little fun."

Howard Ben Tré

BORN 1949, NEW YORK, USA NATIONALITY AMERICAN

Below *"Dedicant 7", 1987.*
h 122.5 cm (48 in), w 45.5 cm
(18 in), d 17.5 cm (6⅞ in).
Cast glass, brass, gold leaf,
pigmented waxes. Ben Tré's massive
upright volumes of cast glass from
the mid-1980s were inspired by
a trip to Greece. He refers to the
Dedicants as quasi-religious objects.

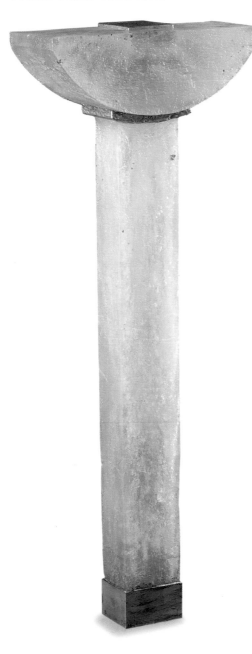

Howard Ben Tré came to glass more or less by chance after studying biology at Portland State University, Oregon. He recalls that, while at Portland, "one day I walked by the glass studio that I hadn't even known was there. I saw the hot glass furnaces, and I just knocked on the door and said, 'Well, what are you guys doing here?' – and they were blowing glass". After Portland he went on to Rhode Island School of Design, from where he graduated with a Master in Fine Arts degree in 1980. Though a native New Yorker he has lived in the area ever since.

Both as a craftsman and as an artist he sets himself challenging tasks in terms of scale and is best known for his monumental cast work. Nothing compares with it, certainly in the United States. Stanislav Libenský and Jaroslava Brychtová and their students have set the standards for monumental casting in the Czech Republic, which is known for its casting facilities; unlike other non-Czech artists (Ann Wolff, for example) making large-scale cast work, Ben Tré works mainly in his native country, adapting industrial facilities to meet his artistic needs. His monumental site-specific work demands pioneering techniques involving a high risk factor, but he has never been put off by setbacks.

Ben Tré can be singled out for two technical processes that he has spent a lifetime developing and improving: glass casting, and covering or "clothing" his glass surfaces with a metallic patina using the electro-forming process. He says: "I got involved in casting out of need. I needed to make certain kinds of objects in order to answer certain questions for myself. At the time I made my first casting, I was looking at early Chinese bronze castings. I was very interested in the idea of the ritual object and in trying to understand its relationship to spirituality. I was also interested in early architecture and in the way people describe space. The first casting came about because I couldn't blow the thing I wanted to make, and I thought, 'Why not pour it?' It was really that simple."

Howard Ben Tré enjoys the technical processes as much as the artistic ones. For him the teamwork and the theatre of the hot shop are an important part of artistic creation. Ladling large quantities of molten

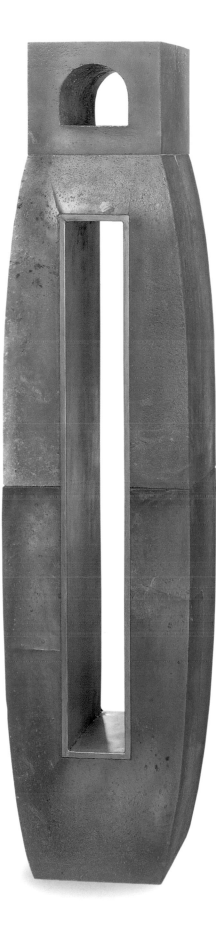

glass out of the furnace into a mould requires athleticism and skill. His monumental castings present many technical problems. Cooling vast quantities of molten liquid can create internal stress factors that are hard to predict. During months of cooling, with temperatures in the kiln being gradually reduced, material imbalances can build up that only become apparent long after the glass mass has cooled. This can lead to serious problems, with the glass developing internal fissures years later. He has come to value accidental effects: "The accident of the glass is part of the process in some way. I think a lot of the 'accidents' are really quite beautiful, they're very lyrical." Such an approach is common among Japanese artists for whom the unexpected in the form of imperfection invites artistic challenge. A fissure is "healed" with artistic treatment. In Ben Tré's work metal cladding of some sort may be used to this end.

His use of metal came from a desire to create a contrast with the greenish industrial glass that he uses in his work. He avoids coloured glass because he feels colour in glass tends towards the decorative, a category with which he would prefer not to be associated. Ben Tré has developed a range of metallic patinas, using copper, gold leaf, and bronze combined with pigmented waxes. The process used to make metal and glass adhere to one another is the electroforming process, similar to electroplating on metal. Another way of achieving patina is by rubbing metallic dust into the surface of the glass. Alternatively the metal may be in the form of inserts – metal plaques slotting into spaces created to house them, or acting as separators between different sections of a sculpture. Ben Tré uses patinas to provide either internal or external light and shade. Sometimes gold leaf, copper, or iron cladding sits deep inside a piece creating an inner glow and radiating its reflected colour out through the glass mass.

Ben Tré is adamant about wanting to be classed as a sculptor. Even so, many of the forms he uses are vessel-based, but the vessel is for him

Left *"9th Figure", 1988.*
h 192.5 cm (75¾ in), w 44 cm
(17¼ in), d 47 cm (18½ in).
Cast glass, metal. Ben Tré's work,
involving a complex casting process,
has been called a visual dialogue
between antiquity and modern times.

sculpture. He sees in it spiritual content: it is a receptacle, a pourer of libations, something filled with mystery. He aims both with the vessels and with the sculptural forms to create something that is archetypal and that expresses fundamental truths about our civilization and our presence on this earth. This need recalls 1960s culture with its agnostic universal truth-seeking and its attempt to throw all religious and philosophical thought into one big melting pot. "I am trying to meld all of these universal feelings into something archetypal, which becomes formal simply because it becomes an object." The titles he gives to works or series of works – "Dedicants", "Cast Forms", "Sections", "Basins", "Solitary Forms", "Paired Forms", "Wrapped Forms", "Primary Vessels" – are a clue to this thinking. Ben Tré is a seasoned traveller and much of his inspiration comes from looking at medieval cathedrals, Mayan temples, the ruins of ancient Greece, Rome, or Mexico, ancient gravestone inscriptions in the Jewish cemetery in Prague. There are no direct references to any of these in his work, but their solemnity, mystery, ceremony, and beauty all give strength to his artistic output.

He is also inspired by the work of other artists: Isamu Noguchi, Louise Bourgeois, and Mark Rothko are among those he has mentioned in this context. Ben Tré's monolithic forms remind one of the simplicity of

Below "Basin 6", 1991.
h 43 cm (17 in), w 88 cm (34½ in), d 41 cm (16 in).
Cast glass and iron filings. Inspired by Constantin Brancusi, Ben Tré searches for the essence of simplicity. His luminous cast vessels are stripped of decoration in an attempt to capture "the real essence of things". He works with light, counting on it to infuse his objects with life.

Brancusi's Modernist sculptures. Brancusi in referring to the concept of simplicity says: "Simplicity is not an end in art, but one arrives at simplicity in spite of oneself, in approaching the real sense of things. Simplicity is complexity itself, and one has to be nourished by its essence to understand its value." Ben Tré's understanding of the materials he uses also reminds us of Brancusi's words that "we must try not to make materials speak our language, we must go with them to a point where others will understand their language". Ben Tré has used industrial glass as an artist's material and in his hands it assumes extraordinary artistic presence. He uses it to trap light within the considerable mass of his larger sculptural works, and in the process has understood how to create an incandescent glow achievable in no other artist's material.

Many of Ben Tré's large-scale and most impressive works are site-specific. Of his public commissions he says: "The nature of making public work is difficult, and it's my responsibility when planning work in a

public context that it be user friendly, but that it also be something which elevates the consciousness of the people who view it or use it." An added factor in large-scale work exposed to the elements is that there are no antecedents; he has had to create his own recipes and this involves a great deal of expensive trial and error. Over two decades of experiment Ben Tré has gone a long way towards controlling processes that will serve future generations of glass artists. Using complex, sometimes daring techniques he has transformed a number of public spaces, such as Post Office Square Park, Boston, where the jets of an architectural fountain form a cascade of water that falls within a temple-like structure made of bronze, patina, granite, and cast Pyrex glass.

The preparatory stages of Ben Tré's work always include drawing. Ideas are sketched into a small notebook in the form of doodles; as they become more evolved larger sketchbooks are used, and when the work is large-scale the drawings can fill a 3 x 3.6m (10 x 12ft) drawing board on his studio wall. Scale is determined by the idea itself. If the idea involves a column the emphasis is on verticality. His "Basins" hug the floor they sit on and horizontality takes precedence. Once he is satisfied with his drawings, the piece is translated into a Styrofoam model which becomes the basis for the mould of the finished work. "The working drawings are anchors," he says, "and they're transformations from concept to reality, because they must exist to bring the concept to reality." The finished glass sculpture gives rise to drawings of a different kind, monotypes or finished works on paper inspired by and reflecting on the work in glass. These form an independent body of work.

Much has been written about this artist and his work has initiated lively critical controversy. Is the work art or craft? Can the factory setting used in the making of it equate to an artist's studio? Is it not simply industrial production? Are Ben Tré's columns and sculptural forms inspired by architecture, antiquity, and ritual vessel forms, or are they charged with sexual meaning?

Ben Tré has created a remarkable body of work that is both elegant and powerful. It is Classical without being Neo-Classical. It harks back to antiquity but its place is in the modern world, either as sculpture or as vessel art. It has an arresting quality, is instantly recognizable, and generates enormous interest.

Giles Bettison

BORN 1966, ADELAIDE, AUSTRALIA NATIONALITY AUSTRALIAN

Giles Bettison has more or less reinvented the ancient Venetian tradition of incorporating *murrine* into glass vessels. The traditional way of preparing *murrine* was to prepare them from thin glass canes, fusing them together with a blowtorch. Bettison makes them out of stacked sheet glass, fusing them in a kiln, chopping and restacking them, and then heating them for a second time in the kiln. During the heating and reheating process colours can melt into one another, creating an altogether different palette. This technique opens up many new possibilities and is enabled thanks to a new kind of glass developed since 1993 at the Bullseye Glass Company in Portland, Oregon. The Bullseye invention has made it possible for the first time to combine kiln forming and blowing, something never before achieved in glass-making. In the new Bullseye coloured sheet glass, colours are more chemically compatible, allowing them to be fused in a kiln and reheated several times. This glass was developed with the help of glass artists such as Lino Tagliapietra, Dante Marioni, and above all Klaus Moje, at Canberra School of Art, where the Bullseye workshops took place at the same time as Bettison was studying there. He graduated from Canberra with a Bachelor of Visual Arts degree in 1996.

Bettison did not start out on his professional life intending to make glass. From 1981 to 1991 he was a welder, fitter, and machinist in the South Australian metal trades. He first encountered glass in his home town of Adelaide at a crafts centre called the Jam Factory, where he worked as technical design consultant and fabricator for a company making neon. During the 1990s glass education in Australia was centred in Canberra, and at the Canberra School of Art Bettison enjoyed the newfound energy among his fellow students and teachers. He is one of a group of young artists emerging from there to be acclaimed on the international glass scene.

Below Untitled, 1995.
left: h 11 cm (4¼ in);
right: h 21 cm (8¼ in).
Both made with *murrine*. The jazzy colours and patterns are inspired by the music that forms such an important part of Bettison's life. He sees a close relationship between the two art forms.

The vessel forms that Bettison blows are simple, traditional shapes, made remarkable by his personalized *murrine* technique. This allows for a new flexibility and sophistication of pattern, which can imitate the ripple of light on water or the shadows cast by changing light in landscape. The patterns he creates are striated and often include tiny dots of colour that create a "pointilliste" feeling. The "Bullseye" *murrine* are semitransparent, making Bettison's vessels look as if they are lit from within and giving a three-dimensional feel to his patterns. Recently he has created groups of vessels that are intended to be seen together.

The patterns and colours of Bettison's glass are inspired by the landscape of South Australia: "the ochres, wheat colours, reds, blacks, the colours of storm clouds, evoke rows of paddocks, a soft chalky pink with small bits of strong colour coming through," as he describes it. These pieces are reflective and capture the mood as well as the colour of the landscape. "Using photos, in conjunction with my memories, I choose the colours, patterns, and forms I will use. By combining these things, I try to create an object that for me embodies a contemplation of time and place, a moment in my life. I am not trying to show specific times or places in my work, but am inviting others to also contemplate the vessels and the feeling that they might evoke." These words might have been written by a *plein air*, or landscape, painter and if he were working in another medium, that is perhaps what Bettison might have been. However, his skill and imagination as a glass artist allow him to be a landscape painter in glass, and his way of capturing the infinite moods of light and shade is a unique addition to the artistic language of glass.

Above "Cell Series", 2000.
h 28 cm (11 in), w 12.5 cm (5 in),
d 10 cm (4 in).
Blown glass, murrine. This series refers to the urban landscape, the translucent cells recalling windows and the grid patterns in pale colours the play of light and shade on skyscraper architecture.

Left "Section Series", 1999.
l 35 cm (13¾ in). *Made with murrine. Bettison's imagery is often tied to the South Australian landscape, with its division of land into paddocks.*

Cristiano Bianchin

BORN 1963, VENICE, ITALY NATIONALITY ITALIAN

Cristiano Bianchin studied painting at the Venice Academy of Fine Arts under the famous Venetian painter Emilio Vedova, graduating in 1987. In 1982 he was awarded a grant by the Bevilacqua La Masa foundation in Venice, a body that supports young artists working in a variety of disciplines. At first he used the grant to work at drawing and to explore the possibilities of working woven hemp (burlap) into three-dimensional forms. However, like any Venetian interested in the arts, he was always fascinated by glass. His first real encounter with glass was in 1992 when, along with seven other artists who worked in materials other than glass, he was invited to design some pieces for an exhibition entitled "Progetto Vetro" (Glass Project), sponsored by the de Majo glassworks on Murano. Bianchin won instant acclaim for his designs, which were executed by master glass-blower Vittorio Ferro. The success he enjoyed encouraged him to explore the expressive possibilities of glass more fully.

Thanks to his background and a deep interest in the history of Venetian glass, Bianchin is well versed in the full range of hot and cold Venetian techniques. He himself does not work the glass, but his knowledge of what can be done allows him as much freedom as if he did. He uses the full range of Venetian techniques, moving with ease from one to another, and giving expression to a wide range of ideas, all of which have a neo-classical feel to them. He draws his inspiration from earlier shapes and styles in Venetian glass, from Italian sculptural tradition, from ancient and modern Italian culture generally. In 1995 he was invited to do a solo show at the Gypsotecha (a plaster-cast gallery) in Possagno, near Venice, a new wing of which was designed by the renowned Italian modern architect Carlo Scarpa. Bianchin's work, using only black and white, paid homage both to the 19th-century Italian sculptor Canova, whose work is in the Gypsotecha, and to Scarpa. Black dots used in different ways recall the black "points" that Canova used in constructing his sculptures, and the shapes recall those of Scarpa, whose 1950s' glass designs are among the best to have come out of 20th-century Venice.

Woven hemp has remained important to Bianchin and is often used to create stoppers, sleeves, or basket containers for the glass. The cellular

"beehive" pattern seen in his work is borrowed from antiquity and recalls the perfect geometry of Sassanid glass vessels from the 7th and 8th centuries, a collection of which is in the Museo Correr in Venice. Other work calls to mind traditional 17th- and 18th-century Venetian glass imagery. In his earlier work pieces were conceived to be exhibited singly, but more recently he has created installations in which table-size pieces are arranged according to a careful plan. He is at home both in black and white (as used in his drawings) and in colour, where his palette tends towards earth tones, with occasional brighter reds or yellows. In his installation work the glass vessels often lie in a bed of sand.

Bianchin's work, with its suggestive shapes and careful positioning of pieces, sometimes overlapping, sometimes carefully separated, is intended as a series of poetic statements or secret gardens. It is work that is born of great sensitivity as well as a deep understanding of and profound respect for Italian art. Bianchin's thorough grounding in art history places him apart from other Italian glass-makers, whose talents tend to be skill-based. His own words best express what he wishes to convey: "Sensuality and sexuality overlap in glass and unconditionally show their nakedness…total nakedness reveals our vulnerability."

Above "Omaggio a Carlo Scarpa"
(Homage to Carlo Scarpa), 1995.
h 19.5cm (7¾in), base 8cm (3in),
circ. 19.5cm (7¾in).
Black blown glass base with
neck of black and white
ivy-shaped murrine.

Right "Semi" (Seeds), 1998.
base 100 x 100 cm (39 x 39 in).
Multimedia composition including
blown-glass pod shapes with gold
foil inclusions and wheel-carved
honeycomb surface pattern.

Opposite "Mentre Accade"
(While It Happens), 1992.
h 52 cm (20½ in), circ. 8.5 cm (3¼ in).
Hand-blown vase and cover with
applied leaf shapes and allegorical
tree-shaped finial, decorated overall
with a wheel-engraved pattern.

Claudia Borella

BORN 1971, CANBERRA, AUSTRALIA NATIONALITY AUSTRALIAN

Claudia Borella is involved with glass through her career as an industrial designer. She has two bachelor's degrees, one in industrial design from the University of Canberra and one in fine arts from Canberra School of Art, where she majored in glass. Her clean lines and bright colour palette have brought early success in what promises to be an exciting career. She would probably refer to herself more as an object-maker than an artist in glass. Most things she makes have a household dimension to them. Some are intended for use, such as her sushi plates, others for decoration. When she works as a designer she pays attention both to function and to a mood that she wants to convey. The sushi plates are elegant and simple, a perfect way of presenting this visually pleasing kind of Japanese food. "I enjoy making unique one-off or limited edition pieces using semi-production techniques, because it permits the […] individuality that commercial mass production lacks."

There has recently been a return to the idea of combining art and industry, a topic much discussed in the first half of the 20th century. In some ways the wheel has come full circle. In the aftermath of World War II functionalism determined parameters in the design world, only to give way dramatically in the early 1980s to a reaction against it by new

Above "Striped Series II", 1995:
h 5 cm (2 in), w 50 cm (19⅝ in),
d 50 cm (19⅝ in).
Fused, wheel-cut, and kiln-formed glass. Borella is a designer who enjoys the artistic licence of the contemporary glass world, where art and design often overlap. This plate could serve equally well as household object or art object.

thinkers such as those who made up the Memphis Group. Towards the end of the century smart designers minimized any idea of usefulness and there was a tendency to make household objects deny their function. Art school graduates needed to show that whatever they were doing justified their existence as artists first and foremost. More recently, there has been a return to design for its own sake, and Claudia Borella is one of a new generation of art school graduates who enjoys artistic freedom without feeling there is any stigma attached to being labelled a designer.

Borella has in a short time been able to create a style that is individual to her, using strong linear patterns and well-chosen colour contrasts. She works with fused coloured strips of glass and has made full use of the new kind of glass developed by Bullseye, which has tempted so many of her generation, particularly in the United States and Australia. Bullseye has conducted workshops in both countries, in 1998 also sponsoring an exhibition entitled *International Young Artists in Glass, Australia*, in which Borella was one of the featured artists. Bullseye was attracted to Australia partly because a young generation of Australian glass artists showed such promise. For Claudia Borella, working with Bullseye glass allowed her to focus on the optical effects of colour. In a way she is harking back to the world of Op Art with its bright linear canvases in which colours reacted to one another with dazzling optical effects. Bullseye glass allows Borella to apply the principles of Op Art to three-dimensional form. "Why wasn't I a painter?" she asks. "Perhaps because of the three-dimensional quality of objects, and the issue of functionality [...] Being able to look at something aesthetically pleasing is one thing, but being able to use more than one sensory perception in space has a greater capacity to make a person's environment, lifestyle or sense of place individual."

Above "Bi-Colour Platters", 1995. h 6 cm (2¼ in), w 45 cm (17¾ in), d 23 cm (9 in).
Fused, wheel-cut, and kiln formed glass with aluminium and rubber feet. These pieces were the artist's first attempt at using Bullseye glass.

Below "Meeting Point (Perspective)", 2000. h 23.5 cm (9¼ in), w 18 cm (7 in), l 98 cm (38¾ in).
Fused, kiln-formed, wheel-cut, and polished glass, metal and rubber stand. The larger scale of this piece marks a departure from the smaller-scale earlier work.

Lucio Bubacco

BORN 1957, MURANO, ITALY NATIONALITY ITALIAN

Above "Unicorns", 1996.
35 x 20 x 12 cm (13¾ x 7⅞ x 4¾ in).
Lampworked & blown glass.
Dancing figures and bodily
movement are the central themes
of Bubacco's work. The soft glass
used in modelling with a blowtorch
flame allows for anatomical
accuracy, so that each limb and
each part of the body can be
choreographically correct.

Lucio Bubacco is Venetian by birth, has lived in Venice all his life, and has created a new art form using the traditional Venetian flame-working, or lampworking, technique, in which a blowtorch warms up thin canes of glass which are bent and shaped by hand. This way of making glass has always been used principally to add ornamental detail, and to shape little animals or figurines in glass. At the age of 14 Lucio Bubacco started out as an apprentice learning to shape glass warmed by a flame. He was taught to work in clear glass, and only much later developed the vast colour palette for which he is known today.

Bubacco's education was a typical glass apprenticeship within a glassworks. An apprenticeship can last for years, and there is fierce competition among those aspiring to become *maestri*, or masters, the title given in Venice to those who head a glass team. Becoming a *maestro* in this technique is a rare accolade. Lampworking has until recently been viewed as something of a "cottage industry" in the Venetian glass world. It is executed in tiny workshops, often consisting of only one or two people. Bubacco practised traditional lampwork until in 1980 he took two years out to study anatomical drawing and painting with the Venetian artist Alessandro Rossi. He is now one of a handful of Italians who use the flameworking technique for artistic expression.

By the time he returned to glass-making, Bubacco had developed a taste for a lively colour palette, inspired by his art studies. A Bubacco work may now incorporate up to 50 colours, which requires great knowledge about colour compatibility (the way in which the chemistry of coloured canes makes the colours react to one another). The glass he uses has a high soda content, making it softer and more flexible, and he sometimes likes to use antique glass which he finds in old factories or antiques shops.

In his two years of study Bubacco became interested in a more developed range of subject matter, particularly Greek mythology and *commedia dell'arte*, in both of which metamorphosis and transformation play an important role. His subject matter is often erotic, and his detailed figures are energetic, balletic, expressive and full of life.

During the 1990s Bubacco's work became more ambitious and grew in scale, with goblet stems extruding horizontally and acting as a scaffold to support a "tableau vivant". The goblet compositions can be up to 120cm (47in) high, variations on the classical Venetian "wing glass" with its elaborate stem. In another kind of work Bubacco's figures form a three-dimensional scene within an architectural stage set inspired by Venetian architecture. In a third kind, figures are worked into the surface of glass vessels using paperweight methods. Bubacco's work combines virtuoso technique and a theatrical narrative closely allied to choreography. It is theatrical and lighthearted, with all the magic of ballet or musical theatre.

Dale Chihuly

BORN 1941, TACOMA, WASHINGTON, USA NATIONALITY AMERICAN

Below "Vase #3", 1967.
h 25cm 9¾in), w 20cm (7⅞in),
d 20cm (7⅞in).
Free-blown glass. At the beginning
of his career in glass and before
he had visited Murano, Chihuly
blew glass in the free-form style of
the first Toledo workshops, largely
arrived at by trial and error in the
absence of technical know-how.

Dale Chihuly's huge personality, his love of glass, his exploration of glass's luminous effects and its colour possibilities, and his entrepreneurial bravado, have all played a key role in the changing world of contemporary glass. His art is about performance. He has devised a whole new routine for making glass, rather like a choreographer inventing a new body language for his dancers. Over the course of more than 35 years, Chihuly has changed our visual expectations.

His first encounter with glass was typical of an alternative approach that is a constant feature of his career. One of his student assignments was to loom-weave with a non-fibre material. Chihuly chose glass – "the material most foreign to fibre". It was the first time anyone had thought of combining these two opposites, one soft and giving, the other brittle and hard. Chihuly does not break rules, he bends and stretches them, in the process becoming an adventurer in unknown territory. He does not travel alone, recognizing the talents of others and inviting them to travel with him, the expedition leader on an endless voyage of discovery in glass.

Aged 24, Chihuly graduated from the University of Washington with a degree in interior design. He then began a graduate course studying glass-blowing under Harvey Littleton at the University of Madison, Wisconsin. It was the first such university course in the United States, at a time of great excitement about the artistic possibilities of glass. Chihuly was captivated by the idea of charting new territory and not having to stick to any rules. He found himself among kindred spirits at Madison and then, after graduating with an MA in sculpture, at the Rhode Island School of Design. In 1969, after further studies at RISD and more travel, including an important first visit to Murano in 1968, he established the Glass Department at RISD, where he was to teach for the next 15 years.

Chihuly's students included some of the most famous American names in glass – Dan Dailey, Toots Zynsky, Howard Ben Tré, Michael Glancy, Flora Mace. He encouraged his students to learn from the past without tying themselves to it. Chihuly himself looks endlessly for new ways of working. In the early 1960s the way forward in glass was to devise equipment to

Right "Glass Forest #1".
In collaboration with James
Carpenter, 1971–72.
15,000 sq.cm (2,325 sq.in).
Neon installation. Chihuly has
never let glass processes limit his
imagination. On the contrary, he
has explored artistic possibilities
in areas never before visited by
glass practitioners.

Below "Primary Yellow Macchia With
Dark Forest Green Lip Wrap", 1992.
h.55cm (21⅞in), w.55cm (21⅞in),
d.57.5cm (22⅞in).
Free blown glass. The "Macchia" series
was a riot of colour in which Chihuly,
with the exuberance of a child in a
sweet shop, could revel in polychromy
and experiment to see how far he
could go with colour combinations.

allow a glass artist to work alone in the studio. But on his first visit to Murano, as one of the first non-Italians to work at the Venini glass factory, Chihuly learned to appreciate the potential of teamwork. In a Chihuly team every member is an individual performer, encouraged to shine. He feeds off their skills, turning a collaborative effort into a Chihuly masterpiece.

Chihuly is a natural leader and entrepreneur. In 1971 he held a summer workshop with 16 students, in which all the equipment, including two furnaces, was built from scratch. The site – isolated forest land in the foothills of the Cascade Mountains near Seattle – has since grown into the Pilchuck Glass School. What started as a summer campus has come to have a worldwide influence on glass-making, having hosted almost every famous glass artist in the world as teacher or artist in residence.

In 1976 Chihuly lost the sight in one eye in a car accident in England, and was obliged to rely more on the skills of other people, although he had always believed in collaboration. His greatest talent is probably to get hold of an idea and turn it on its head. If he sees something that appeals – a substance, a technique, a piece of history – he makes it his own. This is what he has done all along with hot glass, testing its limits in every conceivable way. He stretches it almost to the point of breaking, colours it as freely as if he were painting, shapes it as if it were as soft as clay.

At first his shapes were either quite restrained or completely crazy. On the one hand during the 1970s he was making simple cylinder forms, some in collaboration with Seaver Leslie and Flora Mace, using a glass-blowing technique whereby, "you could make a little drawing in glass and pick it up on the marvering table". The real breakthrough came when Chihuly used this technique to transport Navajo blanket designs on to his glass cylinders in a series begun in 1974. Alongside this work he was experimenting on the wilder side, in collaboration with Jamie Carpenter, with a huge installation consisting of 9,000kg (20,000lb) of ice and neon

Above *"Translucent Yellow Seaform: Persian Set"*, 1994. h 62.5cm (24¾in), w 145cm (57in), d 145cm (57in).
Free-blown glass.
By combining multiple related forms in his "Seaform" and "Persian" series, Chihuly increases the range of visual effects that can be achieved through an aleatory combination of colours and shapes.

Left *"Peach Cylinder With Indian Blanket Drawing"*, 1995. h 52.5cm (20¾in), d 15cm (6in), diam. 15cm (6in).
The "blanket cylinders" remind us that Chihuly studied textile design at the University of Washington before discovering glass and that the first time he ever used glass was in a weaving experiment.

tubing (1971) Similar excursions into the realms of fantasy included "Glass Forest #1" (1971–72), also made with Jamie Carpenter. This forest of glass rods stretched to their limits, twisting and curling in organic shapes, was installed at the American Craft Museum in New York.

During the 1980s organic shapes more or less took over from cylinders as Chihuly worked through ideas with various collaborators. In 1980 he began his "Seaform" series, in which he imitated the movement of the sea and the colours of sea-life. The "Seaforms" were composed of sets made up of multiple-related shapes, which could be arranged at will. He started on the "Macchia" series in 1981, which "began with my waking up one day wanting to use all 300 of the colours in the hot shop". Other ideas duly took over from "Macchia", including "Persians", begun in 1986, "Venetians" (1988), "Soft Cylinders" and "Ikebana" (both 1989).

The "Venetians" marked the continuing fascination with Venice that was central to Chihuly's thinking in the 1990s. It was also the start of one of his most fruitful collaborations, with the Italian *maestro* Lino Tagliapietra. Inspired by Italian 1920s' glass, Chihuly drew the most extreme pieces he could imagine; Tagliapietra, aided by American glass master Benjamin Moore, translated these into glass. Chihuly glass-blowing sessions are like wonderful parties: he draws feverishly with crayons and paints, while loud music helps with the choreography of glass-making. Chihuly has also worked with the renowned Venetian glass *maestro* Pino Signoretto, whose speciality is making hot-formed glass sculpture. That inspired Chihuly with the idea of using *putti* on a series of vases. "Normally I don't like the look of figures in glass, but the *putti* look just right in glass."

By the 1990s Chihuly was world-famous, with his studio becoming something of an industry, although unlike any glass industry known before. He worked on installations for museum shows or public buildings (the Rainbow Rooms in the Rockefeller Center in New York among them). "Public installations are my favourite form of art because so many people get to see them." His work is in the White House collection.

The 1990s were dominated by one big idea, realized at sites all over the world and culminating in "Chihuly Over Venice" at *Venezia Aperto Vetro* in 1996. His idea was to create a series of chandeliers at different glass factories (in Mexico, Ireland, the US, Finland, Venice), and bring them

Below "Ducal Palace Chandelier", 1996. h 270cm (106in), w 240cm (94in), d 240cm (94in). Free-blown glass elements attached to a metal armature. For "Venezia Aperto Vetro", 1996, Chihuly chose a room in the Ducal Palace where a traditional Murano chandelier already hung. Taking that as his inspiration he constructed a mountain of glass which rose to meet it in a playful gesture that was also meant as a tribute to Venice.

together in a symbolic act of homage to the spiritual home of glass. Fourteen chandeliers were suspended at sites in Venice, a riot of colour and shape in glass that transformed the city for a time. The chandeliers are made up of component free-form parts, usually all in the same colour palette. These are fixed to a central metal armature and hang like clusters of exotic fruit. The chandeliers hang like Chihuly insignia in many museums and public places, including London's Victoria and Albert Museum.

Since the chandeliers there has been a raft of new ideas, the most dramatic being a series of installations composed of glass spears and ice sculptures situated at various locations in Jerusalem in 1999. Chihuly is a star performer and entertainer in glass. His one-man shows bring us glass at its most extravagant, colourful, and spectacular. He exploits the most obvious qualities of glass but creates new magic in the process. Chihuly's work goes straight to the heart and comes from there as well.

Below "Red Sarguaros", 1999.
Variable dimensions.
*Free-blown glass. Installations
are often conceived for outside
locations, where the setting itself
and the photography of the
installation in situ are all important.*

Right "Cadmium Yellow Venetian",
1990. h 77.5cm (30½in), w 32.5cm
(12⅜in), d 32.5cm (12⅜in).
*Free-blown glass with hot-formed
applications. Chihuly works with
a number of outstanding Venetian
glass practitioners.*

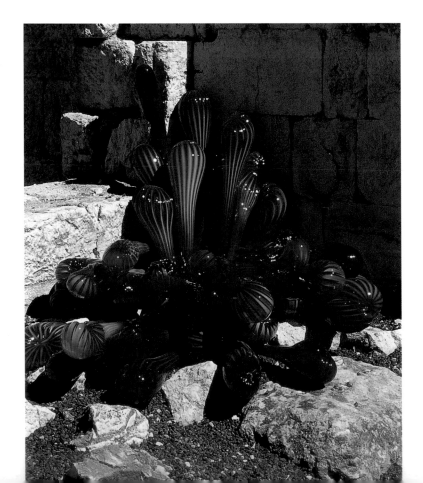

Right "Saffron & Golden Tower",
2000. h 450cm (177in), w 210cm
(82in), d 210cm (82in).
*Blown glass. Chihuly is at his
best when at his most extravagant
and colourful. He is inspired by
the challenge of working on a
monumental scale.*

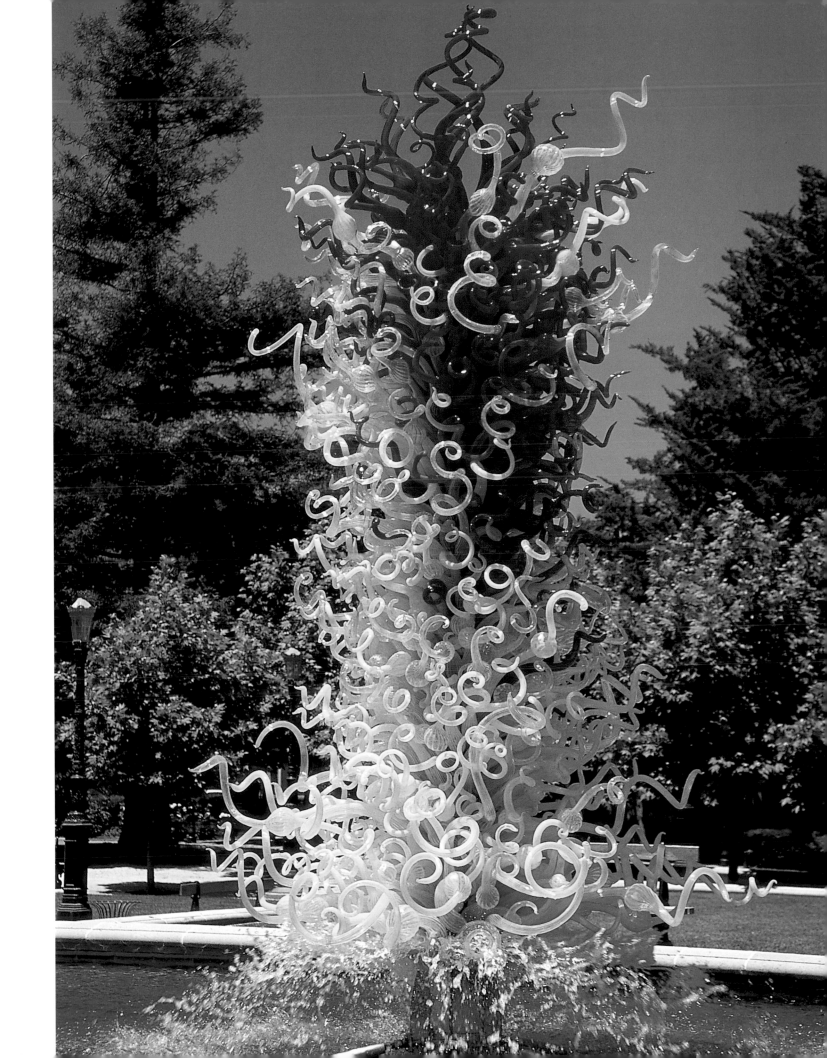

Václav Cigler

BORN 1929, VSETÍN, CZECHOSLOVAKIA NATIONALITY CZECH

Václav Cigler uses glass to redefine space and makes full use of its reflective qualities, its ability both to reflect light and to divert it. Mirrored glass traps and reflects light, while transparency allows light to travel through it in different ways. The volume and outline of the glass take on special significance in this process of entrapment and transmission. Cigler's sculpture, whether flat or three-dimensional, whether intended to be placed in a natural setting or in architecture, changes the nature of the environment it occupies. It creates spatial relationships that depend on transparency and reflection. In planning a site-specific work Cigler studies the setting in detail, considering how the presence of glass will affect light and space. The work grows out of the site itself. Cigler's

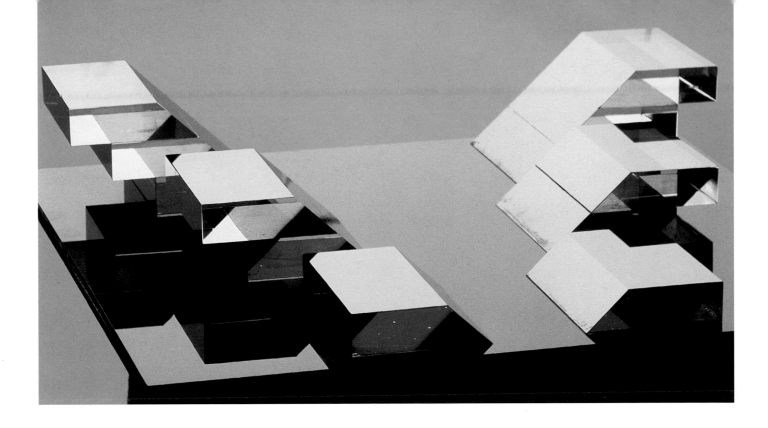

approach to the spaces his work will occupy is sensitive and modest; he seeks to enhance rather than to dominate a space. When a work is planned to be outside, attention is drawn to the limitlessness of space. The reflective qualities of glass are used to bring the sky closer. This form of artistic engineering is both real and philosophical.

Cigler began his glass studies at the age of 19 at the Industrial Glassmakers' School in Nový Bor after leaving high school in his home town of Vsetín. After the three-year course he went on to the Prague Academy of Applied Arts, where from 1957 to 1961 he studied architecture and design in the studio of Professor Josef Kaplický. Cigler himself taught from 1965 to 1979 as head of the studio of glass architecture at the Academy of Fine Arts in Bratislava, where his influence on a generation of artists was considerable. Since 1980 he has worked exclusively as a freelance artist. In the 1980 catalogue for the Düsseldorf Museum, where 25 of Cigler's sculptures formed the centrepiece of a large international cut-glass exhibition, Helmut Ricke wrote: "Cigler is the focal personality in the development of new cut glass. Without his contribution the work of young Czech glass artists would be unthinkable."

Cigler's work in glass is mainly sculptural. He uses optical cutting and polishing (as used in the making of lenses) which provides sharp edges,

Above "Track Of Light" Royal
Gardens, Prague Castle, 1994.
w.15cm(6in), l.3,500cm(1,378in).
Cast-glass bricks. This conceptual
installation was devised for an
exhibition called Glass and Space,
an investigation by six Czech
artists into the way in which glass
can change and be changed by
its environment.

perfect angularity, and jewel-like precision, all of which are seminal to his planning of spatial relationships. Points of intersection play an important role in the way light is directed or redirected in his glass compositions. Cigler uses layered glass, sheets of glass stacked on top of one another, to add further kaleidoscopic qualities. The cutting is carefully thought out beforehand. Its execution requires a high degree of discipline and the kind of precision not usually associated with free artistic expression. Yet discipline and rational thinking are at the heart of Cigler's aesthetic. His sculpture is elegant and perfectly executed, that being an important part of his artistic statement about harmony, its component parts, and the role it plays in our lives and in our world. The ideas are simple but brilliant, born of a mathematical brain and closely related to the principles of constructivist art, which explores the aesthetics of geometry – in Cigler's case three-dimensional geometry. He creates a magical world of optics designing how light will be transmitted through or trapped by his sculptures. In his hands precision engineering becomes an art form. In the 1980s many Czech artists, most of whom had been pupils of his at Bratislava, worked in optical glass. With a series of glass sculptures that make use of the endless possibilities opened up by the use of optical effects as an artistic device, Cigler has for 30 years or more remained the most imaginative exponent of the art form that he pioneered.

Although he occasionally uses colour in his work, the colours are not primary or solid: his colour palette is found in the darting rays of reflected light that make a diamond sparkle. The work is about all the colours of the spectrum, but not about coloured glass. Cigler uses glass to trap the colours of the universe, to create an imagined world of light that exists only through his work. At an exhibition held in the grounds of the Belvedere in Prague, one of the pieces he created was a long mirrored line dividing a tarmac road. Walking along beside it one saw a narrow piece of the heavens brought down to earth and exquisitely framed. Standing at one end of the line the eye travelled down a ray of light stretching away into the distance, providing a new and exciting visual experience. The visual impact changed according to the time of day and the brightness of the sun. Sometimes the long line of mirror was a blinding ray of light, sometimes it had the stillness of a mountain lake.

Cigler's own words best describe his imagined world: "Glass is an intriguing material. It is matter, yet it denies matter. As transparent as

water, as clear as air. Both illusion and reality, true and yet misleading. It can reflect shattered images of our visual experience, even enrich it. In a certain sense, it is the reflection of man… It is capable of acquiring new properties. It is adaptable to human intentions and needs. The presence of glass in a human environment conditions not only the space around, but man himself. Today, due to new technology, glass has new possibilities… It has grown into space in the form of a glass panel, which may be used along with other construction materials. Not only as a wall, but almost as a living organism, reacting to light, temperature, surrounding colour and shape, responsive to the vision of the artist and the whim of the consumer…

"… I use glass as a mediator for observation and meditation… The properties of the glass are an integral part of my vision. Glass has the ability to present its whole content to the viewer, not only the outer form, but the inner space as well. To work with a block of glass means therefore to work with its optical properties. The outer is influenced by the inner and vice versa. Just as with man. As a consequence, a glass object or sculpture is never merely matter in space. It is simultaneously an object which engulfs space, reflects it, deforms it, and decomposes both shape and colour."

Below "Glass Object in the Shape of an Egg", 1996. w 21 cm (8¼in), l 33 cm (13in), base 125cm (49¼in). Optical-cut and polished glass egg-shaped form, one half clear, the other glazed with silver through to gold colouring, on a large circular metal base. Cigler's minimalism adds clarity and strength to his expressions in glass about the poignancy of spatial relationships.

Tessa Clegg

BORN 1946, LONDON, ENGLAND NATIONALITY BRITISH

Below *"Blue Box". In collaboration with Liz Crowley, 1985. h 14cm (5½in), w 22cm (8¾in), d 14cm (5½in). Pâte de verre. In the series of work that they produced together, Tessa Clegg provided harmony and order and Liz Crowley the decorative element.*

With quiet determination Tessa Clegg has worked her way through one idea after another to arrive at the clarity of form that distinguishes her work today. In 1998 she won the coveted Jerwood Prize, a prize devoted to a special area of the decorative arts in Britain every year. For Tessa Clegg it signified long overdue recognition of her contribution to contemporary glass. It is sometimes difficult for British artists in glass to attract an audience; galleries that take glass seriously are few, making it vital for British glass artists to make their name abroad. Yet glass education in Britain has been among the best there is, with the MA course at the Royal College of Art internationally recognized for its excellence. Tessa Clegg teaches there and since 1984 has taught at numerous other British art schools; she was artistic director of North Lands Creative Glass for two years (1997–98), a summer school in the north of Scotland, and for several years during the 1980s was president of BAG (British Artists in Glass).

Tessa Clegg learned about glass at Stourbridge College of Art (1979–82), where she had the good fortune to be taught about glass-casting by Keith Cummings, an artist and author of one of the most frequently used

Right *"Folded Bowl", 1987. h 13cm (5in), diam. 31cm (12¼in). Working on her own, Tessa Clegg concentrated on pure form, experimenting with folds and pleats on traditional vessel shapes.*

textbooks on this glass technique. At Stourbridge Clegg
met Liz Crowley, with whom she collaborated until 1987
in a working partnership that ended when their personal
relationship did. The fruits of their shared experience were
seen in a series of delightful vessel forms in pink, grey,
and blue cast glass. Unlike Tessa Clegg's more recent and more
familiar work, these vessels were decorated with a crowd of
figurative symbols, taken from a variety of cultures and seen against a
background of sober architectonic detail. Buddha's heads were next
to leaping horses that had their origins in classical antiquity, and
both were intermingled with images taken from modern popular
iconography, such as Superman.

It took nearly a decade for Clegg fully to realize her artistic potential.
Creating a form in glass-making, particularly in this kind of glass-making
where a form is much slower to take shape than in blown glass, is highly
dependent on technical experience. Clegg has chosen the laborious
process of lost-wax casting as her particular brand of casting. In this way
of forming glass (based on bronze-casting techniques) a wax model is
made first; a mould is then built around it, and the wax melted out as
glass is poured into the mould. As wax is so responsive to modelling, the
artist has full control of both form and decoration. René Lalique, the
famous French glass artist of the Art Deco period, used this process to
render a degree of detail never before achieved in this way of working
glass. Tessa Clegg has used it to deliver form that is balanced and
harmonious with perfect curves, straight lines and grooves, and the
angularity and clear colour separation of Constructivist art.

Below "Bead", 1998.
h.35cm (13¾in), diam. 15cm (6in).
Cast glass. One of a group of
pieces that earned Tessa Clegg
the Jerwood Prize. The solid colour
and heavy mass of the rigid red inner
cylinder take on a different, softer,
more fleshy character when seen
through the outer form.

Tessa Clegg is one of the few contemporary glass artists who works entirely alone. She has a studio in north London, where she makes small limited edition series in which no two pieces are exactly the same. These explore the possibilities of colour variation. In a series called "Secret Boxes" (1997) the basic form is an elliptical box made in three parts. The base section has protruding ridges; in the middle section the ridges become grooves, creating a positive–negative effect, which is resolved by a perfectly smooth lid. This construction, like the others she uses, allows for interesting colour variations. She usually uses bold or primary colours – pillarbox red, wine red, bright yellow, and deep blue being among her favourite – and often transparent or semi-opaque glass.

In a series of work begun in the mid-1990s Clegg's vessels became more sculptural and developed "inner lives", with internal segments seen through a veiled or profusely bubbled outer form. Her more recent work has also seen the invention of a new casting technique in which a three-dimensional vessel shape is created by channelling glass into the empty space between two refractory moulds. In other words the empty space between the two moulds becomes the solid glass form, and the solid of the refractory mould the hollow of the three-dimensional glass form.

Clegg feels that an important breakthrough occurred with an invitation to exhibit at the international show *Venezia Aperto Vetro* in 1996, for which she broke with a more restrained vessel tradition to create a piece called "Play Boxes". Three shallow bowl forms in opaque glass housed bright red cubic or rectangular shapes. The three pieces were intended as a single work. As she developed this idea, pieces began to fit into each other much more closely than in "Play Boxes". Up to this time, Clegg had worked through a number of ideas, the most distinctive being her series of pleated bowls in various colours, sizes, and shapes. The pleats, borrowed from textile design, brought her instant success, and a number of her pleated bowls are in museum collections. Folds, grooves, chevrons, pleats, and the aesthetics of repeated geometry are Clegg's decorative vernacular, and with the development in her work the use of them has become more sophisticated and mysterious through often being placed inside a form rather than on the exterior.

Although Tessa Clegg's recent work has been of a more sculptural kind, she is satisfied to think of herself as a vessel-maker. There is enough to

explore in vessel form for her not to feel the need to look for any other anchor to her artistic creation. She feels that the "Play Boxes" freed her to use form as her means of self-expression. In her earlier work the vessels were part of a tradition that would always link them to function. Since 1996 she has extended the parameters of her thinking about form, no longer limited by any preconceived associations (whether subconscious or intended) that vessels might have. She now invents forms in glass that have a different artistic status. They make a perfect aesthetic sense that precludes any need to classify them further.

Above *"Ellipse"*, 2000.
h 18cm (7in), w 35cm (13¾in),
d 10cm (4in).
Cast glass. In a more recent series
of interlocking forms that fit together
with the precision of machine parts
Tessa Clegg uses shape and
colour to set up a lively dialogue.

Kéké Cribbs

BORN 1951, COLORADO SPRINGS, COLORADO, USA NATIONALITY AMERICAN

Above "Baudino", 1992.
h 104 cm (41 in), w 61 cm (24 in).
*Carved painted wood, painted linen
coat, hand-sewn buttons, copper,
wheel-engraved glass. This richly
coloured fetishistic figure shows
off the ease with which Cribbs
combines her craft skills.*

Kéké Cribbs has led something of a nomadic existence and is largely self-taught. During the 1980s, when she was already in her thirties and a practising artist, she attended summer courses at Pilchuck Glass School, but apart from that and a course at Penland School in North Carolina, she has learned by trial and error. She discovered glass more or less by chance during the early 1980s, when she was asked to translate her imagery by etching it onto the glass fronts of a series of cabinets; before that she had mainly worked doing coloured drawings. Glass has become her most important but by no means her only work surface, and engraving is still her preferred technique for narrating on glass. She likes to mix her materials, often using wood, metals, and enamel paints as well as glass in a single piece.

Her travels began at the age of 15 when she moved with her mother to Ireland. Her later schooling consisted mainly of learning about life by travelling in Europe and then living on Corsica for six years. She returned to the United States a single mother. During her childhood and while travelling in Europe she was a solitary figure, absorbing disparate cultures and recording her thoughts in the diverse imagery to be seen in her work. Her approach is universal; she says: "The world's a pretty small place, and cultures aren't so different as we would like to imagine. The cave paintings from one side of the world look like cave paintings from the other side of the world."

Cribbs has built up a fantasy world that has been described as "between escapist fantasy and nightmare", in which a central figure is often adorned or surrounded by symbols borrowed from the many different environments of which she has had experience, having moved 23 times in 22 years. "A lot of times when I move I leave everything. My life is always in chaos. I'm always trying to stay upright, on balance, going towards my goal. I know where I'm going, and I have to stay in the eye of the storm." The imagery is often taken from American Indian culture, or from the naive figurative representations of other primitive civilizations. Animals and plants, neatly arranged in informal patterns, form the background material in her work. She uses a wide range of bright colours and her work is highly decorative.

More recently she has added glass mosaic to the range of materials that she uses, sometimes applying it to wood and sometimes to blown glass vessels. The mosaic tesserae are highly coloured and often have linear or dot motifs, adding a patchwork pattern and movement to the lively background matter.

Cribbs has used a variety of different forms on which to apply her narrative imagery. Among them are sails or sailing boats, symbolic of her journey through life. The scarecrow is another of her basic symbols. "The idea was this sort of wooden figure that's up on a hill, isolated, lonely. On the one hand, he's surrounded by nature. He's in the most beautiful place he could possibly be. But he's completely disconnected from everything. And the people view him as something they don't want to be associated with." There is also a series of "doors" and a series of "chambers" or three-sided structures. All are used to give expression to her secret world. Detailed narrative conveys her thoughts about things political, racial, ecological with imagery that is naive and sophisticated at the same time.

Below "Mardi Gras", 2000.
h 71 cm (28in), w 28cm (11in),
diam. 14cm (5½in).
Fibreglass boat form covered in multicoloured plate-glass tiles on forged steel base, depicting characters in fancy dress.

Right "Othoptera" (side A), 1999.
h 59cm (23¼in), w 48cm (18¾in),
diam. 13cm (5in).
These forms are made of fibreglass and covered in tiny plate glass tiles made by cutting up a larger piece of glass.

Dan Dailey

BORN 1947, PHILADELPHIA, PENNSYLVANIA, USA NATIONALITY AMERICAN

Dan Dailey's glass is as catchy as a tune. Its lighthearted humour sticks in the mind, rather like a good joke. Dailey has the confidence of knowing that he can make us laugh, and like any good performer he works hard to entertain his audience. His compositions, with their range of colourful glass, often held together by an armature of precision-turned shiny metal rivets or nuts and bolts, poke good-natured fun at the world. He is brilliant at delivering poignant messages disguised as wit, and his artistic integrity is such that he also gives us the satisfaction of knowing we can depend on their being packaged with consummate craftsmanship. Dailey appeared on the contemporary glass scene at a time when there was much debate about the difference between art and craft, but ignoring the debate, he used glass in such an original way that it transcended all the argument.

Dan Dailey graduated in 1972 as a Master of Fine Arts from Rhode Island School of Design, where he had been among the first students to be in Dale Chihuly's class. However, he was never one for the kind of amorphous free expression in hot glass that was fashionable among Chihuly acolytes, and from the beginning displayed a preference for

Above "Vanity", 1986.
h 89cm (35in), w 61.5cm (24¼in).
Vitrolite, plate glass, fabricated brass. The epigrammatic humour of Dailey's wall reliefs shows he is a master of caricature and a fine raconteur. His subjects are often style victims trying to set a trend but displaying a sad lack of taste.

Left "City Vase (New York)"
Scenic Vase series, 1979.
h 33cm (13in).
Blown, sandblasted, acid-polished. By 1979 Dailey had explored all the techniques he was to use in his career. He has always alternated between vessel form and sculpture.

clean lines and tightly organized composition. He had already received a degree in fine arts from Philadelphia College of Arts and spent a couple of years teaching ceramics at Southeastern Massachusetts University. After graduating from Rhode Island he was awarded a Fulbright Hayes scholarship, which allowed him to spend a year in Venice, working at the Venini glass factory on Murano. On returning to the United States he settled in Boston, and in 1979 he founded the glass programme at the Massachusetts College of Art. He has taught or lectured at many major American glass schools, including Pilchuck and Haystack Mountain School of Crafts. He is very active on the American contemporary glass scene, a popular figure whose good-natured humour extends to everything he does. Dailey met his wife in 1974 when she was a student at the Massachusetts College of Art. She has since become a distinguished jeweller, many of whose jewels feature glass combined with metalwork. She also helps Dailey with the fabrication of the metal parts he needs in his work. The demand for Dailey's work is now such that he has a permanent team of helpers who assist him with all aspects of his work, whether that be glass-blowing, metalwork, or the administrative tasks involved in running what is in effect a small industry.

Some of Dailey's compositions, with titles such as "Sick as a Dog", "Fatigue", or "The Principles of Décor", remind us how ridiculous life can be. These are mainly wall pieces, cartoons in glass carefully constructed or pieced together with a combination of shapes cut out of plate glass and vitrolite glass. Vitrolite is a slick, shiny, hard-edged material available in a great variety of colours. It allows Dailey to use a whole range of colour accents that add to the comedy. These can be in the form of exaggerated cosmetics (hideous lip gloss, for example) or totally unsuitable accessories (designer glasses, costume jewellery). The draftsmanship of his wall pieces is deliberately naive, the style a little reminiscent of "painting by numbers", all of which adds to Dailey's version of comic-strip humour in these works.

A delightful series of table sculptures called "Figurative Busts" are either mood or character portraits. Dailey displays his humour again in a series of vessels, some of them produced at his own studio and some in collaboration with individual artists such as Mark Weiner (his assistant at Pilchuck) and Lino Tagliapietra. Some limited series pieces have been produced in association with important glass manufacturers, including

Opposite "Nude Surprised In The
Garden" (2–98), 1998.
h 71cm (28in), w 63.5cm (25in),
diam. 23cm (9in).
Blown glass and vitrolite with fabricated,
patinated, nickel-plated bronze,
electrified. Dailey's lamps show him
at his most expressive and imaginative:
animal or human figures in strange
situations combine real and surreal.

Below "Chase",
Abstract Head Vase series, 1994.
h 57cm (22½in), diam. 40.5cm (16in).
Blown glass with applications.
The expressive face, half animal,
half human, suggests carnal desire.

Steuben, Waterford, and the French glass company Daum (he has collaborated with Daum as an independent artist since 1976). In these he works through a host of ideas as diverse as urban landscape, birds flying and landing, and exotic fish (which he observed while underwater fishing in the Caribbean). The production vessels made at Daum have simple classical forms and are made of solid thick-walled glass, often with sandblasted or enamelled decoration. Dailey has also collaborated with Daum on a series of *pâte-de-verre* sculptures that have a distinctly Art Deco feel to them. The sculptures are figurative and more generic than the precisely epigrammatic wall pieces, often with a single figure embodying a specific concept, such as speed or greed. The unique vessels that he makes in his own studio may be multi-media pieces, sometimes presented on complex pedestal structures that give them a sense of overblown importance, once again poking fun at convention.

As a teenager Dailey had displayed talent as a cartoonist and even expressed the wish to make this his career. He is an excellent draftsman and uses drawing to put his thoughts down on paper. The drawings are more than sketches: ideas seem to emerge on paper fully thought out and ready to be executed in glass. Industrial design was also a part of his youth. His father was an industrial designer and Dailey's work has a close affinity with product design. It is this unusual combination of interests, together with a talent for observation and a compelling sense of humour, that make Dan Dailey the artist that he is.

He takes his craft very seriously and over the years has explored virtually every area of glass-making, giving him an encylopedic knowledge of glass that allows him to use it in many different ways. "Invention is based on knowledge," he says. Plate glass, blown glass, engraving, and sandblasting often all have a role to play in the same piece. Yet there is no hint of craft exhibitionism in this. Dailey has enjoyed learning about the different ways in which glass can be worked and used, and this enjoyment is communicated to us in the highly polished performance that he delivers as a comedian in glass. He knows exactly when a particular technique will work effectively, and the complexity of skills involved in his work only strikes the viewer as an afterthought. In his choice of mixed media his preference is for metals (aluminium, nickel-plated brass, and bronze among them) used in conjunction with glass, but he also

Below "Cubist Clowns", Circus
Vase series, 1998.
h 35.5cm (14in), w 19.5cm (7¾in),
diam. 28.5cm (11¼in).
*Hand-blown glass with applications
and fabricated, patinated, gold-
plated bronze. Linda MacNeil,
Dailey's wife and a jeweller, has
often been the inspiration behind
his sophisticated use of metals.
Whether drawing or working
in metal or glass, Dailey is
a compelling comedian.*

uses painted wood and sometimes found objects (even, in one instance, pencil stubs with eraser caps). The materials are worked separately and fitted together with consummate skill, making a seamless passage from one material to the next.

In a way the fact that Dailey chose glass is really mostly an accident of history: there is a feeling that he would have been equally successful at expressing himself whatever he had chosen as his preferred medium because he has such a lot to say. In the early 1970s glass was "hot news" in American art school circles. Having discovered it, Dailey decided to leave no stone unturned in investigating it. Paradoxically, as much as he is part of the contemporary glass scene, he is also a loner who has forged his own, very personal way of using glass to comment on the world. "I've always felt like an outsider in the glass scene (even though I know 90 per cent of the people working with glass)... Glass-blowing, the process, never was my inspiration... I make everything from drawings, and nearly all my pieces are about something, instead of colour and form being the reason for the work."

Because he is such a communicative narrator, Dailey is in great demand for commissioned work. If he is given a subject to comment on in glass, his client knows that he will be fully responsive whether the commission be a sculpture or an interior design feature such as a balustrade for a staircase, a piece of furniture, or a door. Dailey has been responsible for a whole series of crazy lamps, where his ideas and his making skills quite simply light up. Among the first of these lamps that he designed was "Pistachio Lamp", made at the Venini glass factory when he was there in 1972; the name refers mainly to the pistachio-coloured glass used. "Antelope Lamps", "Man Lamp and Woman Lamp", and "Bird Lamps" (all dating from 1986) are pairs of wall lights, each of them playfully conceived, and unlike any antelope, man and woman, or bird one could ever have dreamed of. Among his many public and private commissions is a series of lighting fixtures for the refurbished Rainbow Rooms at the Rockefeller Center in New York City.

It is not surprising that Dailey was chosen to work on the refurbishment of the Rainbow Rooms. The Rockefeller Center is one of the most spectacular surviving examples of American Modernism. There is a slickness about the Dailey style that reminds one of Art Deco and particularly the 1930s

American variety, which was more streamlined than the European version and drew its inspiration from the aesthetics of machinery and the linearity of skyscraper construction. Add to this a love of comic-strip imagery and the fact that Dailey grew up in the 1960s, when the art of funk, whether in ceramics or fine art, was in its heyday. All these influences, combined with intelligence, a great talent to amuse, and a profound respect for his craft, make everything Dan Dailey does immensely enjoyable. Moreover, while it is all delightful and great fun, it also gives food for thought when the laughter has died down.

Above left and *above* (detail)
"Dancing Weasels"
Circus Vase series, 2000.
h 142 cm (56 in), w 46 cm (18 in),
diam. 51 cm (20 in).
Blown glass with fabricated,
patinated, and gold-plated bronze.
The variety of Dailey's work is of
itself one of its most impressive
features. "If you stay too long
on one thing, it doesn't work,"
he has said.

Bernard Dejonghe

BORN 1942, CHANTILLY, FRANCE NATIONALITY FRENCH

ernard Dejonghe does not like to be asked when he changed over from ceramics to glass. For him one is simply a continuation of the other; both materials are composed of minerals that are mixed together in different ways and treated with fire. In fact, Dejonghe began working in glass in 1986. Before then, from 1969 to 1976, he had worked for the renowned French potter Emile Decoeur. In 1976 he moved to his studio in the Alpes Maritimes, living and working in comparative solitude and communing with nature. High in the mountains he feels that he is a part of the mineral world. Minerals have ancient "memories", far older than those of living beings, and the memories contained in earth, air, fire, and water fascinate Dejónghe. "I have always been conscious of man being part of the mineral universe. […] I've always approached the material as if it were a 'field of possibilities', as a base for experimentation and reflection. I give no more importance to concept than to the material itself: each contributes to setting something in motion, something I call 'energies'."

Above *"Deux Meules Vives" (Two Living Forms), 1994.*
h 28cm (11in), w 30cm (11⅞in), diam. 30cm (11⅞in).
Optical and opaque cast glass. These forms relate closely to Dejonghe's work as a ceramic sculptor. The contrast of opaque and transparent highlights the luminous qualities of the optical glass part of this sculpture, and also makes a symbolic point about darkness and light.

Right *"Grand Cercle Ouvert" (Big Open Circle), 1996.*
Circ. 160cm (63in).
Monumental optical glass, cast in sections. A stony landscape is transformed by the presence of a huge circle of ethereal light.

Dejonghe works on a monumental scale and only in clear glass. "I enjoy courting limits," he says, and he does so both in ceramics and in glass. He has built the enormous kilns he requires in his studio in the Alps. His huge compositions in kiln-formed glass are photographed in the mountain landscape where he works, resting on the ground, on rocks, or on a riverbed where the water divides as it rushes past. They look as if they were left behind by some ancient civilization that worshipped light. Dejonghe talks of glass as having a massive empty space even though it is solid: a space that is filled with light. His work is based on circles, triangles, and lines, forms that he refers to as "human signs", which he repeats in differing variations depending on his mood. "Circle" (1996) measures 160cm (63in) in diameter and is made of optical glass. It consists of segments that fit together to make an open ring. The glass has intentional internal cracks, reminiscent of an iceberg melting, reminiscent too of an ice age. "Ombres du Blanc" (1997) is a series of round glass boulders which he has had photographed on mossy ground.

Dejonghe's work is mysterious, elemental, and romantic. He thinks long and hard about nature and each piece reflects those thoughts. His philosophical musings shed light on his work. "Miles Davis said that music was easy: with so many notes to choose from, all you had to do was to choose the most beautiful. It was that choice and that singular way he had of playing that made his music... A tree in the countryside or a stone in the desert seem to always have a truthful presence, an obvious beauty, simply by being there." Ideas flow from him and he lives to work, works to live. "I 'do' and then I am what I have done: it's as if what I have done runs before me. It's not me who defines or decides. I am what escapes me."

The fascination of working with massive amounts of glass is partly a technological one for Dejonghe. By exploring highly developed modern technology he is able to produce work that is utterly contemporary. There was no means of producing anything similar before and he sees the new technology as "futuristic symbolism". He neither fears technology nor finds it in any way a problem; it is there to use and to encourage invention. Physical, intellectual, and artistic energy all flow together in his art, and when he positions his work in nature he talks of a collision of energies. He considers himself a forward-looking person. "By working with clay and glass," he says, "I have the impression of looking ahead."

Above "Colonne Triangulaire" (Triangular Column), 1995. h 220cm (8 in). Monumental optical glass, cast in sections. A column of light is set in water that flows past its base. Stillness and motion, life and death, turmoil and repose are symbolically juxtaposed.

Isabel de Obaldía

BORN 1957, WASHINGTON, DC, USA NATIONALITY PANAMANIAN

Above "Pursued", 1997.
h 48cm (18⅞in), w 20cm (7⅞in).
Hand-polished kiln-cast glass.
The kiln-cast glass adds an other-
worldlyl quality to de Obaldía's
figurative sculptures.

Although essentially a painter, Isabel de Obaldía turned to glass in the late 1980s and is the only internationally known glass artist living in Panama. Of French and Panamanian parentage, she studied at the University of Panama in the Department of Architecture and later at the Ecole des Beaux Arts in Paris; in 1976 she took a course in cinematography and graphic design at Rhode Island School of Design. Between 1987 and 1994 she attended Pilchuck School for five summer courses, learning sand-casting from Bertil Vallien and engraving from Jirí Harcuba and Jan Mares. In early experiments de Obaldía engraved and painted the figures and lush vegetation of her paintings on blown-glass vessels. Recently she has chosen sculpture over vessel form, and cast over blown glass.

With cast glass she is able to control the process from beginning to end. Her sculptures are 50–60cm (20–24in) tall, but the scale of her work has grown as her control of cast glass has become surer. At first the glass tended to crack, although she did not view the cracks as imperfections, and they have become a feature of her more mature work. She sees accidents or natural flaws as part of the glass process, considering them beautiful and lyrical – "I'm not striving for the technically perfect image". "Accidents", like stress lines in earth formations, serve to establish a link with a world of ancient mythology that is so important in her imagery. De Obaldía has achieved an impressive repertory of colour and texture in her work. Clay models are used to make plaster and silica moulds fitted inside a wooden box. The moulds are filled with chunks of clear and coloured glass and fired in a kiln for up to 14 days, so that the body seems infused with colour. Coloured powders, or patinas, are added to the surface. Colours may be very dense, with combinations of vibrant scarlet, chartreuse, yellow, and purple. Cold processes include polishing, drilling, and wheel-engraving. An antiqued finish evokes ancient Egyptian or Greek artifacts, while totem-like forms recall pre-Columbian art and Latin America's figural tradition.

Isabel de Obaldía was attracted to glass because of its fragility, which she sees as analogous to the fragility of humanity. Her expressive cast figures have a mythical quality about them: headless torsos with wings;

contorted talisman-like figures whose arms or bodies are in the form of leaves or trees. Wings suggest flight towards a spirit world; winged creatures also symbolize regeneration or rebirth. Trees communicate with the depths of the earth while their branches reach towards infinity. De Obaldía also draws inspiration from the animal world. Metamorphosis and regeneration are recurring spiritual themes. She uses the transparency and luminosity of glass to add mystery, inner light, and soul to her work.

There is a shamanic quality to Isabel de Obaldía's figures. They suggest ceremony and ritual. She sees them as guardian angels or protectors. But there is a darker side to them and they may be demonic and threatening. *Captive Spirits*, a solo exhibition in 1999, featured demons, beasts, gods, and ghosts. Her work is both raw and sensitive, turbulent yet calm. Though its scale is modest, it is powerful and poignant.

Laura Diaz de Santillana

BORN 1955, VENICE, ITALY NATIONALITY ITALIAN

aura de Santillana was born into a renowned family of glass-makers. Her father, Ludovico de Santillana, was managing director of Murano's Venini glassworks, founded by his father-in-law Paolo Venini. Unlike most Venetian glass artists Laura de Santillana undertook her art education away from her place of birth, at the School of Visual Arts in New York. But the technical language of her glass could be none other than Italian – hardly surprising for someone steeped in the Venini tradition since birth.

Venetian glass skills revolve around the blowpipe and hot glass, a basic technique that allows a thousand variations; cold techniques, such as cutting and polishing, play an important role in the surface decoration. From the end of the 1930s until the late 1980s, first under Paolo Venini (died 1959) and then under Ludovico de Santillana (died 1989), a distinctive range of hot and cold skills was developed at Venini, unparalleled in their originality. They involved many of the basic skills used on Murano for centuries, such as the insertion of *murrine* into the body of the glass; and numerous ways of combining colours, such as sinking one colour into another (*sommerso*), or pulling one glass bubble over another (*incalmo*). Laura de Santillana's innate understanding of such skills has allowed her great freedom to develop a highly personal technical language. She makes a range of vessel forms – objects of desire whose strong shapes and dynamic colours raise them above functionality. There have always been such objects in the history of Venetian glass, such as the immensely complex "wing glasses" of the 17th and 18th centuries: they were cabinet pieces, just as Laura de Santillana's are today.

From the beginning she was interested in designing for companies outside Italy. Soon after leaving art school she began designing for the glass industry and early work for Venini in the mid-1970s earned her a reputation as an outstanding designer. Some of her early designs for Venini, such as the *Numeri* plate (1975), a large platter incorporating *murrine* digits, and a series of plates called *The Seasons* (1976) with *murrine* decoration suggesting the seasons, have become classic glass designs of their decade. Since then de Santillana has designed for a number of companies including Vignelli Associates in Venice and

Below "Bambú" (Bamboo), 1995. Each form: h 55 cm (21¾ in), diam. 7 cm (2¾ in). *Manufactured by Arcade, Bolzano, Italy. A playful arrangement of colours and shapes, 12 vessels grouped together like a troupe of dancers.*

Above "Nile", 1996.
h 81cm (32in), w 72cm (28¼in),
d 11.5cm (4½in).
Murrine *vessel formed by slumping*
over a mould, hand-ground inside.
Although de Santillana does not
make the glass herself, designing
such pieces requires intimate
knowledge of complex techniques.

Right "Tilia Indica", 1999.
h 42cm (16½in), diam. 26cm (10¼in).
Hand-formed blown glass with a
light cold-finished surface. Daring
simplicity is achieved through
careful thought and innate
understanding of colour and form.

Rosenthal in Germany. Exposure to the American studio glass movement with its emphasis on individual style gave her the freedom to experiment freely in a way seldom found among Venetian glass-makers during the 1970s and 1980s. Her design ideas are never revolutionary, but are always fresh, whether in her use of colour or in her refined sense of form.

De Santillana is bold in her use of colours and here too she has built on the Venini palette of bright colour combinations. Her use of colour also seems inspired by the sensual juxtapositions of American abstract expressionism and in particular the work of Mark Rothko. Her sense of vessel form (and all her work is very clearly vessel-related) often delights in asymmetry, but however asymmetrical it is always supremely elegant, with the kind of sophisticated chic one associates with the best Italian design. In all her work there is a sense of an utterly polished and finished performance, with no detail left unattended to.

Anna Maria Dickinson

BORN 1961, LONDON, ENGLAND NATIONALITY BRITISH

As an art student Anna Dickinson specialized in metalwork as part of a BA degree in three-dimensional design at Middlesex Polytechnic, and went on to study glass as an MA student at the Royal College of Art. She has made use of both skills to produce a body of work that is both classical, in that it draws its inspiration from ancient civilizations, and modern, in that it could only be of its time.

Anna Dickinson's vessels are blown and cut and then electroformed. Although able to blow glass herself she prefers to rely on the skills of specialists, notably Neil Wilkin, the best glass-blower in Britain and a contemporary of hers. They have worked together since 1989 and she has described their working relationship as "two personalities willing to flow together". Anna Dickinson is a vessel-maker *par excellence*. She wants her vessels to be as perfect as they are in her imagination and it is for this reason that she employs the expert skills of others in the

Above *"Large Clear Cut Vase With Gold & Silver"*, 1998. h 43.5cm (17in), w 18.5cm (7¼in). Blown glass, cut, etched, and polished, electroformed copper rim plated with silver and gold patinas. Dickinson is inspired by details of ancient architecture, ethnic artifacts, textiles, jewellery, and all kinds of sacred regalia.

Right *"Silver Plate With Moonstones"*, 1990. h 8cm (3in), w 20cm (7⅞in). Blown glass, cut and polished, electroformed copper collar silver-plated, moonstones. Dickinson's vessels suggest ceremony and ritual, here heightened by the addition of semiprecious stones set like jewels.

execution of the work; as well as her long-term collaboration with Neil Wilkin she has established a working relationship with a glass-cutter in London, Mehmet Kuzu. After a vessel has been blown, cut, and polished or etched, depending on her choice of surface appearance, the process of electroforming begins. This is a process by which metal is made to adhere to the surface of the glass: the piece is placed in a copper sulphate solution, an electric current is passed through, and the copper builds up on exposed areas of the glass. On completion of this process the metal can be treated in a variety of ways: it can be polished, gilded, or patinated in different colours.

These numerous different processes allow infinite variety and choice, and after nearly two decades Anna Dickinson sees no reason to change course. The vessels have grown in scale commensurate with her growing confidence. Her method of working is highly organized. Ideas are recorded in notebooks and diaries, illustrated with precise annotated drawings, which the finished work will closely resemble. There are a few technical notes too about electroforming recipes. The notebooks also act as a logbook, recording as they do where, when, and how the pieces were made, where they were exhibited, and to whom they were sold.

Anna Dickinson draws inspiration from everything she sees, whether at home or on her extensive travels. She has an eye for pattern and texture, whether perceived in an African hairstyle and cosmetic scarring on her travels abroad, or near home in the rusty patina heightened by sunlight on gas tanks near London's Battersea Park. "I have never really looked at glass for inspiration, other than Roman glass – architecture, pottery, silver, there are so many areas to be involved in."

The aesthetics of Anna Dickinson's works are those of symmetry and perfect harmony. Colour is hardly an issue and the glass she uses – brown, black, or colourless – provides no more than a background for texture and pattern. She finds coloured glass too loud, and the colours would interfere with the serenity that she strives to achieve in her work. The vessels she makes are always perfectly proportioned and pleasing to the eye. Her work introduces a note of calm, elegance, and dignity in any environment it occupies. In a period when most contemporary art aims to shock or disgust, Anna Dickinson's work reminds us that a more classical approach to art has as much relevance as ever in today's world.

Above "Large Green Cut Vase With Gold Rim", 2000. h 44 cm (17¼ in), w 14 cm (5½ in). Blown glass, cut and polished; electroformed copper rim with gold patina. Anna rarely uses other colours than black, white, or smoky brown.

Edols & Elliott

BENJAMIN EDOLS, BORN 1967, SYDNEY, AUSTRALIA NATIONALITY AUSTRALIAN

KATHY ELLIOTT, BORN 1964, SYDNEY, AUSTRALIA NATIONALITY AUSTRALIAN

Benjamin Edols and Kathy Elliott make glass the Venetian way, and the influence of Venetian studio glass from the 1940s and 1950s is immediately apparent. Not only do they use a typically Venetian technical language, but their forms and lively colours also underline the closeness of the relationship. The great difference between the 1950s models that inspire Edols and Elliott and their own is scale. What they do is on a much larger scale than the "originals". They take Italian models as the point of departure and then blow them up, with dramatic effect. Pieces can stand up to a metre tall. The work is so accomplished that this is in itself exciting. The two of them form the perfect team. Edols blows the glass and Elliott does the cold work (wheel-cutting patterns into the surface, engraving, and sandblasting). They also use the *murrine* technique, in which glass canes are fused together, and in this type of work the Venetian influence is all-important.

Both artists learned about glass partly in Australia, at Canberra School of Art, and partly at the Pilchuck Glass School. They were both at Pilchuck in 1996 and have worked as a team ever since. Both have worked as assistants to some of the most famous 1980s and 1990s "Venetian" glass-makers of the contemporary studio glass movement, including Lino Tagliapietra. In 1994 Richard Marquis and Dante Marioni, two of the greatest "Venetian" masters, toured Australia giving workshops in which they demonstrated Venetian techniques. One of their star pupils, Edols is now a great virtuoso in his own right. He combines large-scale blowing skills with a very sure eye, turning functional imagery into sculptural form.

Together Edols and Elliott have developed a style that is in essence Post-Modernist, borrowing freely from other styles, whether it be the industrial glass vernacular of 1950s Venini, the bright palette of the Memphis Group, or the restrained sculptural idiom of the British ceramic artist Hans Coper. The result is a body of boldly coloured pieces that is intelligent and well-designed. A new type of glass developed by Bullseye Glass has been of great importance to Edols and Elliott. Before the Bullseye invention the different chemical composition of glass colours was very

Above *Left: "Soft Dot Vase", 1999.*
h 42cm (16½in), w 11cm (4¼in),
d 11cm (4¼in).
Blown and wheel-cut murrine glass.
Centre: "Soft Dot Vase", 1999.
h 13cm (5in), w 22cm (8¾in),
d 22cm (8¾in).
Blown and wheel-cut murrine glass.
Right: "Up Close Echo", 1999.
h 4cm (1½in), w 43.5cm (17in),
d 44cm (17¼in).
Draped and wheel-cut murrine
glass. The use of Bullseye glass
in making these murrine pieces
facilitates the technical process
while also allowing a greater variety
of colour combinations.

limiting: glass behaved differently at the different temperatures required in the furnace (for blowing) and in the kiln (for slumping or casting). This chemical variation was controlled by Bullseye to such an extent that different glass techniques could be combined as never before. The new freedom allows Edols and Elliott literally to wallow in colour.

In 1997, when Bullseye arranged for a workshop and exhibition to take place in Australia, Edols and Elliott were invited to be exhibitors, and Edols a member of the core group that carried Bullseye research a step further. The work produced by Edols and Elliott as a team was included in the exhibition *Latitudes, Bullseye Glass in Australia*. The pair have since grown more ambitious, thinking in terms of installation work or pieces conceived in groups that interact and relate to each other. In a decade when the predominant international style in contemporary glass was borrowed from Venice the work of these two artists appeals to an international audience. Although still in their thirties, they are already considered to be among Australia's leading artists in glass.

Erwin Eisch

BORN 1927, FRAUENAU, GERMANY NATIONALITY GERMAN

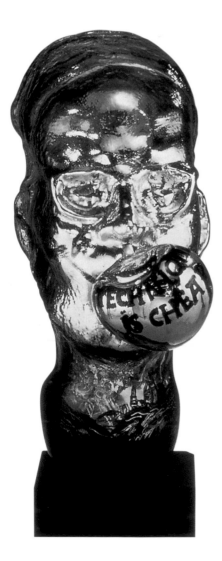

Below "Harvey K. Littleton:
Technique Is Cheap", 1976.
h 40cm (15½in).
*Glass head, mould-blown and
painted. In this portrait head, the
text is a famous Littleton quotation,
an impassioned call to fashion
glass with complete artistic freedom
and without reference to limiting
traditions of past glass history.*

From the beginning Erwin Eisch wanted to experiment with glass and felt connected to what he calls "the renaissance of glass" – the contemporary glass craze sparked off by Harvey Littleton in the United States in the 1960s. Eisch met Littleton in 1962 when the latter sought him out after seeing some of his work on display in Zwiesel, only two months after his first exhibition at a gallery in Stuttgart; the two have been close friends ever since. Eisch grew up in Frauenau in Bavaria, where he still lives with his wife Gretel, a painter whom he met when they were students in Munich and with whom he has often collaborated on work.

Eisch first learned about glass in his father's glass-engraving workshop. He went on to train as an engraver at the technical school in Zwiesel and later studied at the Academy of Art in Munich, originally (until 1952) in the department of design. He returned to the Munich Academy in 1956 to concentrate on painting and sculpture. With glass so much a part of his upbringing, Eisch saw it almost as a calling to work in this medium after his studies. He says: "In its natural condition the matter in itself is mute, valueless and amorphous, the matter is passive; it is a challenge – a provocation to man."

Although Eisch has designed for industry, and now designs for the commercial output of his factory in Frauenau, the constraints of factory production are anathema to him. "Whenever I am forced to design glasses for industrial production my soul is distorted and reduced to a miserable little thing." For him the fascination of hot glass was the artistic and hitherto unexplored freedom it allowed. Until the 1960s a reverence for glass had led to its being confined, even imprisoned, in an industrial straitjacket. Eisch saw it as part of his mission to challenge that status. To him the humanist idea of creating a form with his own breath seemed so much more expressive than producing a two-dimensional design drawing to be translated into three dimensions by others. He began blowing glass of whatever shape he desired, not because he lacked respect for past traditions, but because he felt entirely free to do so, partly as an experiment, partly as a means of conveying what he had learned at art school. He engraves and paints on glass as freely as if he were working

Right "Night Of Crystal
Death: Picasso", 1991.
h 45cm (17¾in).
Glass head, mould-blown,
painted and engraved. Eisch made
a series of Picasso heads, each
superimposed with emotionally
charged imagery. "Night of Crystal"
("Kristallnacht") recalls the
appalling destruction of Jews
and their property in Berlin.

on paper or canvas. He now no longer blows glass himself but works on the cold glass, his hands giving expression to what is in his heart by means of engraving and painting and leaving their imprint on the glass.

During a long career in glass Eisch has moved back and forth between forms of two- and three-dimensional expression, including vessels, goblets, and abstract and figurative sculpture. He is in essence an enemy of functionalism; he may make cups and vases and sculptures, but convention is of no interest to him. A vase can be romantic or poetic, a cup humorous or rude (like his famous mug with breasts from 1972). He shies away from the seductive qualities of the material; his glass can be opaque, transparent, frosted, full of bubbles, clear, or coloured (often white or cobalt blue). The glass is chosen according to the mood it needs to convey: Eisch starts from the premise that glass can serve his artistic needs, not that he will exploit its special characteristics. He likes to rearrange the chemistry of glass, as far as this is possible, making it look like wax, skin, or stone. Fearless chemical experiments are not always successful and his glass is not always durable, but that is all part of the creative process involved in his voyage of discovery.

During the late 1960s and the 1970s Eisch made a series of fetishistic objects in glass – telephones, shoes, fingers, and books. He also began making portrait heads and a series of abstract vertical forms with engraved and gilded figurative drawings on them, highly symbolic of his own state of mind or of the human condition in general. All of these were made in hot glass, free-blown or blown into moulds. Like his vases and cups they were expressionist, loose, irreverent, and anti-functional. They were deformed rather than formed, and "plastered" with painting or drawing (engraving) to distance them farther from reality. They verged on being angry, but were saved from anger by their humour. In addition to coloured paints, gold and silver paints were liberally applied, a statement about the false values they may represent, but also a reminder of German Baroque culture. Eisch cannot help referring to German cultural tradition both past and present in his work. The art historical education he received at the Munich Academy left its mark, while in the early 1960s he was part of an avant-garde group of artists, known as Radama. His imagery combines brightly painted grotesques, symbolic objects, and caricature, and often incorporates textual commentary. Every work contains a message, either metaphysical or philosophical in content.

Below "The Blue Musician", 1999.
h 40 cm (15½in).
Mould-blown glass with engraved imagery. From the 1999 Corning installation. Here again a glass head, this time using blue glass, is the vehicle for thoughts about another art form.

Throughout Eisch's work there is reference to bodily parts and nowhere more directly than in his series of portrait heads, which began in the 1970s. These are not portraits in the traditional or photographic sense, but a way of gaining insight into the "sitter", and through the "sitter" to wider human issues. The heads are made of glass blown into a mould, manipulated while still hot, and decorated with painting and engraving when cold. Over the years Eisch has created numerous portrait head series, and his "sitters" have included Harvey Littleton, the Buddha, his father, and Picasso. His portraits of Littleton are as much an expression of his own personal credo about glass as they are a comment on this important figure in late 20th-century glass. The portrait heads of the Buddha are about the universality of religion, those of his father a private dialogue with his parent, and his Picasso heads a tribute to the greatest artist of the 20th century. He also uses the image of Picasso and Picasso's most famous work, *Guernica*, to deliver his own message about the horrors of *Kristallnacht* and the atrocities of World War II.

When writing and lecturing Eisch often speaks in riddles. As an artist he seems to be trying to manage chaos, with great skill and sensitivity. "I believe that art, today and for all time to come, has but one goal: to make that which is alive visible, to place humanity and dignity above technology".

Bert Frijns

BORN 1953, LIBACH OVER WORMS, THE NETHERLANDS NATIONALITY DUTCH

Above *"Stacking Vases In Balance",*
1999. h 15cm (6in), d 15cm (6in)
Slumped window glass. A sense of
vibrating rhythm is created by these
forms nestling against each other,
touching at some points while free
to move, with the largest bowl
precariously poised as if it has
just come to rest.

Bert Frijns lives far from the madding crowd on an island in Zeeland, a province of the southwestern Netherlands. He never uses colour in his work and is never likely to. This alone sets him apart from most of his contemporaries and current, more colourful trends. He has never been a part of any glass community, and although his work is known worldwide, Frijns tends to stay in his corner of the Netherlands. He has a fixed artistic vision which has been strong since the beginning and which he has developed steadily; yet every new work has new strengths. The scale of his work is generous and has grown over the years, but is not large for the sake of it. Large scale in his case is the logical consequence of concept: his concepts demand the scale he uses. He is inspired by the endless sky and white light of the area in Holland where he lives, and his work is about landscape. In its utter simplicity it generates a sense of infinity, of a world beyond both imagination and reality. His oversize vessel forms, often half filled with water, use the familiar to create the unfamiliar.

Frijns studied at the Rietveld Akademie in Amsterdam in the late 1970s, first as a sculpture student, and then in the Glass Department. One of his early works was a series of circular sandblasted plates in which a central section was cut out and peeled back, curling like cheese thinly cut with a wire – perhaps an idea inspired by the habits of a cheese-loving nation, but more a statement of geometry. His shapes are basic geometry, the circle, the square, the rectangle, softened by bending or rolling, by acts of intellectual intervention. He likes to soften the hardness of clear glass, sometimes rolling it up like paper, sometimes softly denting it or creating folds in it as if it were fabric. His large bowls sit on plinths of steel or wood, and where glass meets a harder substance it is made to look as if it has gently yielded to that hardness at the point of contact, assuming the shape of the harder material. Hard and soft are further emphasized by the use of water, fluidity contrasting with rigidity. In his hands these simple artistic devices become spiritually charged statements.

Frijns uses simple plate glass in his work, and the processes involved in shaping it are also basic, but to make the perfect forms he requires demands considerable technical invention. Plate glass is traditionally a

flat material; Frijns heats it in an oven and transforms it, giving it an entirely new character. The temperature required to bend and shape the glass depends on its thickness, and as with all new techniques in glass, only trial and error over a long period leads to technical mastery.

Bert Frijns enjoys the challenge of site-specific work, partly because it allows him to work on a large scale. The work he creates for a site is dictated by and linked to its aura, as if his glass were part of some ceremonial procedure intended there. His vessels have a ritual or primeval quality, seeming to be there for a purpose although they have none in reality, unless it be to transform real into surreal. In 1986 a trend-setting site-specific exhibition called *Sculpture in Glass* was organized at Fort Asperen in the Netherlands in which a group of artists created works for a large vaulted fortress, derelict and decaying but romantic and atmospheric. Frijns' contribution was a huge shallow bowl 2m (6ft 6in) in diameter into which water trickled from a great height. The shape of the bowl related to the circular brick pattern of the floor on which it stood, as if growing out of it, and the work transformed the area from dead to living.

Irene Frolic

BORN 1941, STANISLAVOV, POLAND NATIONALITY CANADIAN

Above "Dialogue", 1988.
h 30 cm (11¾ in), w 18 cm (7 in),
d 15 cm (6 in).
Kiln-cast plate glass, with copper
powder added to the mould.
The pensive angle of the head
and the parted lips suggested that
the subject is deeply engaged in
conversation and listening intently.

Irene Frolic is much concerned with her family background. She was born in Poland during World War II; her mother is a Holocaust survivor. In her work as a glass artist she "forms careful narratives based on her own family's story". Her mother's pain has haunted her. The pain was mostly psychological, as she recounts when describing a major work called "Baba Yaga" (1998). (In Slavic folklore Baba Yaga is a child-eating witch who lives deep in the forest.) "Baba Yaga", a typical installation piece, is composed of a cast-glass wall with hieroglyphs and a figure of a little girl: it is topped by sharp objects suggesting barbed wire. Nearby stands a metal construction with a cast-glass head wearing a crown of thorns. "The little girl is me. The Baba Yaga forest is the Holocaust. The thicket is flame- or vaginal-shaped, referring to escape from death by fire or rebirth. The indecipherable glass text is a story heard and internalized but not really seen or rationally understood. [...] The thorns are the pain of the teller and the listener. They can also refer to the crown of thorns on the statue of Jesus that my mother visited every day on her way home from working in a German soldiers' hospital. [...] For my mother, as she puts it, he was a Jew too, and he was in pain."

Like her mother, Frolic is a wonderful storyteller. Her graphic narratives in glass are a reminder that her first interest was in literature (her first degree was a BA in English Literature). For 20 years she was a teacher, but around 1985 she quite simply "fell" for glass. She studied for a degree at Ontario College of Art, majoring in glass. She graduated in 1990 and very soon emerged as part of the avant-garde in Canadian glass. Since then she has been a passionate member of the North American glass community. She has exhibited widely in North America and her work is becoming known in Europe. One of only a few Canadian artists working in glass whose work is considered mainstream, she has received a number of major commissions, including one in 1997 for a Holocaust memorial at Shaar Shalom Synagogue in Toronto. She also teaches the technique and the art of cast glass, her speciality as a glass-maker.

Although much of what Frolic does is intended for gallery exhibitions, what she enjoys most is mounting installations, often large-scale, that

bring together her thoughts. In these she uses all sorts of materials – drawings, welded steel, concrete castings, and glass. "I am interested in using the material as an expression of emotion and ideas. In that sense I am not a purist, although I am very firm about the concept of quality and high craft in production." She treats glass, and the other materials she uses, as a fully expressive means of narrative about the human condition, bringing to it all her emotional and intellectual experience.

Since her college days she has been one of a group of women artists in Canada (along with Susan Edgerley and Lora Donefer) whose aim has partly been to express the female view in a field that has been male-dominated for millennia. Irene Frolic sees her life's work as recounting her mother's way of surviving the Holocaust, in the knowledge that hearing the story has shaped her own life and the belief that retelling it may serve to shape the sensibilities of others.

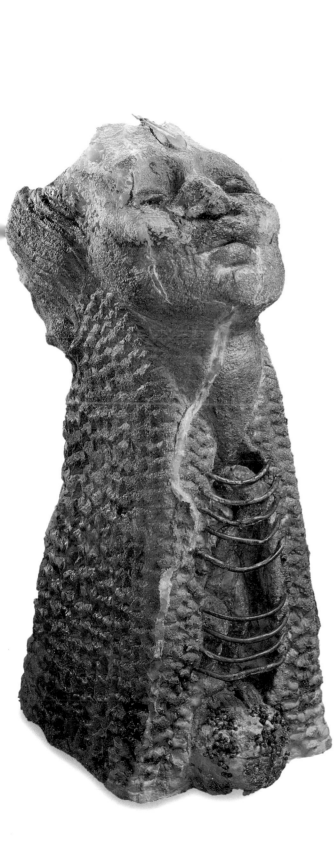

Left "How to Live in the World: Let Me Hide Myself in Thee", 1994. h 41 cm (16 in), w 20 cm (7⅞ in) Kiln-cast plate glass, copper powder added to mould, copper inclusions. Frolic uses the medium to deliver a complex emotional message.

Below "Portrait III: Portrayals Series" (detail), 1999. h 50 cm (19⅝ in), w 30 cm (11⅞ in), d 15 cm (6 in). Kiln-cast plate glass. The process of kiln-casting allows tremendous flexibility of shape and texture.

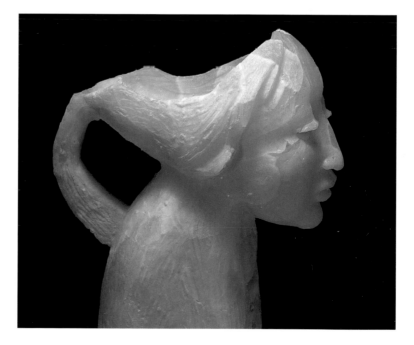

Kyohei Fujita

BORN 1921, TOKYO, JAPAN NATIONALITY JAPANESE

F ujita is without doubt the most famous contemporary glass artist in Japan, recipient of the prestigious Cultural Merit award. In 1996 the Kyohei Fujita Museum of Glass, a private museum in Matsushima devoted entirely to his work, was opened. He has been instrumental in generating the enormous interest in glass in Japan and in 1972 was a founding member of the Japan Glass Art Crafts Association. Although by then well known in Japan, Fujita began to gain an international reputation as an independent artist in glass in 1973 after his first exhibition of his now famous caskets in glass. This kind of object in glass, although in tune with Japanese culture, was completely new to Japanese decorative arts. Fujita makes two very different types of glass, one inspired by Venetian hot-glass techniques in which he adopts a brighter, perhaps more Western palette of colours; the other – the cast-glass caskets – more poetic and reflective, and more in keeping with Japanese tradition. The more decorative Venetian-style glass he refers to as his "fluid glass": it is more popular in Japan because Venetian glass is less familiar there, and Venetian-style glass made by a famous local artist something of a rarity. In the West, Fujita is more appreciated for his caskets: there is nothing to compare with them in the world of contemporary glass.

Fujita's first contact with glass came in 1947 when he was employed by the Iwata Industrial Glass company whose director, Tohshichi Iwata, was then the best-known name in the Japanese glass industry. Fujita had not had any training in glass; as a student he attended the Tokyo Academy of Arts from where he graduated in 1944, having studied in the Department of Metal Crafts. He stayed with Iwata Glass for only two years, and has worked as an independent artist in glass ever since. By 1957 he had gained enough of a reputation to be doing one-man shows in leading Japanese department stores (until very recently the main outlet for studio glass). His relationship with the gallery at Takashimaya department stores in Tokyo and Osaka began in 1960 and continues to this day. In the foreword to his exhibition catalogue for his fortieth anniversary one-man show at Takashimaya in the autumn of 1999, Fujita wrote, "I don't know how much work I will be able to do from now on, but I intend to give it everything I have". While sticking to the same formula for most of his life

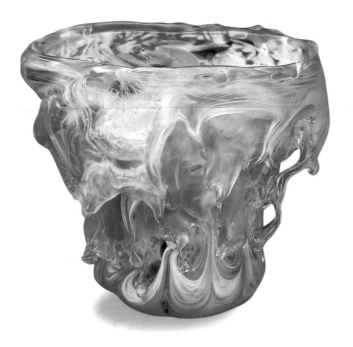

Below "Rainbow Colours", 1964.
h 36 cm (14 in), w 37 cm (14½ in)
d 25 cm (9¾ in).
Hand-blown, acid-finished, with coloured glass chips. When making containers other than boxes, Fujita works using what are essentially Venetian techniques, which he adapts to his own aesthetic requirements.

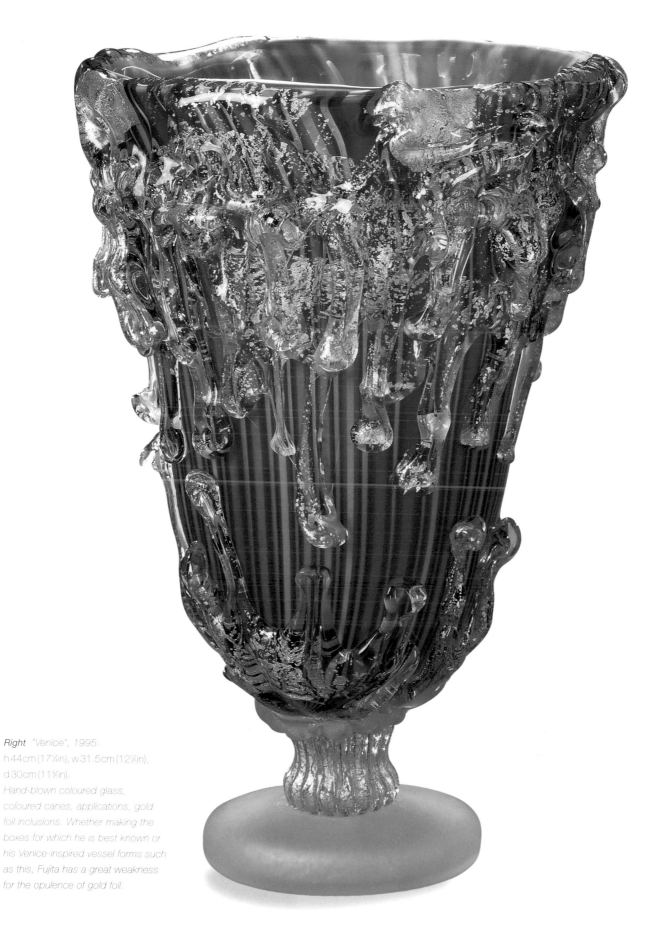

Right "Venice", 1995.
h 44 cm (17¼ in), w 31.5 cm (12⅜ in),
d 30 cm (11⅜ in).
*Hand-blown coloured glass,
coloured canes, applications, gold
foil inclusions. Whether making the
boxes for which he is best known or
his Venice-inspired vessel forms such
as this, Fujita has a great weakness
for the opulence of gold foil.*

in glass this remarkable artist has always been able to produce fresh new work, varying colour, shape, and decoration with every new season.

In the foreword to the 1982 Takashimaya catalogue he had written, "Every autumn I spend one month on the island of Murano in Venice. There, I work with glass and totally absorb myself in its beauty and transience." A whole exhibition often bears a title that links it to Venice, such as *Flowers and Venice* or *Venetian Radiance*. His favourite Venetian technique is working with coloured canes to achieve an intertwined polychrome twisting pattern (*zanfirico*), with a preference in Fujita's case for soft pastel shades, pink and pale blue among them. He likes including gold foil for a touch of opulence and glamour. His vessels are on the whole classical vase or cup forms, often set on top of a milky white circular base above which there is a knopped middle section or a "stem" made of solid glass rods coaxed into different shapes, either twisted like barley sugar or with a ridged finish. Handles tend to be small with "pinched" decoration. Some of the pieces, such as lamps, lidded bowls, and sake cups, are intended for use. Occasionally there are heavier pieces too, where the ductile quality of the glass is felt in areas where it has been left to drip like wax. Fujita has also made sculptural forms in hot glass, abstract in form but with evocative titles such as "Wave" or "Spirit".

It is with his caskets, or ornamental boxes (Japanese *kazaribako*), that Fujita expresses himself most fully. Many of the colour combinations and colour compositions are reminiscent of traditions of other areas of Japanese decorative arts. It was a conscious decision to "borrow" from Japanese culture in this way to create a contemporary Japanese art form in glass. When Fujita first exhibited one of these pieces in 1973, nothing like it had ever been seen in glass before. It attracted a great deal of attention, and those outside Japan were surprised to find independent glass artistry in full flower in Japan. In the United States at the beginning of the 1970s there was nothing so mature or evolved.

The caskets vary in form and in size. They can be square, rectangular, oval, round, or hexagonal, usually with a base and a lid, but sometimes made in three parts. Each section has a small metal rim that creates a tight fit between base and lid. Coloured glass is often enhanced by the inclusion of silver and gold foil, which "explodes" when heated, leaving a rich crackled effect. Splashes of colour, often in the form of asymmetric

Below *"Spirit", 1994.*
h 94 cm (37 in), w 58 cm (22¾ in),
d 54 cm (21 in).
Blown glass, hot-worked and
sandblasted. This is a rare
departure into sculpture. Before
the late 1980s it would have
been most unusual for a
Japanese artist to sculpt in glass.

dots, further enhance the decoration. Very often the colour schemes are inspired by flowers or blossoms and boxes have titles such as "Red and White Plum Blossoms" or "Cherry Blossoms at Night". Other titles such as "Auspicious Light" or "Fine Flaked Snow" suggest landscapes. The word *Rimpa* frequently appears in the titles of these boxes, making reference to a decorative style that reached its height in the middle of the Edo period (1615–1867). It is typical of Japanese culture that spiritual connotations are part of the subject matter: titles are chosen to evoke mood as well as imagery.

Fujita had been interested in glass since his school days and had thought for a long time about re-creating some of the marvellous lacquer work or paper techniques of earlier Japanese periods in this medium. He had been particularly taken with lacquer writing boxes with pearl inlay from the 16th and 17th centuries; it is likely that the boxes he so admired inspired him to use a similar form in glass. The effects that Fujita wanted to achieve in glass also owe something to kimono dyes and perhaps more to *Ryoshi* paper design from the Heian period (794–1185) – a richly coloured and textured paper used to cover poetry books.

By working on these boxes Fujita has brought Japanese tradition into the modern age, partly by updating and adapting traditional techniques, colour schemes, and patterns from other areas of the decorative arts to create a modern decorative idiom, but mostly by creating them in glass for the first time in the history of Japanese applied arts.

Above "Ornamental Box: The Sun & The Moon", 1999. h 23cm (9in), w 25cm (9¾in), d 17cm (6¾in). Mould-blown, cut, acid-finished, with coloured glass chip inclusions, gold foil, and with gold metal rim.

Left "Ornamental Box: Red & White Plum Blossoms", 1995. h 25.5cm (10in), w 24cm (9¼in), d 24cm (9¼in). Mould-blown, cut, acid-finished, with coloured glass chip inclusions, gold and platinum foil, and with silvered metal rims. This box is in three parts.

Michael Glancy

BORN 1950, DETROIT, MICHIGAN, USA NATIONALITY AMERICAN

For Michael Glancy the discovery of glass was a matter of love at first sight, an encounter that changed the course of his life. In 1974 he was an undergraduate studying business at the University of Denver when, on a visit to Santa Fé, he saw some men blowing out of an adobe glass furnace. "I was a goner." After graduating from Denver he went to Rhode Island School of Design to study with Dale Chihuly. At Rhode Island he learned glass-blowing skills and was caught up in the high level of energy among students. At the time students concentrated on hot glass but, as Glancy comments, "there were a few cold-working tools. [...] I started to chop up my work with saws and to try to polish pieces. That began my education. Glass is very plastic hot, but it is also extremely plastic cold."

At Rhode Island Glancy had come across a book about Maurice Marinot, the French glass-maker whose work is generally seen as the most important precursor of the glass scene of the second half of the 20th century. The pieces for which Marinot is best known are his thick-walled vases with deeply cut geometric designs. Glancy openly admits that these were his model and they have remained so throughout his career. Cutting or carving deeply into glass requires the use of hydrofluoric acid – a dangerous process because of the toxic fumes emitted in the process. The danger, or rather the idea of learning to control it, appealed to Glancy's adventurous side and his appetite for technical daring. It was, however, both a relief and a great facilitator in achieving the effects he desired when he discovered the sandblaster on his first visit to the Pilchuck Glass School in 1977. This tool allowed him greater control and much more variation in executing carved designs.

In another stage of his early development Glancy discovered the artistic possibilities of cladding glass in metal through the electroforming process, using copper, silver, and sometimes gold. He had first seen the potential of metal while studying jewellery at Rhode Island, and shiny metal had been a part of his youth in Detroit, the motor capital of America, where he grew up at a time when car design was at its most exhibitionistic. Dressing the glass with electrically charged ions of metal

Below *"R G Square", 1978.*
h 12.5cm (5in), w 12.5cm (5in),
diam. 12.5cm (5in).
Blown glass with copper powder
inclusions, acid-polished. The
deep acid-cutting is reminiscent
of the work of the French glass
artist Maurice Marinot, whose
work has so inspired Michael
Glancy over the years.

provided both contrast and a new texture with which to experiment. Patination of the metal allowed further artistic licence.

By 1980 when Glancy had his first major exhibition, at the Heller Gallery in New York, he had mastered the technical vocabulary that he has used with greater ease and skill ever since. Glass had become the substance of his work, metal a kind of accessory. Glancy no longer blows his own glass and has not done so since in the early 1980s he discovered the blowing skills of Jan Erik Ritzman, who can create the perfect bodies that Glancy needs to work on. Each year Glancy spends some time at Ritzman's studio in Sweden, where the glass is blown under his direction. Over the years Ritzman and Glancy have developed such a degree of understanding that the smallest gesture will suffice to achieve nuance. The first steps of creation occur in Glancy's mind, sometimes helped by sketches, but the real groundwork is laid in the blowing sessions. For Glancy, working on an object is a way of bringing to life something that is inanimate. "I view the inanimate objects that I make as damn near alive."

Glancy's sculptural vessels embody a sense of great opulence, reminding one of important jewellery. Glancy has found the vessel the perfect vehicle for his kind of artistic thinking and enjoys the challenge of creating

Below Left: "Roto-White", 1985. h 15cm (6in), w 5cm (2in). Blown glass, electroformed copper clothing.
Right: "Bean's Foam Inclusion", 1985. h 10cm (4in), w 5cm (2in).

Right: "Pierced Celestial Ambit", 1985. h 12.5cm (5in), w 32.5cm (12¾in), diam. 30cm (11¾in). Blown glass, blue industrial plate glass, electroformed copper clothing. Glancy's graphic titles are always a key to his thinking, which is often inspired by the shape a work may take during its making.

pattern in the round. He derives his inspiration from a variety of sources, all related in some way to his fascination for pattern. His imaginative eye sees source material in the tread of a Pirelli tyre or in the genetic structure of cells magnified under a microscope. Pattern is for him more than surface decoration. It is order arranged out of chaos. One pattern leads him on to another, and his work shows certain recurring features, notably the chequerboard or raised square motif and the spiralling diagonal.

In the 1980s Glancy began using flat bases for his vessels to rest on. Originally the bases came into being as preparatory sketches for the vessel forms. Sketching on paper was only partly satisfactory, while preparing a design on a plate-glass base gave a much better feel of how the vessel could be worked. Eventually the base plates became an integral part of the composition and were as worked as the vessels themselves. Sometimes there were even double base plates with a busy interplay of pattern going on between them. The base plate provided an extension for setting up reverbatory opposites, creating a new kind of link between the vessel and the horizontal plane on which it rested, as well as providing a more ceremonial kind of presentation. Glancy continues to make vessel forms that are exhibited on their own but the marriage between the vertical form, the container, and the horizontal plane has become a hallmark of his work.

Glancy's work is so luscious and so beautifully made that it would be easy to judge it on face value alone, but this would not be doing the artist justice. Often his patterns are based on cellular or molecular structures, and he is deeply concerned by the way in which science both menaces and enhances our survival. It keeps us alive while threatening us with mass destruction. Man's ingenuity can reveal the hidden structures of genetics: that ingenuity can also destroy what nature has made. Glancy looks at the past with a discerning eye and uses his observations to create new ideas in glass.

What Glancy produces requires enormous patience, and a fascination with technical detail, in an endless tinkering that only a meticulously ordered (perhaps even obsessive) personality could bear to do without going crazy. The artistic message is in the labour of love that each piece demands from the artist.

Above "Radical Cleavage", 1997. h 19cm (7¼in), w 22.5cm (8¾in), diam. 25cm (10in).
Blown glass and blue industrial plate glass, both deeply engraved (Pompeii-cut), electroformed copper and silver clothing. The base plate acts as an earthbound extension or anchor for the vessel, and also allows for interplay between horizontal and vertical patterning.

Opposite "Arete – The Virtue", 1991. h 84cm (33in), w 125cm (49in), diam. 52.5cm (20¾in).
Blown glass, copper, brass, silver, gold, and black African granite. This monumental piece combines virtuoso metal and glass skills. The idea of a vessel within a vessel relates to double-skinned Roman "cage cups".

Mieke Groot

BORN 1949, ALKMAAR, THE NETHERLANDS NATIONALITY DUTCH

Above Untitled, 1989.
h 43cm (17in), w 36cm (14in).
Sand-cast, sandblasted, laminated.
The idea for this series of vessels
followed on from the installation
done in the derelict Fort Asperen
in the Netherlands in which Mieke
Groot cast glass bricks to fill in
what were once window openings,
the glass bricks following the lines
of the brick walls.

Mieke Groot has played a key role in European glass as both artist and teacher since she graduated from the glass department of the Rietveld Akademie in Amsterdam in 1976. She had initially taken an undergraduate course in jewellery but went on to study glass under the legendary Dutch glass artist Sybren Valkema, and was one of the first to complete Valkema's postgraduate course. On leaving the Akademie Mieke Groot set up a studio in Amsterdam with fellow student Richard Meitner. From 1981 to 2000 Groot and Meitner held joint responsibility for the glass department at the Rietveld Akademie, and the postgraduate course in glass there became one of the most respected in Europe.

Mieke Groot's basic skill is as a glass-blower. During the 1980s she moved from free-blown vessel shapes to the more controlled yet more adventurous possibilities offered by blowing glass into a mould. The undulations, folds, and indentations of the bottle shapes that she developed could only be achieved by using a mould to hold the shape of the glass. For Mieke Groot form and colour are inseparably linked; the glass form is used as a three-dimensional canvas for playing with colour. In the mid-1980s enamel colours were thinly applied as if she was drawing in colour. Between 1985 and 1990 the brick motif appeared frequently in her work. This idea had come to her while creating an installation at Fort Asperen in the Netherlands, as part of a groundbreaking exhibition of glass installations and sculpture mounted by a group of artists in a disused warehouse; for her part, in a witty and inspired installation, Groot filled a large window-frame with glass bricks, simply continuing the brick pattern of the walls. The effect was surreal, luminous, and beautiful.

The glass brick installation (in which the bricks were sandcast) led to a new range of work in which sandcast bricks were used to build vessel forms. The sandcast bricks were fused together and sometimes enamel colours were applied to these compositions. During the 1990s Groot mixed sand with enamel paints, resulting in a grainy surface texture. The glass is often completely hidden by this thick coating of colour, applied in solid blocks or geometric gridlike patterns on the surface of the glass.

The first time she used this technique was in a polychrome piece made for *Venezia Aperto Vetro* in 1996. The idea of making a work for an Italian show gave her the idea of creating a granular polychrome effect reminiscent of Italian *terrazzo* (reconstituted marble) compositions.

New challenges, such as the exhibition at Fort Asperen and *Venezia Aperto Vetro*, inspire Mieke Groot to broaden her horizons. She is always willing to experiment and the results are nearly always exciting and innovative. Very recently she has gone back to her first love, jewellery, and has made a body of work using glass, largely inspired by the tribal art and jewellery seen on her travels through Africa.

No account of Mieke Groot's life and work would be complete without mention of her work as a curator at the Ernsting Foundation at Alter Hof, Herding, in Germany, where from the time the foundation was established in 1993 she has built one of the best public collections of contemporary glass in Europe. She herself had a retrospective exhibition there in 1999 to celebrate her fiftieth birthday.

Above Untitled, 1993.
h 37 cm (14⅝ in), circ. 22 cm (8⅝ in).
Free-blown, enamelled, enamel application. The enamel coating and the earthy colours are inspired by the sun-baked scenery of Africa, a country whose landscape and tribal arts have left a lasting impression on Mieke Groot.

Right Untitled, 1998.
h 21 cm (8⅝ in), circ. 24 cm (9⅝ in).
Free-blown, enamelled, enamel painting. Groot frequently uses the geometry of linear design as her decorative vernacular, sometimes expressing herself in black and white as here, but often using blocks of colours.

Jens Gussek

BORN 1964, GLAUCHAU, GERMANY NATIONALITY GERMAN

Below "Nameless Vehicle", 1996.
h 29cm (11½in), w 16cm (6¼in),
l 58cm (22⅜in).
Sand-cast glass. This strange vehicle belongs to a whole family of imaginary forms of locomotion invented by Gussek. They are serious in intent and naive in appearance.

Jens Gussek trained as a weaver and then as a painter and sculptor, and worked as a designer for a glass company before going back to school at Burg Gibiechenstein in Halle for six years (1986–92), to continue his studies in painting and to learn the skills necessary to use glass in his work. His attitude to glass is less starry-eyed than that of some of his contemporaries; glass is for him just another artist's fabric, and his sensitivities remain much the same as if he were working in paint or wood or metal. Glass is seldom used on its own in his work. Slate, metal, concrete, paint, or wood sit comfortably together and he treats each of them with equal importance. Glass, the way he uses it, looks rather unglassy – dematerialized almost.

During his formative years the part of Germany where Gussek lived was in the German Democratic Republic (East Germany). He was not subjected to the aesthetic and material values of neighbouring West Germany with its glossy fast

Right "Spoon", 1998.
h 17cm (6¾in), w 10cm (4in),
l 64cm (25¼in).
Blown glass, steel. It is difficult to classify the things that Gussek makes, but they need no classification. Stylistically they belong to a group of objects with a distinctive personal style: that of their creator.

cars and racy lifestyle. His was a quieter and less wealthy world where one had to make do. Attitudes to art were less exhibitionistic and self-indulgent than in the West. When the Berlin Wall came down in 1990, in the middle of Gussek's studies at Burg Gibiechenstein, many of those living in East Germany were exposed for the first time to the brasher and louder artistic statements of their neighbours. There was reaction against this from the majority of those involved in the arts, some of it openly hostile or resentful. Gussek is gentle by nature, a softly spoken man who communicates both as a person and as an artist in an intimate way. His reaction was introspective and not at all aggressive. But the very personal style he has developed speaks of lyricism and quiet resistance.

Although the school in Halle where he learned and now teaches is best known for architectural glass, Gussek does not feel the need to think big in his own work. He has created a family of small sculptural objects, playful and often toylike. They suggest things we all know and recognize, such as cars, planes, people, animals, or agricultural implements. In his hands they become members of a group of small iconic objects, their family resemblance making them instantly recognizable as the work of Gussek. Because pieces are small they give the sense of being precious objects, but one would not associate them with the environment that usually goes with precious objects. A talisman-like quality places them in a different world. They are displayed in vitrines just as precious objects are, but they are distinguished by their modesty rather than their luxury. These are the precious objects of *arte povera* or *art brut*.

One characteristic of his work is that his treatment of different materials seems the same, so that the transition from one material to another is seamless. The glass he uses is colourless in itself, although sometimes painted. He saws it as if it were wood, or chips away at it as if it were stone or slate and this treatment of glass, particularly when seen in juxtaposition with other materials, gives Gussek's work a distinctive personality. Gussek's small totemic objects and figures invite contemplation. Simple titles are clues to their significance. "Small white woman" is an elegant little figure wearing a long hat made of white metal, which emphasizes her slender form and draws attention to her fragility. "King" is a totemic figure majestically positioned on a cruciform slate base, from which a lead snake rises to threaten him. These small objects are material sonnets about the human condition.

Above *"Untitled Crafts"*, 1995–6.
123–82cm (9–32¼in).
Sand-cast glass. This group of toylike little racing cars is naïve enough to belong to the nursery world – but it is also about speed, horsepower, and manpower, a double significance that gives the work its edge.

Jirí Harcuba

BORN 1928, HARRACHOV, CZECHOSLOVAKIA NATIONALITY CZECH

Above *"Bedrich Smetana"*, 1978.
d 2cm (¾in), diam. 15cm (6in).
Copper wheel-engraved crystal.
Harcuba has done a series of
engravings of men of letters and
the arts, attempting in his portrayals
to capture the essence of genius
rather than physical attributes.

As a maker of medallions and a gem-engraver Jirí Harcuba has sought to connect the past with the present, continuing a tradition set by his 19th-century idol Dominik Biemann, whose portraits engraved on glass have served as a benchmark of excellence both in portraiture and in glass-engraving. Before the 20th century most portraits were commissioned; Harcuba enjoys the freedom of making portraits of those he admires, seeking to convey their inner being more than their physical attributes. His subjects include Mozart, Wagner, Gandhi, and Kafka.

Harcuba has been involved in glass from the age of 14, first as a trainee glass-engraver in his hometown of Harrachov and then at the *glasfach-schule* (the specialist school for those planning a career in the industry) in Nový Bor. In the course of his further studies, at the Prague Academy of Applied Arts, he made his first relief portraits, starting with a portrait of his father. By 1958 he was a professional working on medallions (mainly to commission) and designing and engraving glass. During that year he was invited to make pieces for the Brussels World Fair; these were wheel-engraved vases and plates in which his distinctive way of engraving was already established. The engraving was deep and sometimes the glass was engraved on both sides to give an effect of heightened relief.

Harcuba's professional life was divided between medallion-engraving, glass-engraving, and teaching at the Prague Academy. But he was summarily dismissed from his teaching job and imprisoned from September 1972 to January 1973 for making politically subversive art (including in 1969 a medallion in memory of Jan Palach, a protester who burned himself to death). On his release, Harcuba resumed life as an artist, concentrating on portraiture. In the 1990s he was again invited to teach at the Prague Academy, this time as head of the Glass Department.

His *intaglio* portraits are usually engraved on small glass discs (a form ideally suited to framing the human face), thick enough to allow him the freedom to engrave deeply, creating light and shade. A line of text or a title may be included. He sometimes uses rectangular blocks, particularly for mythical or allegorical subjects where he inclines towards abstraction.

Right "Vladimír Kopecký", 1995.
h 27.5cm (10⅞in), w 18.5cm
(7¼in), d 5cm (2in).
Moser crystal, stone-wheel engraved,
partially polished commission made
in fulfilment of the Corning Museum
of Glass Rakow Award. To achieve
a more three-dimensional effect
Harcuba often engraves both sides
of the glass.

Below "Sören Kierkegaard", 1995.
h 23cm (9in), w 16cm (6¼in),
d 4cm (1½in).
Diamond wheel-engraved crystal.
Although Harcuba always pays
tribute to the 19th-century engraver
and portraitist Dominic Biemann,
whose work has clearly inspired
him, it is for the great originality that
he has brought to 20th-century
engraving and portraiture that he
will be remembered.

Carving the image deeply with stone or copper wheels and combining this with shallow surface engraving, he uses varying depths to give an impression of high relief, thereby adding drama to his portraiture. Over the years his style has become freer and more expressionist. On occasion there are double images within a single piece, as in the Rilke portrait of 1988, where the poet is depicted as both a younger and an older man. Gradually, faces, or parts of faces, have come to fill the entire available space; this gives facial features more presence and the sitter's personality more prominence. Harcuba goes beyond physical likeness, delving into the psyche. His subjects are figures from the world of art, literature, and music, and in portraying them he tries to mirror their creative genius.

Brian Hirst

BORN 1956, GIPPSLAND, AUSTRALIA NATIONALITY AUSTRALIAN

Brian Hirst's distinctive "ceremonial" or "votive" vessels are made of blown and cast glass that is engraved and enamelled, often with platinum, silver, or gold. The works are impressive and large-scale, and convey a sense of importance; their precious-metal cladding also makes them lavish. Such seductive qualities have made Hirst the very collectible artist he is. Hirst's characteristic vessel forms are asymmetrical flared and flattened shapes, or cauldron shapes sitting on tripod feet. The glass is partly translucent and partly opaque, suggesting antiquity or timelessness. Opaque areas, where the glass has been treated with colour, suggest the patina of age; the translucent areas, where the glass remains uncoloured, hint at loss of patina. Glass tones are rich and on the dark side – deep purples and greys, for example. The ceremonies and rituals the pieces suggest are important and celebratory although unspecific – neither weddings nor funerals but generic rites of passage. Titles are in themselves evocative: "Guardian Vessel", "Offering Bowl", "Votive Bowl".

Hirst's work shows evidence of his earlier training in printmaking, photography, and sculpture. The *sgraffito* work on metallic parts demonstrates his drawing skills, reflecting his early training at Monash University, where he studied Visual Arts. He is fascinated by Cycladic stone sculpture, its mystery and anonymity, and there are references to such qualities in the simple monumentality of his own sculptural idiom. The vessels are sometimes accompanied by complementary drawings or prints from engraved metal, and the juxtaposition of two- and three-dimensional renderings of the same idea is a pleasing one, suggesting an object and its shadow, a being and its alter ego. This aspect of his work has become increasingly important over the past decade and he has figured out different ways of creating a dialogue between two and three dimensions, using drawings on paper or etched glass panels.

Before he began making the votive vessels for which he is best known, Hirst imitated the Cycladic figures he had seen in the Art Gallery of New South Wales, using laminated glass, etched and outlined in

Above "Votive Bowl – 1999", 1999.
h 20cm (7⅞in), w 33.5cm (13¼in).
Blown/cast glass, engraved, fired on platinum.

Below "Cycladic Series", 1986.
Panel: h 40cm (15¾in).
Black glass, engraved, enamels, poliergold.
Vessel: h 25cm (10in).
Blown/cast glass, acid-etched, engraved, poliergold.

neon. In the 1980s he started using blown glass, and he has experimented with a various techniques, using them in different combinations to create his double imagery. He uses acid-etching and sandblasting to create overall surface pattern. An unusual combination of blowing and kiln-forming is used in the making of his vessel forms.

Hirst has taken great pains to master all the different techniques he uses and his work shows him to be a technical wizard. Using ancient forms he has created a modern language in glass, very different from that of other Australian glass artists. The work is impressive and majestic partly because of its allusions to ceremony and historical precedents and partly because of its scale. But it also has an intimacy born of the very personal language that Hirst has invented over two decades, an attractive and easily interpreted language that allows us clear insight into his thought processes and provides an interpretive link with the historical antecedents that have inspired him.

Franz-X. Höller

BORN 1950, OBERNZELL, GERMANY NATIONALITY GERMAN

" I can create, draw, and think with the cutting wheel on glass and attempt to elevate this apparently banal process of cutting." Thus Franz Höller describes how he works as an artist in glass. He treats the glass block much as a sculptor might treat marble, enjoying the process of creating organized form from shapeless mass. The result is sharp-edged and strong on geometry: the forms are precise and calculated, and nothing is left to chance. Every surface is perfectly finished, every angle perfectly cut or rounded, giving machine-like precision to imaginative form. Cutting provides the body shape in Höller's sculpture and engraving the complementary decoration; colour seems organic rather than cosmetic.

Höller started his education in glass aged 14 with one of Germany's best-known industrial training programmes at the school in Zwiesel, where for three years he learned the specialized art of engraving on hollow glass forms. After a three-year stint as a glass-worker Höller went back to Zwiesel to continue his studies. He completed his training as a master engraver and went on to take a fine art degree at the Academy of Applied Arts in Munich, specializing in sculpture and glass-forming. He lives in Zwiesel; since 1981 he has taught design at the State Glass School, while working in his own studio as an independent artist in glass.

Höller's artistic work sometimes relies on vessel form and sometimes dispenses with it, veering towards sculpture. His objects are perfectly formed, as if maximum growth has been achieved. They are perhaps best described as playthings, toys for the super-intelligent, not actually for playing with but for suggesting mind games, generating thought. The scale of the work may be thought of as "right" rather than as large or small – size seems as if it has been dictated by shape. During the 1990s the work grew in scale, but without loss of intimacy.

In his single pieces Franz Höller explores the dynamics of pattern imposed upon form. A cone-shaped object is engraved with fine lines or with a single deep line like cosmetic scarring. Linear decoration is inspired by the sightlines of landscape. Competing shapes come together to form a whole, and a jumble of cylinders, rectangles and spikes coexists in

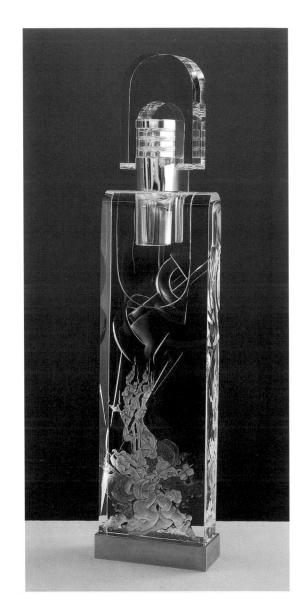

Above "Pacemaker", 1980.
h 53cm (20⅞in), w 12cm (4¾in),
d 4.5cm (1¾in).
*Colourless optical glass, cut,
polished, and engraved. This
piece, from early on in Höller's
career, relies largely on the
first skills he learned in glass
as a glass engraver.*

perfect harmony. One can interpret this as one wishes, or simply enjoy the result for the visual pleasure it provides.

From single pieces Höller moved on to groups of multiple elements. In the groups, the relationship between individual shapes constitutes an important part of the imagery as a whole, so that the pieces become connected although they are separate. The relationships thus established inevitably refer to human situations, a transference of association that occurs spontaneously without any need for explanatory notes. Within the groups different materials are sometimes used. Shapes are repeated in glass, metal, or wood, although (quite intentionally) the materials may be almost indistinguishable in appearance, a comment about illusion and reality. Höller feels that his work is connected to the void from which it came. "I would like to return the things I made to nature, ie they should not communicate anything artificial, literary, or aesthetic, instead they should be as natural as a stone or a shell."

Above "Box", 1999.
h 18cm (7in), diam. 18.5cm (7¼in).
Colourless glass, violet underlay,
cut, semi-matt. Höller uses colour
underlays to create inner light in
his work. His colours are veiled
and luminous rather than primary.

Left "Box – Polar Order VI", 1996.
h 21cm (8¼in), diam. 26cm (10¼in).
Colourless glass, two glued
sheets in blue and yellow, cut,
acid-engraved. As it matured
Höller's work became simpler,
stripped of decoration and surer
of form, assuming a purely
sculptural character.

Toshio Iezumi

BORN 1954, ASHIKAGA, JAPAN NATIONALITY JAPANESE

Above "Light & Water", 1989.
h 340cm (134in), w 35cm (14in),
d 35cm (14in).
*Free-standing, greenish-coloured,
stacked sheet glass, glued and
polished, exterior sculpture
mounted on a metal base
standing in a pool of water.*

In Toshio Iezumi's work nothing is left to chance. Thorough technical mastery allows him total control over what he makes. He uses layered sheet glass, bonding the sheets together with glue. Sheet glass has a greenish tint to it which changes in intensity when stacked or bonded, the thicker areas taking on a deeper and darker shade. The layers are individually worked with cutting and polishing so that, in their final bonded version, a mysterious inner space is created, a pool of peace and tranquillity. These inner spaces seem watery, but they are dry. Undulating contours give the impression of waves or ripples. The forms are simple, but Iezumi uses the reflective and light-transmitting qualities of glass to create an illusion of depth and movement. Although the pieces are shallow they give the viewer a sensation of looking deep inside something. This visual illusion adds a new dimension to sensory perception, unbalancing our sense of both the visual and the conceptual norm.

Iezumi graduated from the Tokyo Art Glass Institute in 1985 and since then has worked, exhibited, and taught, mostly in Japan. The concept of using technique as a means of self-expression in glass is more recent in Japan than in the West. Until the 1970s there was little opportunity for an art student to investigate the possibilities of being an artist in glass at any Japanese educational establishment. News of developments abroad, especially in the United States, was brought back by a generation of artists who had made a reputation as glass designers for the industry, most of them during the 1950s. In 1972 the doyen of Japanese glass, Kyohei Fujita, founded the Japan Glass Artcrafts Association; by the 1980s international exhibitions of contemporary glass were hosted by Japanese museums, notably the Hokkaido Museum of Modern Art in Sapporo. Commercial galleries selling contemporary glass began to open and university curricula began to include glass programmes.

By the 1990s there were many artists in Japan working outside the industry in their own glass studios. The work of Japanese glass artists began to be shown abroad. Iezumi was one of 20 artists included in the prestigious international exhibition *The Glass Skin*, which travelled to North America and Germany after opening at the Hokkaido Museum of

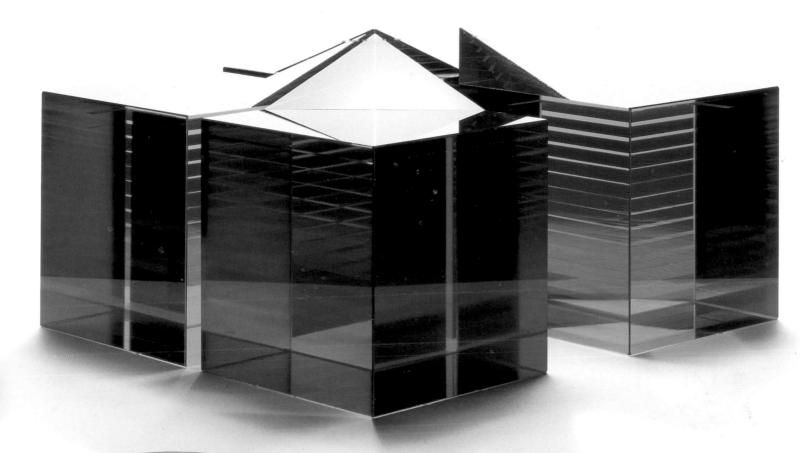

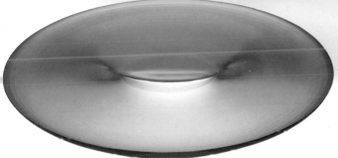

Top *"Division Of Mass"*, 1987.
h.20cm (7⅞in), w.50cm (19¾in),
d.46cm (18in).
*Greenish-coloured sheet glass
stacked in the form of a rectangular
building with pyramidal roof, glued
and polished.*

Above *"Projection 061199"*, 1999
h.10cm (4in), circ. 50cm (19¾in)
*Large greenish-coloured sheet-
glass plate with "dimpled" central
section, glued and polished.*

Modern Art in 1997. Before that his work had been seen in Europe at *Venezia Aperto Vetro* in 1996, where it was singled out for its excellence and awarded a prize.

The range of techniques that Iezumi uses is comparatively narrow, limited to forming sheet glass, cutting it and polishing it, and glueing it together. But he has investigated the artistic possibilities of these processes thoroughly and imaginatively and created a body of work distinguished by its lyrical appeal. Glass is a cold hard material, but in his hands it seems to float and to flow, encapsulating the mysteries of light on water. A romantic, he expresses this side of his nature in the glass he makes.

In the 20th century the influence of the West on Japanese art has been noticeable; contemporary Japanese glass takes its conceptual inspiration from the American studio glass movement. But a Japanese respect for fine craftsmanship imposes something akin to good behaviour on this as on all forms of decorative art. Delving deeply into a corner of glass technique Iezumi has come up with winning artistic content that sets him apart among contemporary glass artists, Japanese or otherwise.

Marián Karel

BORN 1944, PARDUBICE, CZECHOSLOVAKIA NATIONALITY CZECH

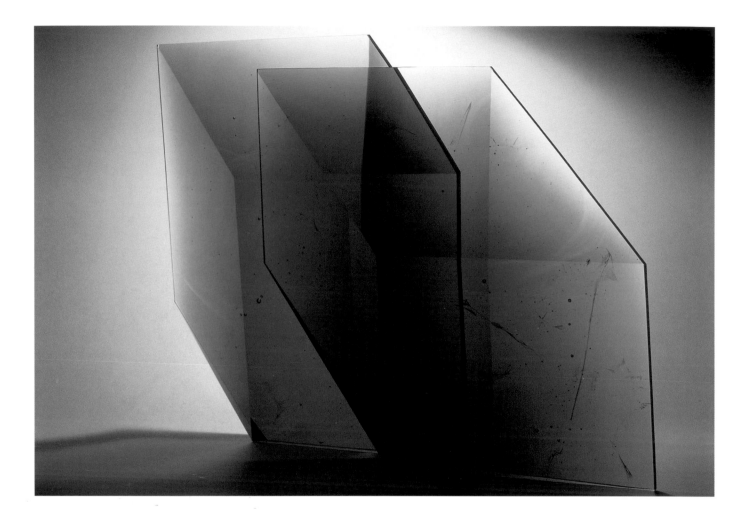

Above "Illusive Cubes", 1983.
h 32 cm (12½ in), w 35 cm (13¾ in),
d 8 cm (3 in).
Melted glass, cut and polished.
Carefully thought-out mathematical
and geometric precision and an
understanding of light and shade,
whether in coloured or colourless
glass, give Karel's compositions
their strong architectural presence.

Innovator, educator, and artist in glass, Marián Karel plays an important role in Czech glass. He was considered one of Stanislav Libenský's star pupils at the Prague Academy of Applied Arts (1965–72), where he was a student after having studied metalwork at the school of jewellery-making at Jablonec nad Nisou. After leaving the Prague Academy Karel became involved in exhibition work and in site-specific commissioned work. The Czech tradition for commissioned work in glass for public spaces served him well. His work attracted wide interest and earned him commissions in public buildings at home (including banks and hotels) and in embassies abroad. He began being invited to exhibit in galleries abroad from the mid-1980s and by 1990 had participated in exhibitions

in Germany, France, and the United States. In 1992 Karel was asked to lead the Studio of Glass in Architecture at the Prague Academy.

His preference for working in glass has always been to think of glass in architectural terms. He sees his work in glass as a dialogue with the environment and its inhabitants. Although he has done solo exhibitions with smaller work destined to be exhibited in galleries, he is most at home when his work is environmental. At the beginning of his career, like so many of his generation who experimented with optical cutting, he explored the possibilities of deflecting light. His solid glass forms with prismatic cutting transformed sight lines, creating a world of optical illusion by playing visual and intellectual games. He never relied on decorative detail in his work: that was provided by reflected imagery or transmitted light, the material creating its own scenic effects. Karel now works mainly with sheet glass, using it to make constructions that distort reality and in the process create a new kind of reality. It is his intention to lead the eye where it has never been before, altering our state of mind in the process, leading us beyond reality to a world accessible only by means of his manipulations in glass.

Sometimes his installations are variable and movable, such as the various "pyramids" he created during the 1990s. "Pyramid 1994" was an installation in iron and stained sheet glass, an imposing monument that transformed the interior space it occupied by its volumetric presence, filling an otherwise empty room in a majestic way. "Pyramid 1996", created for the glass exhibition *Venezia Aperto Vetro*, drew attention both to itself and to its environment. One could not help comparing the reflections with the reality. Two worlds, one real and one illusionary, were combined in one place in a visual and sensory experience.

Perhaps the best way of understanding this artist's conceptual way of working with glass is to quote his own thoughts: "Working with glass sheets I create illusionary transformations of light which reflect, and thus empower the surrounding reality... This light evokes a feeling of unsteadiness and movement which corresponds with our vulnerability and our own lives."

In essence Karel has taken the idea of the window as his point of departure. The transparency of a plain window allows us access to the

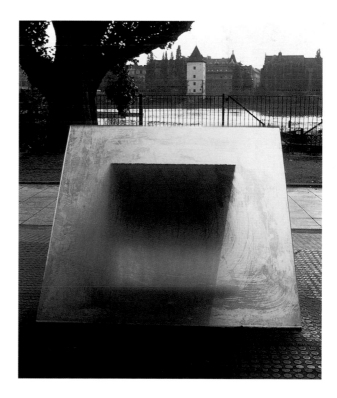

*Below "Square", 1991.
h.50cm (19¾in), w.100cm (39in),
d.100cm (39in).
Flat glass. Libenský-Brychtová
Award For Excellence In The Art Of
Glass, 1991. The utter simplicity
of Karel's work hides the complex
thought about space and light that
goes into every piece he creates.*

outer world from within as no other material can. By using sheet glass as a basic construction material destined for artistic ends, Karel has created a whole new visual world. Although his structures are not architecture, they stand like buildings and have architectural presence, accommodating our senses rather than our physical being. They invite thought about a world that exists because Karel decided to create it out of nothing. It is there and not there. With outside installations it exists only as long as it is allowed to stand there. "Pyramid 1996" in the Ducal Palace, although it was photographed many times, needed to be seen *in situ* in order to appreciate it fully. The piece owed its soul to changing light, to the bricks, mortar and stone around it, and to the viewer's physical presence.

Karel's approach to glass is unique among contemporary glass artists in that he has not sought to develop a glass process as part of his artistic development. The sheet glass that he uses is the simplest of ready-made materials. It can vary in colour from transparent to tinted to matt and non-reflective. Karel uses such differences to create his colour palette. Glass becomes a conductor of colour, allowing the colour around it to pass through it, to enter into it, or to be reflected in it. Sheet glass can be cut to any shape and in this respect is the most flexible of "building" materials. It can also be stacked while letting light pass through it. It can be set at any angle, accommodating light in a variety of ways. Although the material that Karel works with could not be simpler, the thought processes he brings to it are so much his own that they would be difficult to imitate. By thinking the way he does Karel has introduced his generation of students to a new culture in glass. His own teacher, Stanislav Libenský, had established a cast-glass tradition at the Prague Academy that left its mark on generations of students. Karel's approach has pointed the way to new directions for glass both in architecture and as an artist's material.

Because much of the work that Karel does is by its nature temporary, his art is difficult to grasp. Photography cannot do it justice; only real light brings it to life in the way the artist intended. Karel conceives his work as a visitor to the environment it occupies, and to a large extent it depends on the environment for its existence. He uses the environment as one of the main ingredients in his creation, not so much as an inspirational force, but more as a material reality that will transform his work and in the process become transformed itself.

Above "Pyramid", 1996.
h 340cm (134in), w 290cm (114in),
d 120cm (47in).
*Steel, flat reflective glass. Palazzo
Ducale, Venice, Italy, 1996; Borgholm
Castle, Borgholm, Sweden, 1999.
The reflective qualities of this piece
enable it to mirror the surrounding
architectural features.*

Opposite "Prism", 1994.
h 300cm (118in), w 200cm (79in),
d 200cm (79in).
*Flat glass, profiled steel. Old Town
Hall, Prague. Karel reanimates a familiar
space by redefining its sightlines.*

Gerry King

BORN 1945, ADELAIDE, AUSTRALIA NATIONALITY AUSTRALIAN

Above *"Twin Necked Bottle"*, 1980.
h 18cm (7in), diam.13cm (5in).
*Free-blown, hand-applied silver
nitrate decoration. The simple
monochrome of an early blown
piece of Gerry King's shows a
side of him that he never reverted
to in the lively polychrome palette
typical of his kiln-cast work.*

Gerry King became involved with glass while working in the United States at the New York State College of Ceramics (Alfred University) from 1973 to 1974. He then attended workshops in Canada, the United States, and Australia. Trained initially as a glass-blower, he is better known for his colourful kiln-formed work, which bears very little relation to his earlier free-blown vessels inspired by garment shapes and the human torso. Although he had earlier explored its possibilities, King did not choose kiln-formed glass as his mode of expression until the 1980s.

King was in at the start of the Australian contemporary glass movement in the mid-1970s. In 1978 the first Australian Glass Conference was held at the Sydney College of Arts and, as King writes, "the path of Australian studio glass forever changed". Since that time he has been at the forefront of the Australian glass movement as an artist, as an active member and one-time president of the Australian Contemporary Glass Society (now Ausglas), and as a teacher of art and design.

Early in his career King was almost wholly absorbed by the fascination of the glass process, the excitement of hot glass and the furnace. As his technical abilities matured, he was able to concentrate on content rather than material. There is a sociopolitical focus to his work and he uses an interest in archaeology as a mode of expressing this. Shapes and out-lines may be inspired by archaeological fragments, which suggest to him the concept of hypothetical objects and also that of remnants that imply familiarity with the whole, the thin line between suggestion and reality. Some works, such as "Glory Boxes", refer to specific relics (for example, the relic boxes in the Victoria and Albert Museum that allegedly contain the remnants of Thomas Becket). Moroccan wall tiles also act as source material in the same series of work, in which highly patterned pieces refer to his concern about the damage caused by cultural colonization.

King's work often alludes to Aboriginal culture too, although again the allusion is only part of a more complex story. Of the early 1990s series "Cicatrix", he says: "[It was] initially inspired while living in Japan, by the experience of media coverage from Australia ignoring any reference to

the indigenous population while reporting the plans for bicentennial celebrations. The coloured forms are loosely influenced by the 'wirra', an elongated wooden bowl, and images of dot painting."

The serious content of King's art never prevents it from pleasing the eye. Knowing the artist's concerns helps to understand the work, but on another level it can be viewed as something highly coloured, of attractive shape, and finely made. While King's artistic statements are illuminating, the work speaks for itself whether as sheer visual delight or as interesting comment.

Above "Trepein No. 2", 1996.
h 35 cm (13⅞ in), w 25 cm (9⅞ in),
d 77 cm (30 in).
*Kiln-cast, flame-formed glass,
etched surface, base cold-worked.
King says, "The [...] patterns drawn
from Western and other cultures
might be reasonably interpreted
as indicating that the great damage
wrought by cultural colonization is
now lessening as multiculturalism
grows in some countries."*

Alison Kinnaird

BORN 1949, EDINBURGH, SCOTLAND NATIONALITY BRITISH

Alison Kinnaird has always used copper-wheel engraving as her means of expression in glass. She was a student of Harold Gordon and of Helen Munro Turner (herself a renowned glass engraver) at Edinburgh College of Art. Apart from her glass engraving studies, she graduated from Edinburgh University with a Master of Arts degree in archaeology and Celtic studies.

Usually Kinnaird uses simple glass blocks or sheet glass for her imagery in glass. Sometimes she has also chosen cut-out forms to frame her engraved imagery, forms such as the human figure, a wing, or a boat that in some way relate to the subject matter. Although most of her work is on colourless glass, she has also experimented with engraving on coloured crystal. When colour is used it tends to be subdued. Dark shades of blue or grey bring contrast and mood; colour is not used for its own sake, but as a background that gives the foreground enhanced prominence. There is a timeless, dreamlike quality about her work. The transparency of glass is used to create illusions of imagination and reality. Different depths of cutting into the glass create shadow and substance, each playing an equally important role; the images themselves, trapped in and on the glass, seem suspended between two worlds.

Copper-wheel engraving allows for a degree of precision that appeals to Alison Kinnaird. Every line she engraves, whether it is clear and bold or thin and wispy, is fully intentional. Her drawing is about detail, and an attention to detail builds the fuller picture. One is attracted first and foremost by her great drawing skills, all the more impressive because of the technical mastery required in this medium. She does not do preparatory drawings on paper. For her the qualities of glass, its transparency, and its shining clarity, dictate the nature of her drawing. She could not convey her desired effect if she were drawing on paper. Her use of the qualities of glass makes what she does a very special form of drawing. Her copper-wheel engraving, and particularly her method of engraving onto the reverse side of the glass, allows for a degree of three-dimensionality that could never be achieved on paper. Kinnaird's drawing has a sculptural quality to it. The technique of drawing

Below *"Doors on the Past"*, 1986.
diam. 25cm (9¾ in).
Copper-wheel engraving on colour-cased crystal disc, supported by two clear blocks, silver mount. This piece, with its reference to past cultures, was commissioned in 1986 to mark the formation of the Royal (now National) Museums of Scotland.

on the reverse side of the glass also gives the illusion of figures being trapped inside the glass, adding emotional power to their presence.

The human figure features prominently. Sometimes the figures are seen in something suggesting a landscape. Air and water are nearly always implied. Shading suggests the sky, and water is represented by different graphic devices. Figures are androgynous and featureless, although their musculature suggests some sort of male predominance. Most of the figures are in a standing position, sometimes seen in groups, sometimes as single figures arranged in a series of vignettes that cover the surface of a block or sheet of glass. The repetition of imagery in the vignettes reminds one of Eadweard Muybridge's late 19th-century photographic studies of man or animal in motion. Kinnaird's unclothed, unidentified, unspecific figures have a monolithic, perhaps prehistoric feel to them. They are inspired by Scottish mythology and refer back to her Celtic studies, to archetypal figures, standing stones, pillars, and the Scottish landscape in which they are set.

Alison Kinnaird's imagery is simply outside time and alludes to a world long gone. And yet it embraces questions about identity and relationships, about naked truth and social pretence. Her figures relate to the human condition as we think of it today.

Above *"Eostra", 1989.*
h 22cm (8¾in), w 12cm (4¾in),
d 10cm (4in).
Copper wheel engraving on crystal block and sphere. Kinnaird's androgynous figures express human anxiety and frailty.

Below *"Standing Out", 1997.*
diam. 28cm (11in).
Copper-wheel engraving on colour cased crystal disc, small scale cutting.

Kirkpatrick & Mace

JOEY KIRKPATRICK BORN 1952, DES MOINES, IOWA, USA FLORA MACE BORN 1949, EXETER, NEW HAMPSHIRE, USA

Above "Doll Drawing", 1983.
h 30cm (11⅞in), diam. 17.5cm (6⅞in).
*Hand-blown glass cylinder with
wire and glass cane pickup.*

Opposite "Voyage Carrier", 1984.
h 137.5cm (54in), w 42.5cm
(16¾in), d 20cm (7¾in).
*Free- and mould-blown glass,
fabricated wood, wire, and steel,
mould-blown head fired with
glass enamels.*

Joey Kirkpatrick and Flora Mace love objects, the human figure, and the relationship between the two. Their work together is a celebration of their life together. They first met in 1979 at Pilchuck Glass School, at the start both of their professional lives and of that prestigious school founded by Dale Chihuly. Flora Mace was a sculptor and Joey Kirkpatrick a painter. Mace had already worked on several projects as assistant to Chihuly since 1975, developing a technique of drawing on glass by fusing coloured glass threads onto the surface. Kirkpatrick wanted to put her own drawings on glass at Pilchuck and hoped Chihuly would teach her; instead it was Flora Mace who did so. They have lived and worked together in the Seattle region ever since meeting at Pilchuck, for the first five years of their relationship in a hand-built cabin on the school's forest property. They live a simple life and feel close to nature. Their work describes how they live, and their relationship with each other and with the world around them.

Pilchuck has played a vital part in the lives of Mace and Kirkpatrick. It was in the countryside around Pilchuck that they began collecting alderwood, which has become such an important part of their craft lives. For more than two decades they have been central figures in the evolution of the school as teachers and devotees of the informal way of teaching and exchanging ideas there. They were instrumental in developing the artist-in-residence programme at Pilchuck, where they have met and mixed with some of the most distinguished glass artists in the world.

The early pieces with drawings on glass are now rare collectors' items. In these pieces Kirkpatrick's drawings were re-sketched in wire and then applied to the surface of the glass in a craft process developed by Flora Mace. Since their early collaboration they have branched out in many different ways and their mixed media sculptures include subject matter such as doll-like figures, objects of all sorts, and fruit. The artists explain: "The figure has been prominent and evolved throughout our collaboration for the last 20 years [while] objects from everyday life have been important to serve as a metaphor to support and define the figure." The doll-like figures they started creating in 1983 have pod-like bodies and

tiny globular heads with androgynous features drawn in black. The simple (usually milky white) body forms often have symbols added to them, such as leaves, ladders, hoops, coloured balls, and oars. In another series of work sculptural collages combining blown glass, stone, or wood include fruit, figures, and vessel shapes. Wooden torsos or wooden cage-like constructions are made of alder branches gathered in the forest, then cut, peeled, and steam-bent by the artists themselves. As Kirkpatrick and Mace have become more successful the space accorded to them in museum and gallery shows has been larger and their work has grown in scale accordingly. The fruit began by being life-size but has grown into massive floor pieces, and the new figurative works are also much larger in scale than they used to be.

No artistic partnership is straightforward, but Mace and Kirkpatrick have arrived at a way of working independently as well as collaborating to produce a finished result. The collaborative process is there from start to finish in a lively exchange of dialogue and ideas. Each of them has certain talents. Joey explores possibilities of translating her drawing skills into three-dimensional sculpture. Her work is more the conceptual kind, the concepts developed in ink, pencil, and watercolour drawings and mono-type prints. Flora does the woodwork and leads glass-blowing sessions with a team of assistants (including Joey). The furnace is fired up twice a year and a range of glass components made to be incorporated into the sculptural work. In exploring the creation of fruit shapes in glass they have experimented with two techniques. In one glass frit sprinkled onto hot glass imitates the peel of citrus fruit. In another they decorate the fruit with the lacy coloured overlay using the Venetian *zanfirico* technique. The huge fruit — apples, peaches, pears, lemons, peppers, and gourd shapes – is visually surprising and somewhat surreal, a glorious celebration of colour and pattern, of everyday life and its cycles and seasons.

An insight into the way they work comes from Joey Kirkpatrick: "For the most part, Flora and I work together, separately. Our differences make the collaboration work and force the broadening of our individual visions. When we begin to work on a new piece we discuss an idea, consider possible directions, and then go our separate ways to develop our own thoughts – Flora to the woodworking shop and I to my drawing studio. I think of us in this phase as explorers, each of us searching through the many dimensions of a particular idea. We work from a palette of images,

shapes, textures and materials from which we are constantly adding and subtracting." The imagery of their work comes from the countryside and seascape around them and from the objects they collect – including antique single-master miniature pondboats, the sail forms of which are motifs in their work. As well as their miniature boats, they own cedar strip kayaks, a sailing boat, and a 91m (30ft) cruiser dating from 1919. They sail for relaxation and inspiration, fishing and cooking what they catch.

The subject matter and the titles given to each of their mixed-media compositions leave one in no doubt as to the meaning of a work. They make simple, clear statements about easily accessible everyday things that we all understand. In a 1998 interview for the magazine *American Style*, Kirkpatrick comments on the ethos behind their work. "In the studio we surround ourselves with objects, things that are meaningful symbols to us assembled over the years that constitute our visual vocabulary. Through our sculpture we reshape these diverse elements to make a coherent whole… There is no specific meaning to any piece. Our challenge is to set up the imagery, the metaphors. People bring their lives to the work. I know this sounds corny, but they walk in here and their spirit is actually moved by something they can't put into words. For me that's enough, that they're moved."

Left "Paint and Brush", 2000. h 87.5cm (34⅜in), w 50cm (19⅝in), d 37.5cm (14¾in). Free-blown glass with wood, fibre, and steel. The subject matter of Kirkpatrick and Mace's work is always simple and approachable, relating to landscape, the seasons, life cycles, or domesticity.

Right "Still Life", 1999. h 72.5cm (28½in), w 122.5cm (48in), d 122.5cm (48in). Free-blown glass with crushed glass powders for colour. Hand-carved wood bowl, painted. This luscious still life is a kind of harvest festival, a celebration of life contained in a bowl of giant fruits.

Vladimír Kopecký

BORN 1931, SVOJANOV, CZECHOSLOVAKIA NATIONALITY CZECH

During his career in glass, which now spans nearly half a century, Vladimír Kopecký has gone from ordered and geometrically clean to messy and unstructured. Since 1990 Kopecký has been professor of architecture and design at the Academy of Applied Arts in Prague, where he himself studied from 1949 to 1956 under Professor Josef Kaplický. Glass studies in the Czech Republic are more protracted than anywhere else in the world. Kopecký, and others of his generation destined for a career in glass, started his glass education at secondary school level, attending two glass schools in northern Czechoslovakia, Kamenický Senov and Nový Bor. Both schools prepared youngsters for work in the glass industry, teaching them a variety of skills; the most talented and serious went on to do a six-year course at the Prague Academy.

When Kopecký graduated from the Prague Academy in the mid-1950s the glass industry was in a sorry state under the Communist regime. Yet many young artists chose to work in glass even with virtually nowhere to exhibit their wares. The exceptions were world fairs such as Expo '58 in Brussels (where Kopecký was awarded a gold medal) or the XI Triennale in Milan in 1957 (where he also exhibited). Glass artists exchanged their wares in an atmosphere of friendship rather than commerce – a lack of constraint that stimulated artistic freedom.

During the 1950s and early 1960s Kopecký made simple but geometrically elegant vessel forms on which he painted bold abstract designs in thick enamels with black areas setting off a palette of radiant reds, yellows, and blues. In the 1970s he created glass objects from sheet glass, cut in strips and stacked in various ways. Intersecting planes, often in graded colours going from pale to dark and dark to pale, provided interesting optical effects related to the aesthetics of Op Art. Kopecký has always moved between paint and glass and is equally at home in either medium. During the 1980s his composition became more random, the linear effects more confused and also more interesting. There has been a growing feeling of restlessness and commotion in his work. In his earlier work the eye finds a fixed viewpoint, but with the growing complexity of his compositions it does not know where to rest. It darts busily around

Below "Vase", 1967.
h 17cm (6¾in), diam. 14cm (5½in).
Large clear glass vase with circular thin lines and abstract patterned inclusions. Even before abandoning the vessel to devote himself to sculpture Kopecký used traditional glass forms to explore different kinds of abstract imagery.

splashed colours and meandering contours in a state of nervous emotion. Kopecký's later work is challenging and aggressive, less at peace with the world around him.

Part of the process of evolution has been about using a far wider variety of materials in his work, perhaps in a bid to break with convention and the restraining nature of glass and flat surfaces. Kopecký's studio at the Prague Academy is a mess, with papers piled high, jars of paint, some of it spilt, broken glass, wood, nails, rubbish of all kinds. But somehow it is organized chaos: one has the feeling that Kopecký knows where everything is. He grabs a piece of debris – a chair leg, a brick, a pot of paint – and it finds its way into his work. The disorder he creates is about inner conflict, opposing forces, the world of blood and guts that we live in.

Danny Lane

BORN 1955, URBANA, ILLINOIS, USA NATIONALITY AMERICAN

Above "Etruscan Chair", 1992.
h 88cm (34⅝in), w 40cm (15⅞in),
d 50cm (19⅞in).
19mm (⅞in) float glass seat and back
with stainless steel studding. This is
surely one of the most unusual chair
designs of the 1990s and has earned
itself a place as a classic of late 20th-
century design.

Danny Lane's work is unique and instantly recognizable: it makes a powerful impact, stops you in your tracks – and not simply because of its scale. Lane shows a preference for the monumental, but even in his smaller-scale work the dramatic effect is there. The work has show-stopping qualities whatever its dimensions. A charismatic American, Lane moved to London in 1975 to study stained glass with the British artist Patrick Reyntiens; he also studied painting at the Central School of Art in London with Cecil Collins before setting up his own studio in 1981. Some of the graphic language in his work reflects his studies with Collins.

The single best-known work by Danny Lane must surely be the balustrade of stacked glass on the staircase of the new glass gallery at the Victoria and Albert Museum, installed in 1994. But some works of more modest proportions will almost certainly ensure him a place in the annals of modern design, notably his "Etruscan Chair" (1986), now considered an icon of 1980s. The chair is in various museum collections. It is made of 20mm (⅝in) float glass, with forged, sandblasted, and polished stainless steel studding, and steel legs with "stiletto heel" tip feet. Metal and glass are the two main ingredients of all Danny Lane's work. His use of glass is particularly distinctive. Heavy float glass, more commonly used for large windows in multi-storey buildings, has its edges smashed and then polished smooth in his studio. The effect is one of danger removed but remembered. Broken glass is lethal, but treated in this way it retains all of its theatricality without the original menace: it is glass translated into drama.

Lane makes tables, chairs, screens, fountains, sculptures, and sometimes smaller vessels (bowls and glasses). The combination of float glass (often stacked) and forged iron or steel makes the pieces extremely heavy. The float glass he uses has a distinctive sea-green tint to it. Glass surfaces are often decorated with patterns of distinctive busy etched or sand-blasted sketched symbols; these give the impression of doodles, but from the hand of an accomplished graphic designer. The metal parts are a mixture of high tech and romantic or emotional. Metal finishes are rusty or rugged. The metal is bent and twisted in rhythmic patterns as if

Above "Pantheon", 2000.
h.340cm (134in), diam. 670cm (264in).
Glass and steel. Twelve columns of
post-tensioned, stacked, 12mm (½in)
float glass on a circular, rusted steel
ring. Formerly called "The Ring".
Danny Lane has a flair for creating
dramatic statements with his
monumental (usually stacked) glass
sculpture, usually in combination
with rusted metals.

manipulated by a giant. On occasion large pieces of wood find their way into the work. Both wooden and metal parts may be found objects, such as old planks or railway tracks.

Of course Lane's work is designed, but it appears artless, although the artist has certainly had his way with the materials he uses. Float glass does not usually bend and curve: it is flat and thick and straight. Yet Danny Lane cuts curves into it, almost as if it were wood, and they become emphasized and dramatic when the glass is stacked. The work is both primitive and sophisticated in feel. Lane's artistic ethos is perhaps best summed up in his own words: "Since the beginning of my working life I have sought the route of least resistance. Glass breaks, break it first: it scratches, scratch it first. Metal rusts, rust it first. Decay is inherent in these materials, and this is a quality I don't neglect."

Warren Langley

BORN 1950, SYDNEY, AUSTRALIA NATIONALITY AUSTRALIAN

Below "Spirit Of Earth – Puzzling
Evidence Series", 1989.
h.80cm (31½in).
Kiln-formed glass; bowl component
hand-shaped from pre-fused blank.
The triangle, here constituting the
main element in the design, is
a favourite in Langley's language
of symbols and shapes.

Having majored in science at Sydney University and then worked for some years as a geologist, Warren Langley began exploring the possibilities of glass in 1972. He did not become seriously committed to working in this medium until he returned to Australia after a tour of the United States and particularly the West Coast. A visit to Pilchuck Glass School he refers to as his single most inspirational experience. His travels – with the specific aim of learning – have essentially constituted his education in glass. He devoted himself to glass full-time in 1977, and in 1980 opened his own studio in Sydney, where he began making a series of sculptures, panels, and vessels, decorated with signs and symbols derived from characteristic features of the Australian landscape, both urban and rural. In addition to his programme of exhibition commitments, Warren Langley receives many large-scale architectural commissions. His glass company, Ozone Glass Design, which he runs with his brother Michael, manufactures innovative oven-formed glass products for architectural and interior applications. He is justly proud of having developed a whole new range of techniques in his work with architects "that large-scale manufacturing industry did not even know about".

The work for which he is best known is his series of autonomous kiln-formed free-standing glass constructions or panels, with sandblasted and acid-etched decoration of signs and symbols. Each series is a chapter in which an idea or a story is thoroughly developed. Langley began to attract serious interest with his "Future" series in 1981, fused glass constructions in which he made use of quite specific graphics and symbols to explore the theme of Australia's identity and the way it was perceived beyond its own borders. Langley refers in his interviews to an interest in symbology and iconography. The triangle is a favourite of his. "I think the triangular symbol for me is a symbol of strength, of purity – perhaps it has something to do with the Trinity. I'm not a religious person, but I'm fascinated by the concepts of religion."

In the mid-1980s came the "Druid" series, which Langley describes as "shrine-like objects of ritual worship". The pieces have lively patterns of chequerboard motifs and vertical, horizontal, and diagonal stripes. They

are architectural structures incorporating slabs and lintels, including large kiln-cast blocks in excess of 1m (3ft 3in) in their broadest dimension. They are ambitious from a technical point of view, and Langley is proud of having resolved the problems inherent in large-scale casting. After the "Druid" series came the "Puzzling Evidence" series at the end of the 1980s, the "Gnostic" series, and then "Maps and Mapmakers", in which he is concerned with the inevitability of change. He has been occupied recently with a series of glass and light installations.

After an initial flirtation with blown glass Warren Langley decided that he preferred kiln-working. This is partly for practical reasons, principally the fact that a furnace is costly to run and needs constant attention. The kiln process is a more gradual, more reflective process, requiring fewer "heat of the moment" decisions than hot glass. In a process not dissimilar to baking a cake, a glass mixture is placed in a mould, which is then heated and cooled in the kiln as appropriate. But he has declared his reason for preferring kiln-work to blowing as being that "the kiln offers you a much greater potential to go beyond the vessel". Essentially Warren Langley feels that so much has been said about the smooth and shiny surface of hot glass in the 3,000 years of its history that he prefers to explore its textural possibilities, the feel of kiln-formed glass. "I want to create the glass so that as you walk past, you feel that you must touch the surface."

Top "Last Days Of Samarkand –
Maps & Mapmakers Series", 1994.
w 240cm (94in).
Kiln-formed glass and mosaic.

Above "Journey", 1999
h 230cm (90in).
Kiln-formed glass, enamel,
and applied metal coatings.

Antoine Leperlier

BORN 1953, EVREUX, FRANCE NATIONALITY FRENCH

Above *"Evidence de la Pierre"*
(Evidence of the Stone), 1991.
h 38 cm (15 in), w 23 cm (9 in),
d 23 cm (9 in).
Pâte de verre, lost-wax technique.
This shrine, suggesting antiquity
and past civilizations, is a typical
subject chosen by Leperlier to
explore the power of memory
and its importance in our lives.

For Antoine Leperlier *pâte de verre* is a family tradition. His grand-father, François Décorchemont, one of the most famous French glass-makers of the early 20th century, was instrumental in reviving the ancient art of glass-casting. Antoine Leperlier watched him work and after graduating from the Sorbonne and the Ecole du Louvre with degrees in philosophy and sculpture, he made a serious study of his grandfather's technical notes. By 1982 he was exhibiting his own work in *pâte de verre*.

As an artist Leperlier makes use of his studies in philosophy, questioning the power and content of memory and delving into it like an archaeologist to trace what lies there. Archaeology, whether it be the mystery of pyramids or the magic of pre-Columbian architecture, interests him passionately. Half-remembered, dreamlike images and ideas emerge and find their way into his work.

Antoine Leperlier's earliest work – opaque vessel forms in solid colours – recalled that of his grandfather, but it was only a short time before he developed a strong sculptural language of his own. The first sculptural works were narrative with titles that clearly related to subject matter, such as "Porte" (Doorway; 1986) or "Espace d'un secret/Chaos I" (Space for a secret/Chaos I; 1993). Since the mid-1990s works are simply referred to as still lives, moments in time and thought captured in glass. He has an obsessive nature and is obsessed by trying to grasp the ethereal. "My objects are a bit like images, the same as dream images, physical, synthetic sensations, like the impression of holding something when the hands are empty." He thinks about the passing of time and what it carries in its wake, about how time is remembered. "I try to express time more than space by a series of associations... Memory, as the place where time is registered, will be like a great transparent void containing imprints." Such ideas are expressed in a collage of imagery that seems frozen inside the glass mass. Occasionally quotations on or in the glass guide our thoughts.

The technique that Antoine Leperlier works in requires great technical expertise, something that has always been of seminal importance in his

artistic endeavours. To get the subtle veiled and shaded effects he achieves requires detailed knowledge of how the glass mass will behave in a kiln and this comes with years of trial and error. What he learned from his grandfather was only the start. He has added greatly to the range of possibilities in *pâte de verre*, partly through his own ingenuity, partly thanks to modern technology; his grandfather could not have conceived of working on the large scale that his grandson does. Recently Leperlier has more or less eliminated colour from his work, a development that is particularly noticeable because early on, perhaps while in the process of breaking away from his grandfather's influence, colour seemed important.

Leperlier writes and draws in the process of formulating ideas that will eventually be translated into glass. He sees his heritage as part of some inevitable destiny and uses all his intellectual powers to unravel the mysteries of what has led him to where he is today. "I feel imbued by this ambivalence of past and present... My purpose focused on time and memory has now retrieved its roots in a childhood preoccupied by the discovery of the past... The grandfather was like a monument and behind him were glimpses of the great-grandfather... a whole lineage weighing down the household with the traces they left."

Above "Still Life/Still Alive XII", 1998
h 75cm (29½in), w 55cm (21½in),
d 25cm (9½in).
Pâte de verre, lost-wax technique.
Leperlier likes using the rough
transparency of colourless pâte de
verre to re-create the excitement
and mystery of archaeological
discovery, often incorporating
hieroglyphs or the written word.

Left "Effets de la Mémoire"
(Effects of Memory), 2000:
h 25cm (9½in), w 25.5cm (10in),
l 26cm (10½in).
Pâte de verre, lost-wax technique.
In a quest to create dreamlike
imagery Leperlier combines
disparate subject matter, in the
form of densely packed vessel
decoration, or as part of his
sculptural narrative.

Libenský & Brychtová

STANISLAV LIBENSKÝ BORN 1921, SEZEMICE, CZECHOSLOVAKIA NATIONALITY CZECH

JAROSLAVA BRYCHTOVÁ BORN 1924, ZELEZNÝ BROD, CZECHOSLOVAKIA NATIONALITY CZECH

Below "St Wenceslas Chapel", 1964–69.
h700cm (275in), w120cm (47in).
Layered glass. The stained-glass
window creates its own Modernist light
show in contrast with the traditional
effects elsewhere in the cathedral.

Stanislav Libenský and Jaroslava Brychtová first collaborated on a glass-related project in 1956. At the time Libenský was principal at the *Glasfachschule* (Specialized School for Glass-making) in Zelezný Brod and Brychtová headed the Department of Architectural Glass at the Zelezný Brod glass factory (where she worked from 1950 to 1984). The project was a cast-glass bowl in the form of a girl's head with a downcast gaze. Libenský had done a simple sketch and Brychtová asked whether she might use this for a glass object. The pair married in 1963, and their extraordinary working relationship has continued throughout their lives. Although they began their collaboration at a time when Czechoslovakia was under totalitarian rule, they were fortunate in that the state required those working in the decorative arts to design wares that would appeal to an international audience. To some extent this enabled artists to travel and establish contact with the outside world.

In 1937 Libenský began his training in glass at the Specialized School for Glass-making in Nový Bor, transferring a year later to the school at Zelezný Brod after Nazi Germany occupied the Sudetenland. Forced to move from there too, he was accepted at the Prague Academy of Applied Arts, graduating in 1944. He then moved to northern Bohemia, the heartland of the Czech glass industry, where he has spent most of his working life. From 1945 to 1948 he produced a series of designs, some based on religious themes and Renaissance art, on thin-walled blown vessels with linear etching coloured with transparent enamels; these rank among his most exquisite work.

In 1948 he returned as a student to the Prague Academy to study under Josef Kaplický, who had been an avant-garde artist before World War II. Kaplický's glass programme kindled enthusiasm for glass as an art form, and Libenský responded eagerly to the call for a new language in glass. Eventually he became professor of glass art at the Academy in 1963. Under his inspired direction generations of glass artists have graduated, and the modern Czech language of monumental glass-casting owes an enormous debt to his teachings and to his life with Jaroslava Brychtová.

Brychtová came from an artistic background. Her mother established a textile-weaving workshop and her father co-founded the Specialized School for Glass-making at Zelezný Brod in 1920. She too studied at the Prague Academy of Applied Arts; her education was interrupted by the war, but she finished it afterwards specializing in sculpture. During the war she experimented with the fusing of glass frit in plaster moulds, making a charming series of naive small relief pieces. At the Prague Academy she continued her experiments, pouring molten glass into a mould. When

Above "Blue Concretion", 1966–67.
h 180cm (71in), w 200cm (79in).
Twelve blue cast-glass panels,
Montreal Exposition 1967.
This large wall piece was named
thus by Brychtová's younger
son because it reminded him
of geological concretions in
his collection of stones.

Below "Metamorphose IV", 1984.
h 65cm (25¼in), w 35cm (13¾in).
Cast glass. Cubes, spheres,
and geometric shapes generally,
influenced by a strong shared
interest in Cubist art, are the
main ingredients of the powerful
sculptural language in cast glass
invented by these artists.

she began working at the Zelezný Brod glassworks, an interest in the three-dimensional possibilities of glass in sculpture and architecture, and in the optical qualities of glass, led her to create a department known as the Centre for Architectural Glass. A store of technical knowledge was built up and used, both in individual artistic pieces and in large-scale commissions which came shortly after the establishment of the centre.

When Libenský and Brychtová met, their complementary interests opened up a huge range of artistic possibilities, and by 1957 they had begun to collaborate on interior design commissions. Their joint efforts attracted great interest, and in 1958 they won a public competition to make a glass wall for the Czech Pavilion at the 1958 Brussels World Expo. A concrete wall was inlaid with a series of jewel-like cast-glass relief sculptures of animals with a prehistoric flavour to them. "Zoomorphic Stones", as it was called, was awarded a Grand Prix, and in 1960 was redesigned and replicated in a version installed in the United Nations building in Geneva. Their work was also exhibited at the Corning Museum of Glass in the USA in 1959 and at the XII Triennale in Milan in 1960.

Libenský and Brychtová's work was increasingly in demand, whether in public buildings in Czechoslovakia, for World Fairs, or for Czech embassies abroad. Among their most celebrated works from the 1960s are windows made of cast-glass sections in the St Wenceslas Chapel in Prague's St Vitus cathedral. As yet, however, they were more interested in painterly effects than in the optical qualities of glass, although experiments had begun in painting on glass of varying thicknesses. One of the finest examples of this phase of their work was a series of 13 panels exhibited at the VIII Biennale do São Paulo in Brazil in 1966.

Their shared interest in Cubist art was to make them explore the optical effects of transparent volumetrics in glass, which over the years they

turned into their personal art form. This form of abstraction in glass and its application to monumental casting is their invention. The earliest monumental works in which optical effects became the main artistic ingredient were three pieces for the Czechoslovak Pavilion at Expo '67 in Montreal: "Blue Concretion", "Sun of Centuries", and "Big Conus". During this brief period of relative freedom in Czechoslovakia before the uprising of 1968, Libenský and Brychtová travelled and met other glass artists, some of whom became friends for life. Despite the repression of the years before 1989, when the régime finally collapsed, the influence of the Libenskýs on the international glass scene was tremendous.

Some of their experimentation with optical effects and with the idea of merging geometric shapes, such as "Sphere in a Cube", was carried out on small sculptures made during the 1970s, mostly in colourless glass. At this time a generation of Czech artists in glass was obsessed by the artistic effects of optical cutting, producing sculpture that was too often cold, mechanical, and formulaic. The Libenskýs' style of shaping glass in new ways and of creating inner space through optical effects was charged with drama and emotion. They created space within the glass mass that had never before been imagined, making hollow spaces on the rear side of the glass, thus introducing a whole new range of tonalities.

The most spectacular of their colourless pieces was "River of Life", a sculpture measuring 22m (72ft) in length, the central piece for the Czech Pavilion at the Osaka World Expo in 1970. Though expected to be uncontroversial, it was full of symbolism suggesting a turbulent passage through life and a progression from happiness to misery. Quite aware of the references to political oppression, the authorities asked the artists to remove the offensive imagery. Until 1989, the Libenskýs had to fight to maintain their artistic integrity in the face of the régime's restrictions. It is to their credit that they managed to survive as artists and in Stanislav Libenský's case as the most free-spirited of educators as well.

It was only during the late 1980s that the Libenskýs felt free to begin working without artistic compromise. By this time world-famous, they retired from their jobs, to be welcomed with open arms by glass enthusiasts all over the world. Dale Chihuly had called their installation at Montreal in 1967, "the most impressive thing that I had ever seen". Work of theirs had been included in the landmark show *New Glass 1979* at the Corning

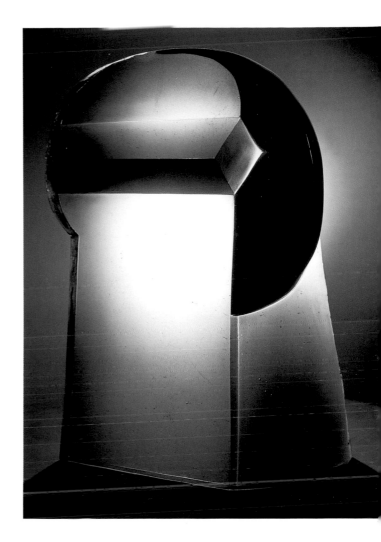

Above "Head V (With Square Eye)", 1996. h 50cm (19¾in), w 37cm (14½in), d 24cm (9½in). Cast glass. Though essentially abstract, much of the imagery created by Libenský and Brychtová has strong figurative associations. Their brand of Cubism involves a clearly human element.

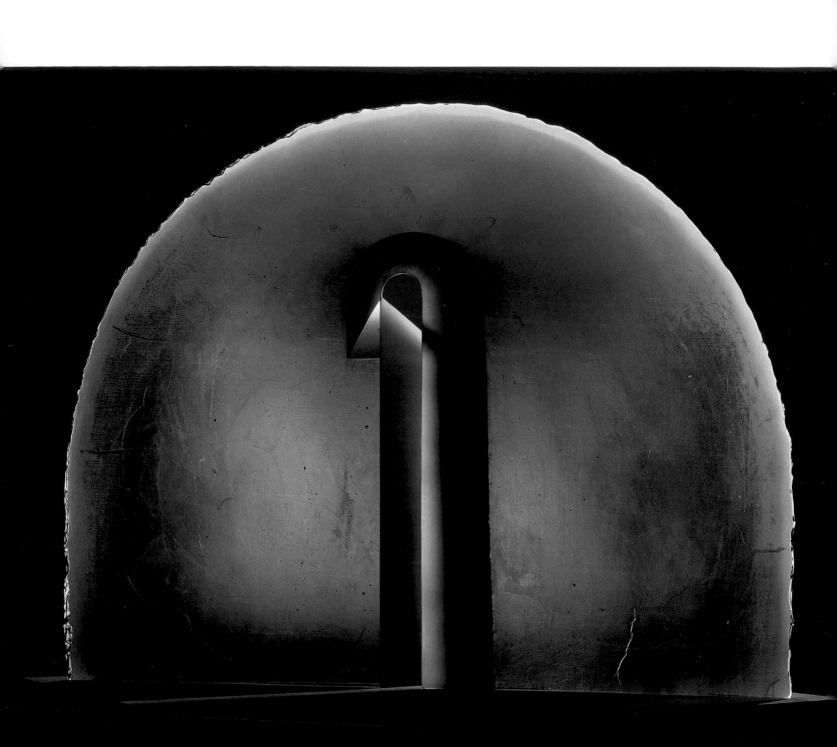

Above "Arcus I", 1990–91.
h 75cm (29½in), w 100cm (39in),
d 11cm (4¼in).
Cast glass. Libenský and Brychtová
are able to vary the thickness of their
cast glass, controlling luminosity,
so that it is dense or translucent.

Right "Spaces I, II & III", 1991–92.
h 85cm (33in), d 85cm (33in).
Cast glass, metal base.
Perhaps the area of greatest
innovation in their work has been
the monumental scale of cast
glass that the artists have chosen.

Museum of Glass and later purchased for the museum collection. In 1980 they received a major commission from the Corning Museum and produced "Meteor, Flower, Bird", a huge installation in colourless glass that is a permanent feature of the museum entrance.

By the mid-1980s they had built their own studio, and, gradually, with the freedom to invent and create exactly as they wished, colour came into their work. The result was a series of sumptuous sculptures in coloured glass in which they explored more than ever before the possibilities of inner volume within their preferred idiom of abstract geometry. After 30 years of technical and artistic probing into glass, they were able to be wholly emotive with inner light and outer form. The imagery was now uncompromisingly their own. Some pieces, such as "Cross Composition", "Red in Space", and "Diagonal", were geometry with psychological implications; others, such as the series of "Heads", "Coronation", "Queen", and "Empty Throne", were accessible via a more figurative route, although the language of geometry remained the same.

In 1994 the Corning Museum of Glass celebrated the 40-year collaboration of Libenský and Brychtová with an important exhibition of 200 works and praised them as a "transcendent creative force".

Below "Horizon", 1992.
h 85cm (33⅜in), w 108cm (42½in),
d 25cm (9⅞in).
Cast glass, metal base. Red is a colour that Libenský and Brychtová have often used in their work with dramatic effect. Their technical control is such that they can produce reds ranging from the pale glimmer of dawn to the rich glow of sunset.

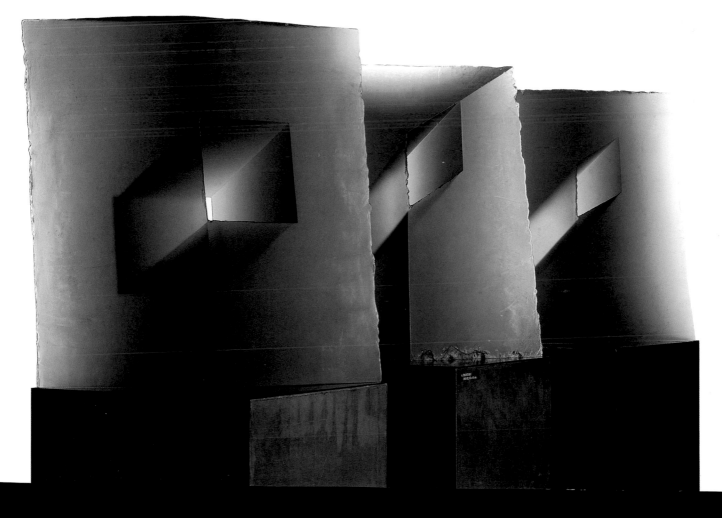

Marvin Lipofsky

BORN 1938, BARRINGTON, ILLINOIS, USA NATIONALITY AMERICAN

Above *"California Loop Series 1970",
1970. h 28cm (11in), w 51cm (20in),
d 33cm (13in).
Blown glass and paint and rayon
flocking. In 1970, when this piece
was made, such free forms in
glass were still a novelty and rarely
showed such a degree of control
over colour and form.*

Marvin Lipofsky has earned himself something of a reputation as the "bad boy" of glass. Prickly, abrasive, and single-minded, he has been something of a trooper in the glass world and omnipresent on the international studio glass scene from its beginning. He is a passionate member of the international glass community; a merciless critic on occasion. From 1964 to 1972 he was assistant professor in the Department of Design at the University of Berkeley in California, where his influence was significant. Before that he had enrolled in the graduate programme at the University of Wisconsin in Madison to pursue a Master's degree in sculpture. No sculpture student there at the time failed to be captivated by Harvey Littleton's brand new glass programme.

Lipofsky is an inveterate traveller, the itinerant glass journeyman *par excellence*, and has made glass in Bulgaria, California, China, the Czech Republic, Finland, Italy, Mexico, Poland, Seattle, Serbia, and the Soviet Union. Travelling for Lipofsky means seeking out glass studios that have their own idiosyncrasies and their own specialities. He is motivated by the dynamics of each new team he encounters and allows the dynamics to influence his artistic creation. At Fratelli Toso in Venice, for example, the speciality is juxtaposing different-coloured canes and using them to achieve coloured stripes in blown glass. This is a difficult technique: it would have been virtually impossible for Lipofsky to combine orange, black, white, and cerise stripes in a work unless it had been made at Fratelli Toso. He fashions his own wooden tools from hardwood, with which he shapes and controls the hot glass. Much thought goes into the design of the tools, which are in a sense an extension of his hands, allowing him to work the red-hot surface of the glass as if it were clay. Lipofsky uses the tools as a painter might use different brushes; each tool leaves a different impression on the glass. He has an extensive tool kit made to exploit the possibilities of each new location he visits.

The most remarkable feature of Lipofsky's work is the way in which he has remained true to his first artistic impulses. It is commonplace in the art world to work through an idea and then move on to something new. Artists feel the need to break new ground and reach for new horizons.

Lipofsky's strength lies in his commitment to a single aesthetic throughout his career. His art is about the visceral and the gestural. The forms are inspired by internal organs, intestines, breasts, stomachs, brains; their colourful, mottled, crumpled, broken shapes an expression of turbulence and restlessness. The pieces are blown, sometimes freeblown and sometimes blown into a mould. Much more than any perfect version of the bubble form could do, his tortured shapes contain the memory of blowing, of filling a form with human breath, of the gestures and hard labour of wielding a blowpipe. Lipofsky's art, whether intentionally or not, records perhaps more forcefully than that of any other artist the physical labours of the glass-blowing process. Sometimes Lipofsky blows his own forms, but he also likes availing himself of the skills of others.

When his forms fully enclose the space within, the viewer's attention is focused on outer surface. Often, however, the bubble is broken open. The shards thus created are sometimes grouped together to form a sculptural composition. These open forms lead one inside the bubble and the space within takes on a physical (sculptural) presence. There is an intentional textural contrast between matt satin outer surfaces and shiny interior. The effect is organic and visceral, outer skin and inner gut. There is a definite allusion to the human body, tough on the outside, soft and vulnerable inside. None of the forms is symmetrical: Lipofsky is a master of controlled asymmetry. Every dent or fold has a rhythmic quality to it. His misshapen bubbles are carefully controlled shapes, born of the

Above "IGS II Series 1985–93 #4", 1985–93. h 37cm (14½in), w 56cm (22in), d 46cm (18in).
Glass blown into unique wooden mould forms made by artist; cut, ground, sand-blasted, acid-polished. Blown in Nový Bor, CZ. Made with glass-master Stefan Stefko and a team; finished by the artist in his studio.

Left "Pilchuck Series 1988–99 #25", 1988–99. h 28cm (11in), w 61cm (24in), d 36cm (14in).
Glass blown into unique wooden mould forms made by the artist; cut, ground, sandblasted, and acid-polished.

"hot gospelling" 1960s American glass tradition. Unlike many of his peers, Lipofsky has used the basic idea of a misshapen bubble as something to elaborate on and impose his will upon, and he has spent his whole life doing that. He has interpreted the bubble as no other artist has done, making it the focal centre of his artistic world. Part of the attraction in working the bubble is the unexpected and the unforeseeable that can add to artistic content in the glass-blowing process. It is obvious that Lipofsky enjoys the unpredictable and gives it room in his work; but however informal a piece may look, the final version is an exercise in control. The accidents of glass-blowing are never left in their raw state.

Lipofsky is a contemporary of the American potter Peter Voulkos, and both artists were influenced by the bold language of American abstract expressionism. Lipofsky more than any other contemporary glass artist has captured the nerve of abstract expressionism in glass. Voulkos and the group of potters around him revolutionized the look of clay forms and their work has only recently been fully appreciated for its bold eccentricity of shape and painterly decoration. As a young man living on the West Coast during the 1960s Lipofsky was also subject to psychedelic imagery as seen in hot-rod (automobile) design, surfboard design, and the extravagantly colourful graphic freedom of record sleeves of the period. Both as a student and as a young teacher Lipofsky was in at the birth of the studio glass movement and revelled in the powerful feeling of discovery and freedom that this allowed.

Lipofsky enjoys colour and pattern and knows how to control them. He avails himself of many of the possibilities that coloured glass techniques can offer, such as mottling or stripes. His colour palette is bright and cheerful and makes much use of primary colours, to which a full array of sharp supplementary colours add tonal variety. Cold work (either the cutting and polishing of edges or the sandblasting of surfaces) is used to add textural effect. Cold cutting is done in his California studio. Pieces made elsewhere are transported back there, and during the cutting process are transformed into meaningful sculpture. In contrast to the theatre of the hot workshop, the cutting is practised in a more reflective and isolated environment. The rough blown shapes suggest where and how to cut, and in the cutting process a piece is, as it were,

Below "Group Taiwan 1995 #3", 1995. h 23cm (9in), w 34cm (13¾in). Glass blown into unique wooden mould forms made by the artist; cut, ground, sandblasted, and acid-polished. Blown at Royal Li Land Art Glass, Hsinchu, China, with help from Harvard Tsai; finished by the artist in his studio.

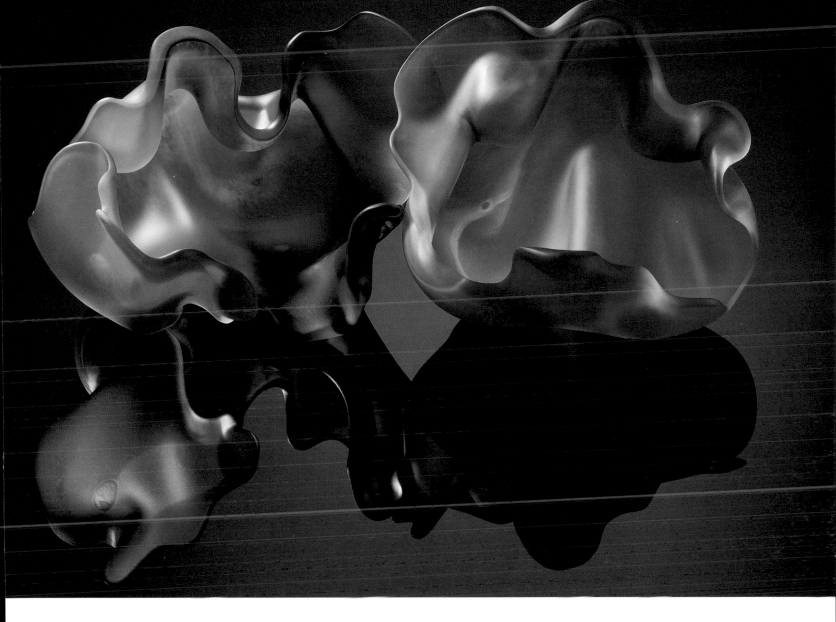

landscaped. Further textural refinements are achieved by other cold processes such as acid etching and sandblasting. Acid etching gives a smooth silky finish; sandblasting can create a rougher texture. Internal areas are sometimes fire-polished to make them glisten and shine.

The scale of Lipofsky's work can vary from small to medium-sized pieces, but he has to date not been tempted to produce larger-scale works. His organic shapes may look casual or "off the cuff"; in fact they contain huge knowledge of numerous glass-making techniques. In discovering glass Lipofsky found a material ideally suited to his version of abstract expressionism in which organic shapes become abstract art.

Harvey Littleton

BORN 1922, CORNING, NEW YORK, USA NATIONALITY AMERICAN

Above "Vase, Segmented Form:
Exploded Vase", 1964.
h 28cm (11in), w 12.5cm (5in),
d 12.5cm (5in).
*Glass from #475 marbles, manganese
oxide. This vase is typical of Littleton's
early anthropomorphic forms that
relate to the gestural expressions
in glass of Erwin Eisch, whom he
had met two years earlier.*

Reference is made in this book's introductory essay to Harvey Littleton's role in the studio glass movement as its most important pioneer. As a glass artist his appetite for technical experimentation has been a leitmotif, all the more remarkable because of his famous quip "Technique is cheap", made in the early days of his career.

Littleton has been a potter, a writer, a teacher, a sculptor, an inventor, a glass-maker, and an entrepreneur. His first love has perhaps always been glass, reflecting his background – his father was director of research for Corning Glassworks. As a student at the Cranbrook Academy of Art in Michigan in the late 1930s, he showed a preference for figurative sculpture. When he made his first work in glass, in 1946, it was a small cast-glass torso that he had first cast in bisque.

From the end of the 1950s Littleton was at the forefront of the search for a way to move glass away from its industrial environment. Experimentation, both technical and artistic, concentrated on hot glass creation. In the 1960s Littleton made his "Prunted, Imploded and Exploded Forms", in which the traditional symmetry of glass-blowing was challenged. All the historical rules of glass-blowing were broken by Littleton and his students. As well as blowing air into the glass bubble, for example, they sucked air out of it, collapsing it in the process; they re-invented the blowpipe as a means of using human breath to create art. This early body of work is among the most expressive that Littleton ever made.

By the end of the 1960s a reaction to this way of creating glass had set in. Littleton began a series of pieces in which blown tubes or columns, sliced off at top and bottom, were allowed to slump. Sometimes the glass was twisted while still hot. Cold techniques became more important, and the slumped or twisted forms were finished with cutting and polishing. The forms were grouped together and mounted on bases. For a decade he experimented with variations in colour and form around this idea, as the pieces became larger, heavier, more technically challenging. A series followed in which strips of plate glass were bent and combined with pieces slumped or worked in the furnace, all of them assembled as

Below "Blue Crown", 1985, '88, & '89.
h 78cm (30¾in), w 55cm (21⅝in),
d 55cm (21⅝in).
*Blown barium/potash glass with multiple
cased overlays of Kugler colours.*

Left "Four Seasons", 1977.
h 14cm (5½in), w 35cm (13¾in),
d 30.5cm (12in).
*Blown glass. The various half-
spheres of glass are seen as
concentric rings of colour so
that form is translated into image.*

sculpture. Loops and U-forms, straight lines and curves are grouped together in an endless series of visual and intellectual games.

Since the 1970s Littleton has been experimenting with *intaglio* printing from glass plates. Printing from glass plates allows unique colour effects as glass does not react to colour in the way that metals do. Littleton's prints are about colour: "Their origin is in glass and in the manipulation of color. My best prints are built as a sculptor builds sculpture." His glass-printing studio in North Carolina, near the Penland School of Art, attracts visiting artists from all over the world to experiment with this technique, and Littleton has built up an impressive collection of their work. His home and his studio are open to the glass-making and -collecting community: a visit to the Littleton household has become a kind of pilgrimage.

Mária Lugossy

BORN 1950, BUDAPEST, HUNGARY NATIONALITY HUNGARIAN

Mária Lugossy did both her undergraduate and graduate studies at the Hungarian Academy of Applied Arts in Budapest (1969–75), and she has taught there throughout her career. She works as an independent artist in glass, sometimes with her husband, Zoltán Bohus, but usually on her own. She mainly works in Hungary, but has travelled widely, lecturing, teaching, and on occasion making glass in France, Switzerland, Germany, the Czech Republic, England, and the United States. She is a sculptor whose principal medium is cast glass. Lugossy finds glass the ideal material for expressing her thoughts about genesis, about the divine and the spiritual. She has set up a dialogue between light and glass that encapsulates her vision of creation, seeing the optical phenomena that glass can create as in some way parallel to natural phenomena: she uses the one to try to explain the other.

According to myth, when the world came into being light was created out of darkness. Lugossy's glass sculpture attempts to re-create that genesis. There is a sense in her work of order being both inherent in

Above "Cosmic Dream", 1990. w.24cm (9⅜in), diam. 65cm (25⅝in). *Laminated grey glass sheets, cut, sandblasted, polished, smaller green lens included. The title is a clue to the imagined landscape in the artist's mind.*

chaos and created out of it. In the process of creation life forms emerged out of primeval mass, just as they do in Lugossy's work, in which often the human torso appears to be chiselled out of a glass block, or rather, not so much chiselled as revealed. It seems as if the torso was always inherent in the glass mass, just as a sculpture might be said always to have existed within a marble block, waiting for the sculptor to unlock it. The torsos are truncated and faceless. In her later work faces eventually appear, but they are lifeless or asleep, as if belonging to a time when life has not yet begun. When later on in her career feeling is expressed, it is a feeling of the suffering and pain that can accompany creation.

The glass Lugossy uses is monochrome, sometimes tinted green, sometimes white, and sometimes dark. The darker hues reject light, the lighter ones allow the light into dark recesses. Transition from dark into light, from chaos into order, from mass into form is the basic subject matter. Sometimes (mostly early in her career), she is concerned only with land mass, the transformation of primeval slime into ice, rock, and finally vegetation.

Lugossy often uses materials other than glass in her work, notably metal, bronze, or cast iron. The piece "Victims of All Times" (1992) is composed of ten separate elements arranged in a row. The first two are simple blocks of laminated grey glass sheets. In the third the glass is "broken open" to reveal an embryonic form. As the line progresses a more identifiable human form emerges, first wrought out of glass but eventually cast entirely from bronze. The change of material symbolizes the process of evolution. The progression in this piece also mirrors Lugossy's own artistic evolution. At the beginning of her career she experimented with the way that glass could trap and hold light. Her thinking evolved along with her casting technique, allowing her to give free rein to more complex thoughts about creation, pain, suffering, divinity, and the transcendental.

Lugossy has created a body of work that amounts to her personal credo, her vision of how this world came to be and the demands that it makes of us. It began with concerns about genesis and has progressed along a path that traces the evolution of the human condition. Seen as a whole it is a forceful artistic statement, full of emotion, intensely personal, but also urgently demanding a response from the viewer.

Above "Double Form", 1999. h 42cm (16½in), w 23cm (9in), l 55cm (21½in).
Laminated green and grey glass sheets, cut, sandblasted, polished. The two forms, their genders clearly suggested, are both divided and a whole, close but distant.

Opposite "Tribute To Béla Bartók", 1996. h 125cm (49in), w 125cm (49in), l 120cm (47in). Laminated green glass sheets, cut, sand-blasted, set into limestone block. Inspired by the music of Bartók, Lugossy has created a luminous, semi-reflective glass mass that lies like a deep pool in its limestone bed.

Finn Lynggaard

BORN 1930, BALLING, DENMARK NATIONALITY DANISH

Below *"Banana Chair", 1996.*
h.28cm(11in).
Collage with free-blown banana
form, coloured rods, marble,
granite, commercial plate glass,
gilt wooden base. This lighthearted
piece of sculpture is characteristic
of Lynggaard's good-natured
disposition both as an artist and
as a promoter of art in glass.

Although Finn Lynggaard has spent half his life working as a potter, his name is synonymous with the development of contemporary studio glass in northern Europe and above all in his native Denmark; he is known as the "grand old man" of European glass. Apart from his own work his great contribution has been his encouragement of others and his vision in creating the glass museum at Ebeltoft, Denmark. The driving idea behind this was Lynggaard's belief that artists themselves should decide which works they were represented by in museums. He persuaded colleagues to donate or loan works, which could be changed or added to so that the collection would evolve. The museum opened in 1986 with approximately 500 objects by 300 artists from 28 countries.

As professor of ceramics and glass at the School of Applied Arts in Copenhagen Lynggaard was very much involved in the lives of young craftspeople. An American ceramics student of his, Joel Philip Myers, who had moved back to the United States in the 1950s, wrote telling Lynggaard about his "fascinating" experiences in glass-blowing. Yet it was not until years later, in the early 1970s, that Lynggaard began to understand that fascination. His first contact with glass was memorable: "I dipped a pipe in the hot glass and – on drawing it out of the furnace – pulled a long cord of glass and turned in such an elegant way that I twisted the hot cord around my neck. It left a burn and a scar which will forever remind me of my first direct encounter with glass."

That first encounter turned into a passionate and on-going affair. As a potter, used to the slow process of turning clay into ceramic, Lynggaard was excited by the immediacy of hot glass. In the early stages he had to invent all the equipment necessary, from furnace to glass cullet, which initially consisted of "beer bottles and whatever junk glass I could get hold of". By May 1972 he had made enough glass, using his home-made equipment, to exhibit it (largely in a spirit of experimentation) at Den Permanente museum in Copenhagen, then the centre of Danish design and handicraft. Over the years he learned enough about furnace construction and proper glass supplies to work in a more professional

manner, although it was still to be a long time before he could earn a living as a glass-maker rather than as a potter. He finally decided to devote himself entirely to glass in 1974.

At the beginning of his professional career in glass Lynggaard made colourful blown glass vessels (assisted, from 1984 to 1993, by a student from Japan). The vases and bowls from his studio workshops were typically Scandinavian, traditional shapes decorated with coloured speckling, a sprinkling of background colour with a *craquelé* effect, and simple lip wraps. Later the decoration included loosely drawn insects and flowers. During the 1990s Lynggaard experimented with small cast-glass and blown-glass sculptural compositions combining figural and architectural elements. In some, portrait heads with long bulbous noses are set on top of classical columns; in others, an arch frames a small set piece with figures and symbols. There is also a series in which the chair is the central theme. Lynggaard has a light touch. While making no great demands on the viewer, his work is good-natured and pleasant.

Ivan Mareš

BORN 1956, DECÍN, CZECHOSLOVAKIA NATIONALITY CZECH

Like so many of his peers Ivan Mareš began his glass education at
the Specialized School for Glass-making in Kamenický Senov and
then went on to the Academy of Applied Arts in Prague to study under
Professor Stanislav Libenský, graduating in 1983. The emphasis at this
time was on creating sculpture in cast glass that was individual in style
and strong in form. A distinctive trend in Czech glass emerged during the
1980s as a result of Libenský's teaching, and Mareš was one of the most
talented of his students. Mareš found his identity in glass early on and
has built steadily on it, producing large, technically challenging sculptures
in cast glass that have a stark quality about them. Nature is a source of
inspiration for him, but he does not attempt to copy it.

Mareš' sculptures tend to be large-scale, seeming larger than they
actually are because of the simplicity of their form. They stand 80–90cm
(31–35in) tall and are architectural in feel. As in much Czech cast glass of
the 1980s, colour was limited by availability, used as an enhancement
rather than a colourist statement of any kind. Mareš chooses his colours
carefully, but colour has never been of primary importance. Rather, his
work is about form, about defining both surface and hollow space. The
empty spaces in his work are perhaps most important of all. In creating
his forms he defines the nature of emptiness. His forms are muscular
and energetic yet have a touching fragility. Pride of stance is tempered
by refinement. Strong lines are softened by an attention to detail that
seems structural rather than ornamental.

A distinctive trait of Czech cast-glass artists who studied under Libenský
is the way they play with the thickness of cast glass, allowing it to be
denser in some areas than in others. This variation of density makes for
an inner life, as if light were being generated inside the glass mass,
flooding parts of it while denying any light to other parts. The effect is
theatrical and mysterious and achievable in no material other than glass.
Mareš uses this technical trick with great skill.

One of Mareš' best-known works is "Rope Egg" (1997), a piece that
bears all the signature qualities of this artist. It is monumental and yet

Above "Imago", 1988.
h 85cm (33⅜in), w 30cm (11⅞in),
d 27cm (10⅝in).
*Mould-melted crystal and green
plumbiem glass partly cut and
polished. Mareš created his own
individual style in glass early on
in his career.*

Right "Bud", 1999.
h 120cm (47in), w 80cm (31⅞in),
d 18cm (7in).
*Mould-melted glass with
structure partly cut and polished.*

Above "Rope Egg", 1997.
h 113cm (44⅜in).
Mould-melted crystal plumbiem glass.
This giant egg, a virtuoso technical
performance, is conceptually one
of Mareš' most successful works.

delicate. More than a metre (3ft 3in) tall, the sculpture is best described as an egg form composed of rope – there is a knitted feel to it even though it is made of glass. To achieve the effect of rope a mould has to be made that is carefully worked so that the glass will pick up or "remember" every detail with which it comes into contact. To create such a mould and to produce from it a sculpture such as "Rope Egg", without its breaking into a thousand pieces, is in itself a kind of art. Preparing the mould is the most important part of the process in this type of sculpture and inherent in it is a perfect understanding of how glass will behave during the heating and cooling processes.

Learning to understand the behaviour of glass has allowed Mareš to make demands of it that very few other artists could hope to do. He has achieved a new language in monumental cast glass that allows him to suggest textures as complex and detailed as rope or hay, and uses this refined detail to compose a kind of glass sculpture that is as raw as something made of a more solid substance. For him glass is an adventure. What is already known about it serves merely as a point of departure into unknown territory.

Dante Marioni

BORN 1964, MILL VALLEY, CALIFORNIA, USA NATIONALITY AMERICAN

Above *"Whopper Vases", 1987.*
Greatest h 60 cm (23¾ in).
Blown glass. In this group of
vases Marioni provides the viewer
with an eyeful of colour on perfectly
formed shapes that show off
his great blowing skills.

Dante Marioni comes from a family of artists: both his uncles are artists and his father, Paul Marioni, is a prominent glass-maker. Paul Marioni belonged to the first generation of American "hot gospellers" – that group of glass artists working during the 1960s when the aim was to "let it all hang out", to "blow glass for peace", to dispense with formality and tradition. Dante was brought up near San Francisco, a city that in his formative years was a centre of cultural change in the United States. Yet he initially had no intention of being an artist. "When I started working in glass at age 15, I had no interest in being an artist or a craftsperson. But then I saw Ben Moore work. For the first time I saw someone make something round, on center, and perfect. In the early 1980s most people were still making goopy, amorphous things. I also saw how much my dad

and his friends had to struggle to make a career out of glass, and I had no intention of trying to do that until I saw Ben work and how different glass-blowing could be. A year later I saw the Italian glass master Lino Tagliapietra work and there was no turning back."

Ben Moore, a pupil of Dale Chihuly's at Rhode Island School of Design, had visited Venice several times during the 1970s and had, like Chihuly, been seduced by the Italian way of working in a team. This was far removed from the highly individual styles pioneered by the first wave of American studio glass artists who were breaking new ground during the 1960s and 1970s. Dante Marioni, reacting in the normal way a teenager reacts to the fashions of a preceding generation, wanted nothing to do with experimental aesthetics. His view of life was not bohemian, like that of many of his father's contemporaries. He did not intend to live in a garret and had he not ended up working in glass, he wanted to become a famous baseball player or motorcycle racer. To him the experimental shapes created by artists of his father's generation looked formless and ugly. Lino Tagliapietra first came to teach the Venetian way of making glass to students at Pilchuck Glass School in Seattle in 1979. It was a surprise for all of them and many, like Marioni, became instant converts.

During the 20 years since his first "conversion", Dante Marioni has come a long way. He is now one of the leading artists in glass of his generation, with work in many public collections, including that of the White House. He exhibits glass all over the world and also teaches and gives demonstrations. He is generous about passing on knowledge. Venetian though it be in inspiration and execution, this is now the favourite way of making glass in the United States. Seattle, where Pilchuck Glass School is situated, where Dale Chihuly lives, and where so many glass artists have settled, has become known as "the Venice of the West". Marioni has both learned and taught there. But American glass-makers gain experience in a far more liberal artistic environment than Italian *maestri*. Whereas Italians are likely to begin by sweeping the factory floor, young American glass-makers are educated from the beginning to think and work as artists; being apprenticed in a glass factory and studying glass at an American university are very different experiences. There is excitement about studying or working as a glass artist in Seattle, as is reflected in a comment made to Dante Marioni, which he cites: "Somebody came into my studio and said that he was told that being a glass-blower and

moving to Seattle was like being an abstract expressionist in the 1950s and moving to New York. I thought that was a flattering analogy."

Marioni has mastered the art of Venetian glass-making as few Venetians have: he is a true *maestro*, the title accorded in Murano to those with exceptional glass-making skills. His way of working in glass is a combination of American and Venetian, the latter in that he works as the leading member of a team, the former in that the inspiration comes from him – the artist and the craftsman combined in one person. He is a creator rather than an interpreter of other people's designs. Yet his craftsmanship is astounding, born of a natural talent and years of experience. Glass-making skills combine athleticism and body language that, in their way, can be as complicated and as artistic as ballet. The memory of Marioni's elegant body language and the fluidity of his gestures are there in his perfect elongated glass shapes. Every curve is perfectly executed, every lip wrap applied with utter precision. In the preparatory stages of his "performances in glass" he rehearses on his own with a small-scale version of the piece and, when the idea is fully developed, goes on to make the final large-scale version with a team of workers that varies according to the size and complexity of the piece. In the rehearsal stage the piece is blown again and again in clear glass to perfect its shape.

When Marioni is convinced that he has completely mastered the form that is in his mind, he begins to think about colour. He likes bold colours best and chooses sharply contrasting combinations that tend to set one's visual tastebuds on edge. The combinations are either unexpected and original, such as chartreuse and yellow, or so obvious as to be startling, as when he combines strong reds and yellows.

Marioni likes technical challenge and among the Venetian techniques he has chosen for his work is one of the most complicated of all, the *occhi* technique. The Italian word *occhi* means "eyes", and here describes a complex way of making glass by fusing what are in essence mosaic sections, each of which looks like an eye, consisting of a clear "window" framed by colour. The mosaic pieces are pre-prepared and then picked up on a hot gather of glass so that they can be blown and shaped together with the glass bubble to which they have attached themselves. The finished mosaic pattern is luminous and jewel-like. When the technique was pioneered at Venini during the 1950s,

pieces were modest in scale. Marioni has succeeded in blowing them up to as much as 1m (3ft 3in) tall. Their over-size scale gives these pieces a sculptural importance.

The shapes are basically traditional Venetian shapes, but exaggerated and elongated to form a language that has become his personal style. These shapes often refer back to 17th- and 18th-century forms typical of the whole range of *façon de Venise* glass. Italian still-life painters in the 17th and 18th centuries loved to include glass in their compositions and Marioni's work also draws on the still-life tradition. In still-life painting mundane objects assume formality and artistic importance. In the same way, when Marioni arranges his vessel forms in groups of two or three, taking into consideration shape and colour, they become sculptural. Sometimes the pieces are placed so that they overlap, with the colour of one piece visible through another. Such juxtaposition also allows shapes to intermingle, forming a lively scenario of cylinders and curves. When not overlapping the pieces stand close together, suggesting almost human stances. Although each individual piece has a clearly designed form, the overall shape created by the group as a whole is of equal importance.

Above "Red With Yellow Group", 1999. Greatest h 97.5cm (38¾in). Blown glass. These classical shapes derive from Venetian glass history, but are elongated, adding extra elegance to already harmonious proportions.

Left "Red and Yellow Finestra" (detail), 2000. Greatest h 97.5cm (38¾in). Blown glass. The Italian word finestra (window) describes the technique used to break up solid colour, in this case by inserting a luminous pattern at the shoulder of the vases.

Opposite "Mosaic With White Dots", 1998. h 87.5cm (34¾in), diam. 20cm (7¾in). Fused murrine, blown glass.

Richard Marquis

BORN 1945, BUMBLEBEE, ARIZONA, USA NATIONALITY AMERICAN

Richard Marquis, one of the pioneers of the studio glass movement in the United States that started and grew rapidly in the 1960s, introduces a welcome note of relaxed humour into American glass. He was a student of Marvin Lipofsky at the University of California at Berkeley. At that time Harvey Littleton's half-serious quip that "technique is cheap" largely defined the American attitude to glass. Marquis was quick to realize that blowing misshapen bubbles in an attempt at free artistic expression in glass had its limitations, and a Fulbright scholarship in 1969 allowed him to travel to Venice, where he found work at the Venini factory, one of the leading glassworks on Murano. Dale Chihuly had been there the year before, the first American to be allowed into the secretive world of Venetian glass-making.

In Venice, apart from learning about blowing perfect bubbles, Marquis immersed himself in the complex skills of Venetian glass-making, including *latticino* and *murrine*. He was the first of the young Americans to absorb these traditional Venetian glass-making techniques and make

Below *"Hexagonal Bottles"*, *1969–70. Greatest h 11cm (4⅓in), w 7.5cm (3in), d 7cm (2¾in). Blown glass; filigrano and murrine techniques. Though made early on in his career, at the time of his first visit to Murano, these vessels show Marquis already to be a master of Venetian glass techniques.*

something entirely new out of them. Even the Italian glass-makers, usually deeply distrustful of innovation, applauded his imaginative and somewhat cheeky approach to their techniques. By adding his own playful aesthetics to ancient Venetian skills Marquis transformed them and created an instantly recognizable style full of American humour and a very personal brand of wit.

He is an incurable collector of American ephemeral kitsch, plastic ducks, toy motor cars, or rockets and the like, which he regularly includes in his assemblages, as in a piece called "Toothbrush propeller cup", where two toothbrushes are an airplane's landing gear. The icons of middle-class America, whether they be stars and stripes or hamburgers, make up a palette of symbols which he uses with intelligence and great humour. Found objects from his collection of junk or kitsch are frequently incorporated into his compositions. In one of his installation pieces, "Siesta Wall 1994", a wall is covered with plastic Walt Disney figures among which hang four open white-painted wooden boxes, each containing a piece of his work, in a contrast that is funny and effective.

Marquis uses a range of simple forms that are personal to him, the miniature teapot and a cup with a handle being among his favourites, sometimes on their own, sometimes incorporated into eccentric goblets

Above "Teapot Goblets", 1989–94. Greatest h 28cm (11in). Blown-glass forms; zanfirico technique. With their jumble of familiar shapes that have been rendered useless, these goblets take on the surreal character of a nonsense poem.

Below "Crazy Quilt Teapot", 1988. 00 h 15cm (6in). Blown glass, murrine.

as in his "teapot goblet" series of the 1980s. The teapot is traditionally a ceramic shape and Marquis' use of it reminds us of the fact that he, like fellow artist Marvin Lipofsky, was close to the California ceramics community of the 1960s and 1970s and was himself once a ceramics student. Potters such as Peter Voulkos, Robert Arneson, and Ron Nagle were busy both debunking tradition and turning clay into a contemporary art medium. Marquis was equally sacrilegious and serious, often incorporating rude words into superbly crafted pieces. His first experiment with the *murrine* technique was to make little glass tablets incorporating the word "fuck"; another *murrine* piece made at about the same time (c.1972) had the whole of the Lord's Prayer written on it. His work resembles a diary of random but connected funky thoughts, a kind of vivid daydream, with pieces arranged into fabricated assemblages. Marquis is recognized as one of the great American glass-blowers, but the playfully perverse streak in him will combine in a single piece the beautifully centred with the intentionally misshapen, perhaps a reference to the early beginnings of American studio glass, perhaps a ruse to divert attention away from the demanding craft skills he has perfected.

Despite his love of debunking Marquis always shows his respect and love of glass history, of which he has made a serious study. There are often references in his work to historical techniques (Roman, Venetian, German, and English) and glass-making traditions. A perfect example of this can be found in a series of pieces he calls "Marquiscarpias", a title that pays homage to the influential Venetian architect and designer Carlo Scarpa, who was one of the main designers at the Venini factory. The Marquiscarpias are canoe- or shallow bowl-shaped mosaic glass vessels ceremoniously placed above a mosaic glass (or *murrine*) knopped stem. "Glass objects have been made for thousands of years. I've been doing it for 30. Sometimes it seems like all the good ideas have been used up and the new things are either reflections, comments, adulations, or rip offs of old stuff... The [Marquiscarpias] are the result of my wonder and admiration of [ancient] Roman work and Carlo Scarpa's designs for Venini before World War II. I made [the Marquiscarpias] because I pay attention to history. I made them because I wanted to see how I would make them. I made them because to me it was the obvious thing to do."

Marquis veers from transparent and smooth to lumpy and opaque surfaces in his work. The *latticino* teapots and goblets are

Below "Blue Boy's Mamie", 1995.
h 58.5cm (23in), w 55cm (21¾in),
d 33cm (13in).
Blown glass, occhi technique, cast glass. Vessel forms often take on human characteristics in Marquis' work, which can be intentionally quizzical in nature, with component parts acting as clues to the bigger story.

smooth, his "lumpyware" teacups not at all so. Endlessly inventive, he has created an astonishing range of work, his technique evolving both with experience and with the availability of new kinds of glass.

Richard Marquis lives and works in the depths of the country in comparative isolation, although he is as friendly a person as one could hope to find. He fabricates his eccentricities in glass, removed from urban life yet totally aware of the outside world. He makes light of convention, and in so doing draws attention to it. For all its humour, his work is a serious comment on consumerism and waste in the United States, and combines a typical American irreverence with a great respect for traditional processes. "What some see as my irreverence toward glass," he says, "I see as a good balance of form, colour [and] decoration."

Richard Meitner

BORN 1949, PHILADELPHIA, PENNSYLVANIA, USA NATIONALITY AMERICAN

Above *Untitled, 1981.*
h 29cm (11¼in), diam. 19cm (7½in).
Blown glass vessel, red glass
stopper, paper, and string.
It is typical of Meitner to take
ordinary forms and materials
and transform them into objects
that challenge the imagination.

Richard Meitner makes nonsense poems – beautiful and serious nonsense poems in glass. He delivers his seemingly inexhaustible fund of slightly surreal ideas with great skill in and understanding of the medium in which he works. He is a thinker in glass, puzzling over the philosophy of science, considering unlikely relationships between the human and the animal worlds. A boyish sense of humour takes him to the edge of good taste, but never beyond it. For more than half his life he has lived in the Netherlands, where he moved after receiving his BA degree at the University of California in Berkeley. His studies continued at the Rietveld Akademie in Amsterdam, an institution with which he would be involved for nearly 30 years. He headed the glass department with Mieke Groot, finally making a break from it early in 2000. With his vast teaching experience at the Rietveld Akademie, there is no area of glass-making with which he is not familiar. It has been his choice as a maker, however, to stay with his first love, hot glass, which he has explored in many different ways and to which he has applied endless different finishes with the taste, flair, and inventive fantasy for which he has become known.

Meitner's work does not slot comfortably into any particular glass tradition, whether European or American. He is his own person, an American of European descent, a citizen of the world, somebody constantly re-inventing himself in his work. Meitner encourages his students to think in conceptual terms, as he does himself. He has an idea, a concept that resembles a vision inside his head, and then he sets about realizing it in glass. Every concept can be realized in different ways, and Meitner works through the various possibilities, exorcizing an idea by varying it until he feels the variations have been exhausted. Then he is ready to move on to something completely different.

For a time during the 1980s, after a visit to Japan, he experimented with the kimono shape, translating it into a blown-glass vessel and decorating it with enamel-painted symbols. In the 1990s he made a series of bottles in which animal or object forms were suspended. The idea came from the "ship in a bottle" tradition, but in Meitner's hand the elegantly shaped bottles became showcases for a weird and wonderful display of objects.

Above "Memfish", 1984.
h 90cm (35½in), w 29cm (11in),
d 20cm (7¾in).
*Blown glass, enamel-painted, with
painted wooden fishbone and table.
A tribute to the anti-functionalist
Italian Memphis design group.*

Meitner is himself a good glass-blower, but he is also content to use the skills of others. He understands and loves vessel form and enjoys the endless possibilities it offers as a three-dimensional canvas. He likes to puzzle his audience with visual effects that seem significant but may be no more than a decorative device. What he does is not exactly *trompe l'oeil*, but the eye has difficulty in grasping what is on offer visually and often cannot make sense of it, although there is a logic about it. In a recent

Above "Kimono Series", 1986.
h 38cm (15in), w 29cm (11½in),
d 12cm (4¾in).
*Blown glass, enamel-painted.
In a series of work in the mid-
1980s the kimono became a
kind of shaped canvas upon which
an assembly of imagined objects
took on a collective importance.*

piece, a bird with gold-leaf plumage perches above a bowl half-filled with water. It is not clear why and there is no chance that the bird will be able to drink even a single drop of the liquid. The two, bird and water, are part of the same scene, connected but apart. The symbolism is simple and the way of presenting it brilliant. There seems no rhyme or reason to the living pictures that this artist creates yet they make perfect sense as long as you do not try to apply the normal rules of logic to them.

In 1998 Richard Meitner was invited to do an exhibition at the Museum Boerhaave in Leiden, which has an esoteric collection of scientific devices and specimens, surgical instruments, and bizarre medical contraptions. Meitner is both amused and fascinated by the scientific mind and with this work recorded his reactions as an artist to the world of science. Called *Cold Fusion*, the exhibition comprised 18 pieces and was in part a tribute to his great-aunt Lise Meitner, the atomic scientist who conceived of nuclear fission. The work has a hybrid elegance that some find difficult. "Introspectometer" depicts a bespectacled figure bending over to con-template his navel. He looks at ease even though his exaggerated neck is stretched to its limits. His body and head are filled with a lime-green (life-sustaining?) fluid, but his U-shaped neck is empty, somehow relieving

Below "Progress II", 1999.
h 46cm (18in), w 58cm (22⅞in),
d 20cm (7⅞in).
Blown glass, enamelled glass.
There is a lot of double meaning
in Meitner's work. He has a soft
spot for the absurd and, while
having the greatest respect for
science, also wishes to draw
attention to the absurder side of
what is involved in scientific discovery.

the pressure on his brain. A long, pointed nose suggests curiosity, but its similarity to Pinocchio makes one doubt the character's reliability. One of his lenses is cloudy, and, half-blind, he fixes the good eye on a nonsensical measuring table. It is all clear, relevant, ridiculous. This sharp-witted jumble of paradoxes, full of absurdity and *double-entendre*, gives the piece its unmistakable Meitner factor.

In making this body of work Richard Meitner collaborated closely with Edwin Dieperink, a scientific glass-maker. As Meitner says, "Science is in the back of my mind as part of me", and this led him to experiment with the possibilities of working with borosilicate glass, a much harder substance than the soft glass generally used by artists. With Dieperink, Meitner came up with some beautiful new ideas about shaping, deforming, and reforming glass over burners.

Meitner manages to remain true to himself without being repetitive. His handling of glass stands out in an environment where artists struggle to get away from obvious effects. His ideas are always clear if one takes the trouble to tune to his wavelength, but there is nothing obvious about his artistic or technical approach. Each new piece is refreshing and after 30 years the flow of ideas is still endless. He does not mind being thought slightly élitist, even a touch perverse; and these qualities tempered by intelligence and humanity make him the irresistible artist that he is.

Klaus Moje

BORN 1936, HAMBURG, GERMANY NATIONALITY AUSTRALIAN

Above Untitled (Mosaic Bowl),
1975. h 4 cm (1⅜in), d 15 cm (6in).
Hesenglas canes, fused,
kiln-formed, and wheel-cut glass.
A comparatively monochrome
mosaic piece of classic shape
dating from early on in the
artist's career.

Klaus Moje started his training in glass aged 16 as a glass-cutter in the family workshop in Hamburg in 1952. His studies (1957–59) were at an industrial glass school, or *Fachschule*, the traditional training ground in Germany for those going into the glass industry. In 1961 he opened a glass studio with his then wife Isgard Moje-Wohlgemuth. It was not until 1975 that he exhibited the first of the mosaic glass pieces that would earn him a reputation as one of the finest glass artists of our time. Unlike so many of his contemporaries Moje was not attracted to glass-blowing, preferring the north European tradition of glass-cutting, treating glass more like hardstone. He first became interested in the possibilities of mosaic glass almost by chance when, at a glass supplier, he noticed the coloured rods destined to be sold to button and costume jewellery manufacturers and decided to buy some and experiment with them.

In 1982 Moje moved to Australia and founded the glass workshop at Canberra School of Art, where he taught until his retirement in 1992. The glass-making programme he developed combined blowing and kiln-forming, and the workshop became a place of international renown. His move to Australia had a profound effect on his imagery. In Germany he had been influenced by Bauhaus design; the colour and vastness of the Australian landscape and the intensity of light were unlike anything he had seen in Europe and are reflected in the colourful vessels created since his arrival in Australia. One of his hobbies is diving off the coast, and the colours and patterns of marine life are also an influence.

Like many of the best contemporary glass artists Moje has expanded his chosen technique farther than could ever have been imagined, and in so doing has also vastly broadened the artistic possibilities of mosaic glass fused and formed in a kiln. Kiln-formed glass requires sophisticated electric and electronic equipment and sensitive temperature controls. It is a hugely flexible process, in Moje's case one in which glass of different colours is fused together during a carefully controlled process of heating and cooling. Great knowledge of how glass behaves is required in order to master this technique, especially when different colours, each with its own recipe of chemical ingredients, are fused together in the same

mould at the same temperature. Coloured glass is cold-cut into strips and mosaic tesserae, or *murrine*, and arranged to form an abstract composition. These are transferred to a kiln, stacked into a mould or left resting on top of one. In the heat of the kiln they fuse together and, as the glass softens, slump into any hollow space designed to receive them. In order to visualize how the finished piece will look, it is necessary to understand the way in which the melting of colour layers into one another will affect the final outcome. Moje says: "In my early years I used to say that there was 20 per cent of the good Lord in my pieces. Today I would say it is closer to 3 to 5 per cent of the good Lord. There must be space for others now!" Once the work has been fired in the kiln and cooled, it is cut and polished, giving it the appearance of semi-precious hardstone.

Moje revels in chromatic splendour and says of his work: "My principal concern is working with colour and achieving something out of it." His patterns, whether herringbone, linear, or patchwork, are usually grid-based.

Above Untitled (Mosaic Bowl), 1991. h 7.5cm (3in), w 53.5cm (21in), d 53.5cm (21in). Bullseye glass, fused, kiln-formed, and wheel-cut. Moje's mastery of colour enables him to make statements that express every nuance of romantic, joyous, or reflective mood using a huge range of colours.

Left "Song Lines (Mosaic Bowl)", 1989. h 5.5cm (2¼in), w 50cm (19¾in), d 50cm (19¾in). Bullseye glass, fused, kiln-formed, and wheel-cut. Moje was a principal player in the development of Bullseye glass, which transformed his colourist imagery by allowing him the complete freedom that a painter in oils might enjoy.

His shapes never veer far from flat plates and shallow bowls, some of them with wide rims, although recent glass technology has made it possible to combine the blowing and kiln-forming processes, encouraging him to experiment with more vertical vessel shapes. His splashy and showy abstract imagery and kaleidoscopic colour palette have been compared to the work of Frank Stella and Jackson Pollock, although Moje himself claims never to have been conscious of any similarity. His earlier work is closer in character to the harder-edged op art aesthetics of the late 1960s and 1970s. The work varies in size, and can on occasion be expansive and really large-scale, covering an entire wall as it did in the Venice biennial glass show of 1998, *Venezia Aperto Vetro*, where he exhibited a large wall piece at the Ducal Palace.

Moje's work inspired Bullseye, a company producing coloured glass in Portland, Oregon, to develop a range of coloured glass that is chemically compatible and therefore allows a palette of infinite variety, which has greatly added to the range of possible colour effects in glass. Before Bullseye glass was developed the more complex and ambitious colour polychromy of Moje's more recent work would have been unthinkable. In recent years the developments at Bullseye have provided Moje with artistic challenges that have resulted in a change of direction once again. Since 1993 he has made a series of blown mosaic bottle and vase forms in collaboration with the American glass-blower Dante Marioni.

Moje's most adventurous work remains his kiln-formed creations, where in recent years the patterns have become less rigid as formal geometry has given way to a more fluid approach. The colours overlap and are richer, the polychromy is more sumptuous. The hard edge has given way to softer contours; the lines, no longer straight, twist and turn like ribbons. Surfaces are saturated rather than decorated with colour, and colours have become more luminous, expressive, and gestural. But even though this later work may look more informal, it requires just as much control and planning. In earlier years Moje simply could not have controlled the glass processes enough to be so free in his use of colour. He now works as a painter rather than as a designer in glass. Perhaps distancing himself from the academic environment has played a part in this artistic evolution. Despite his European roots one now thinks of Moje as an Australian artist, who more than anyone else has set the high standards of contemporary Australian glass.

Isgard Moje-Wohlgemuth

BORN 1941, GUMBINNEN, LITHUANIA NATIONALITY GERMAN

Over a career of more than 30 years Isgard Moje-Wohlgemuth has stuck to a formula for making glass, but within it has found endless variation. Glass is painted in a cold process with metallic resins, and further decorated with diamond engraving and sandblasting. Painted or enamelled glass has its roots in northern Europe, and is a tradition to which Moje-Wohlgemuth was exposed as a girl when she entered the state *Glasfachschule* in Hademar, an area famous for enamel-painted glass. She has always lived in northern Germany, but travels widely. At the start of her career she worked on stained glass; in 1967 she left flat glass to decorate vessels, after which she never looked back.

Unlike many of the "first generation" glass artists of the 1960s who believed technique to be overrated, Isgard Moje-Wohlgemuth believed that craft led the way to art. Expert knowledge of colouring techniques allowed her to explore a completely new aesthetic, that of tonal abstract painting on three-dimensional forms. As enamel paint is semitransparent, light travels through it, creating an incandescent glow, and the colours absorb as well as transmit light. This technique applied to vessel form was as new to glass as any of the "free expression" of her peers.

In Isgard Moje-Wohlgemuth's colourful language of signs, symbols, and linear decoration, recognizable forms sometimes appear. She began a series of "kimono vases" in the late 1980s, and kimonos have since appeared repeatedly in her work, as basic shape or surface decoration. The shape evokes Japanese culture and brings to mind the inventive fabric designs on these garments, which have so inspired this artist.

Surface decoration varies from decorative geometry to a more sketchy design vernacular. Repeating patterns are a part of her design language. Colours are bright and cheerful. The thin blown forms that she uses as her canvas may be straightforward cylinders, but her more recent shapes

Above *"Kimono HGM", 1987.*
h 60.5 cm (23⅞ in), base 44 cm (17¼ in).
Glass with coloured oxides fired on Isgard Moje-Wohlgemuth has chosen glass as the canvas on which she paints. The kimono has been a central theme in her work, either as an independent shape or as a decorative device.

have areas of asymmetry such as folded rims. Such folds, resembling fabric, led to a new departure in the form of shapes like unwinding ribbons. She thinks of glass as fabric or skin or peel.

After making stand-alone vessels, Moje-Wohlgemuth began to make related groups of two or more similar shapes, in which a relationship was established through colour and form. There is a tendency to call things sculpture when they can no longer be classed as vessels, but Isgard Moje-Wohlgemuth's non-vessel forms are more in the nature of deconstructed vessels, vessels taken apart or divided into segments. Whatever she makes is beautiful, because beauty is a priority in her life.

Above *"Schmetterling"*, 1971.
h 9 cm (3½ in), diam. 7 cm (2¾ in).
Blown glass painted with transparent enamels, diamond-engraved butterfly. From early on in her career Isgard Moje-Wohlgemuth specialized in decorating glass with transparent enamels and was able to express her affinity with nature in a rich and luminous palette of colours.

Right *Collection of Miniatures, 1990–2000.*
h 2.5–8.5 cm (1–3¼ in).
Mould-blown and free-blown vessels with coloured oxides fired on. The iridescence of coloured oxides adds a golden glow to Moje-Wohlgemuth's colour palette. It is through colour that she expresses her emotions, ideas, and experiences.

William Morris

BORN 1957, CARMEL, CALIFORNIA, USA NATIONALITY AMERICAN

William Morris, huntsman, visionary in glass, poet and philosopher, master craftsman, first became intrigued with glass during his high school days in Carmel, California. He experimented with ceramics and glass while at California State University and later at Central Washington University, but his real love affair with glass began at Pilchuck Summer School in Seattle, where in 1978 he was hired as a truck driver. It was in this year that he met Dale Chihuly, and he remembers the first time he saw Chihuly blowing glass: "It was one of the most inspiring demos I had ever seen. Because Dale approached the glass and dealt with it without any tools, just using heat, centrifugal force, and gravity. And I thought that was brilliant." Morris and Chihuly began to work together and their close collaboration, in which Morris became Chihuly's preferred and principal gaffer, lasted for a decade.

Above "Petroglyphic Urn with Horn", 1994. h 62.5cm (24⅝in), w 60cm (23¾in), d 15cm (6in).
Cased blown glass, powdered glass drawing. Morris took up hunting early on. It enabled him to wander alone in the woods and to get close to nature. His love of animals and of nature is everywhere in his work .

Left "Tribe Burial", 1991. h 57.5cm (22⅝in), w 55cm (21⅝in), d 60cm (23⅝in).
Cased blown glass, hot-formed detail. Burial grounds have fascinated Morris since his boyhood. Life and death are contained in the bones that are depicted in his work. For a hunter they occur within a split second of each other.

In the hot shop at Pilchuck Morris worked with glass-blowers from all over the world and developed skills as a glass-blower that place him among the best. He controls the hot glass with flare and imagination, creating perfect forms that are familiar as well as those never before seen in this material (animal heads, tusks, antlers). Morris has an innate understanding of glass, its magic, its unique colour qualities, its potential as a medium for expression. He experiments with surface texture, with drawing techniques, with the possibilities offered by using carefully crafted moulds into which his unusual forms are blown. Shapes are often determined by a hand-carved wooden mould, itself a work of art. These are carved by his close collaborator and friend Jon Ombrek.

Ombrek has also developed innovative drawing skills using glass threads and crushed glass based on a technique first used in the 1970s by fellow American artist Flora Mace. This technique for drawing on glass, thought to have been invented by the Romans, involves drawing a figure or a pattern with glass threads on the marver, and then picking this up on the molten bubble during the blowing process. Ombrek has also developed a drawing technique that enables him to interpret Morris' drawing on paper: coloured glass powders, carefully arranged on a steel table with a heated surface, are picked up by the hot bubble being rolled over them; in the process the drawing on the table adheres to the glass surface. Ombrek has worked with Morris since they met at Central Washington University in 1977 and is a member of what is by now a well-established small team. In many ways it is like any traditional glass-making team with its gaffers and technicians, but the demands made on them by Morris' ambitious projects are unusual. The team is required to invent continually as Morris comes up with imaginative new ideas.

From boyhood Morris sought inspiration in the woods and hills around his California home, where he explored caves and dug the earth in search of ancient artifacts, arrowheads, potshards, and the like. He has a serious interest in ancient civilizations, their primitive tools, their burial rituals. He is a hunter who shoots deer and elk with a bow and arrow, preferring to hunt alone. Among the many things that have inspired him are Stonehenge, the cave drawings at Lascaux, and the bleak landscape of the Orkney islands. The imagery in his work reflects these many interests and influences. Morris creates an archaeological scenario in glass with skulls, mounds of bones or antlers, weapons and tools, inspired by Native

Above: "Artifact Panel" (detail), 1998.
h 243cm (96in), w 980cm (386in),
d 40cm (15¾in).
Blown glass, steel
Morris' "Artifacts" are a series of
sculptures, often with animal or
human figures as their central
theme, though here a series of
invented reliquaries fills a wall.
Morris' skill allows him to make
glass look like bone, skin, leather,
stone, metal, and more.

Above "Beetles with Flora", 1999.
h 55cm, w 40cm, d 37.5cm.
*Blown cased glass, powdered
glass drawing, hot-modelled
detail on iron tripod stand. Morris
is an extraordinary craftsman
who puts his whole being and life
experience into what he creates
with his hands and breath. The
necessity for flawless technique
is just a given fact of life for him.*

American, ancient Egyptian, Cycladic, and African cultures. There is no attempt at historical or anatomical accuracy in his work. Drawing on imagination and nature, he is more concerned with portraying the mystical powers invested in historical and human or animal remains.

Morris had his first solo show in Seattle in 1980 at the age of 23. His early blown free-formed vessels are decorated with abstract patterns. Flattened shapes allow for more graphic surface decoration, enabling him to draw on the glass with greater freedom. During the 1980s he made his "Stone Vessels", creating a series of related boulder-like shapes with colourful and grainy finishes reminiscent of lichen or moss. In the late 1980s the stone vessel series gave way to "Petroglyph Vessels", similar in shape but where the drawing became more figurative, often featuring the animals that Morris hunted. At the same time he began organizing the vessels into groups called "Standing Stones", which though often brightly coloured recall the boulder formations one might find on a hillside ramble.

As his technical confidence grew so did Morris' artistic ambitions, both in scale and in concept. Some of his installations are measured in metres rather than centimetres. He began to depart from vessel forms and begin making a series of artifacts and objects in glass, such as antelope horns, arrow-heads, pouches, and gourds. These objects are grouped together, sometimes in bundles, heaps, or mounds (reminiscent of burial mounds), sometimes suspended from an arrowhead or an antler form modelled in glass. "The biggest jump," he says, "was moving into artifacts. They didn't have anything to stand on, and so they didn't hold together as single objects. The associations became more important." In a series of "Burial Rafts", boat-shaped forms are filled with an assemblage of bones, skulls, and weapons, all made of glass. Morris is reluctant to discuss the metaphorical content of his pieces. The work comes from an imagination fired by passion for the animal kingdom and for man's intervention in that kingdom. These are hunter's trophies on the one hand, deeply felt comments about human life, both primitive and contemporary, on the other. The groupings need no explanation: they are highly evocative and allow the viewer free interpretation. The work is mystical but not mysterious.

During the 1990s came the series of giant "Canopic Jars" inspired by the Pharaonic jars of ancient Egypt. These beautiful vessels are topped with

the heads of North American animals lovingly sculpted in the best tradition of *animalier* figures. The jars themselves are perfect blown forms, the tops exquisitely sculpted out of solid hot glass, freely formed by manipulating the glass with a series of tools consisting of blowtorches, pincers, fireproof gloves, and wooden paddles. Such dexterity in glass using two completely different techniques is simply astounding. One can admire Morris' work in glass on many different levels, either for the strong feelings it evokes or simply for its beauty of form, texture, and colour. It is glass at its most seductive. Morris does not set out to make his glass beautiful. In themselves many of the effects are dark, scabrous, or scaly and lugubrious. He uses the luminosity of glass as well as trying to remove it. Finished results can give the glass a jewel-like glow or a unique and sensual body texture that has not been created in any other medium. Morris is truly an alchemist who has created a completely new world out of sand and silica.

Above "Raven Jar with Incised Drawings", 1999.
h 62.5cm (24⅝in), w 40cm (15¾in), d 32.5cm (12¾in).
Blown cased glass, powdered glass drawing, hot-modelled finial in the form of a raven. Morris borrows from various cultures, most of them prehistoric.

Left "Mediterranean Red Deer Situla", 2000.
h 42.5cm (16¾in), w 27.5cm (10¾in), d 40cm (15¾in).
Blown and hot-formed glass. Inspired by a medieval drinking horn.

Joel Philip Myers

BORN 1934, PATERSON, NEW JERSEY, USA NATIONALITY AMERICAN

As early as 1964, when Joel Philip Myers was design director of the Blenko Glass Company in West Virginia and before he became an independent artist in glass, he wrote: "My approach to glass is to allow the material an expression of its own. Press the material to the utmost and it will suggest ideas and creative avenues to the responsive artist." Having studied design in the United States (at Parsons School of Design and New York State College of Ceramics at Alfred University) and in Denmark (at the School of Applied Arts in Copenhagen), Myers worked as a designer in packaging and then in the glass industry. He attended the revolutionary Toledo glass seminars of 1962 and 1963 and, inspired by developments in American glass, began experimenting during the 1960s with a series of small sculptures.

After a flirtation with sculpture he invested his artistic energy in a series of vessel forms, the "Contiguous Fragments". The vessels are mostly about colour. Myers developed a glass marquetry technique to a fine art, allowing him to experiment as freely with abstract colour compositions as if he were painting on canvas. Fragments of coloured glass are fused into the surface of a vessel using a blowtorch. In expert hands this skill can create an artistic syntax of endless variations and for more than two decades Myers investigated them, producing an extensive body of work remarkable for its superb colour effects.

From 1970 until 1997 Myers was professor of art at Illinois State University, where he remains professor emeritus today. In the early 1990s he felt it was time for a change. "I needed to get away from the seduction of colour, to get away from my facility with glass." For three years, he stopped making glass, immersing himself in a study of World War I,

Left "Valmuen B", 1990.
h 41cm (16in), w 38cm (15in),
d 10cm (4in).
*Blown glass form, opal cased
in clear glass, red glass drawing
beneath surface, shard additions
applied hot to outer surface,
form flattened on graphite cloth.*

Top left Untitled, 1979.
h 21cm (8¼in), diam. 8cm (3in).
*Blown opal white glass form,
black and white shard
additions applied hot.*

visiting Europe's battle sites and cemeteries. When he returned to working in glass in 1995 he began making groups of vessels, mostly black or colourless, occasionally streaked with red, that had been "wounded" or "punctured", collapsed forms with their necks broken, their "skin" peppered with metal pins like gunshot. In contrast with his earlier work, titles are evocative, such as "Ghosts of War". The cylindrical vessel shapes suggest wounded bodies and pain. In a series called "Dialogue", coloured cylinders have rhythmic anthropomorphic shapes that turn them into something almost balletic, whereas previously vessels merely served as a formal three-dimensional background for abstract imagery.

By breaking with the past Myers has shown enormous courage as an artist. The newer work is as remarkable for its expressive powers as the earlier work was for its colour.

Below *"The Dogs go on with their Doggy Life and the Torturer's Horse Scratches its Behind on a Tree" (detail), 1997.*
Each cylinder: h 36cm (14in), diam. 14.5cm (5¾in); each plinth: h 99cm (39in), w 20cm (7⅞in), l 117cm (46in).
All vessels blown in ceramic fibre moulds. Installation of 65 cylindrical glass vessels studded with pins; opal and black glass; mounted on eight plinths.

Matei Negreanu

BORN 1941, BUCHAREST, ROMANIA NATIONALITY ROMANIAN

Above "Waves", 1986.
h 52 cm (20½ in), w 30 cm (11¾ in),
d 32 cm (12⅞ in).
Industrial glass, cut, glued, broken,
sawn, sandblasted. A graphically
descriptive piece that captures
the movement of breaking waves
by treating the glass in a variety
of imaginative ways.

In his work Matei Negreanu creates an impression of evolution and change, of emergence from dark into light. His imagery evokes the movement of earth, air, and water. There is implied movement in glass anyway as it changes from its molten state into a more static material; even when cold the chemical composition of glass is not constant. With its inherent quality of flux glass is the ideal material for Negreanu. His structures are technically inventive and full of spirit. The work seems to divide itself into two categories, one neat and formal, the other freer, more rhythmic, more expressive. The titles of the latter suggest the kind of subjects that inspired him – "Waves", "Icarus", "Wing", "Lunar Landscape", "Cliff". The more fluid work came first but soaring themes gave way to a stiller, more earthbound kind of abstraction contained in blocks of glass or symmetrical vessel or globe shapes often inlaid with lead.

Negreanu arrived in France as a political refugee from Romania in 1981; by 1990 he was exhibiting at galleries in France, Switzerland, Germany, and the Netherlands. At technical school he had learned metal-working, drawing, and foundry work. Later he attended the School of Fine Arts in Bucharest, with glass his special subject. After leaving he earned his living in theatre design and the fashion industry, and was head of design at the official National Industrial Design Institute of Bucharest, where everything made of glass came under his control. But he did not find his artistic voice until he arrived in Paris, where the work of the Czech sculptor in glass Jutta Cuny made a lasting impression on him. His treatment of glass is experimental and adventurous. He has tried practically every glass technique, bonding it with ultraviolet rays (a technique used in making cameras and telescopes), cutting it with a saw, fracturing it with hammers and mallets, coating it with metal, engraving and sandblasting it, blowing it into moulds. An adventurer, he asks, "How could one possibly be content with a single mode of expression?"

Although beguiled by the beauty of glass, Negreanu is not seduced into falling under its spell. Even in the more baroque style of his earlier work with its scrolling and convoluted forms, the character of his glass remains virile. "For me it's always a question of transforming it in my own way,

to create works which exploit its potential while avoiding its pitfalls." Negreanu usually works in glass that may have a tint but no colour, although in his more recent work with blocks of optical glass, small areas of colour are used with dramatic effect.

Negreanu has already produced two distinct bodies of work, very different from one another. He is constantly drawing, painting, thinking, and experimenting, and expects to turn another corner during his career as a sculptor in glass. "Glass is deceptive and I don't trust it. I don't intend to let it dominate me. The artist should always have the last word."

Above "Vasque" (Vessel), 1998.
h 15cm (6in), diam. 60cm (23⅝in).
Blown glass, the interior and exterior with applied lead decoration. Simple linear decoration on a traditional vessel form expresses Negreanu's quieter and neater artistic side.

Left "Sculpture No. 60100 – Sans titre", 1999.
h 41cm (16in), w 46cm (18in), d 25cm (9⅞in).
Lost-wax-cast pâte de verre, painted wood. In this complex mixed media construction Negreanu shows off a diversity of technical skills.

Yoichi Ohira

BORN 1946, TOKYO, JAPAN NATIONALITY JAPANESE

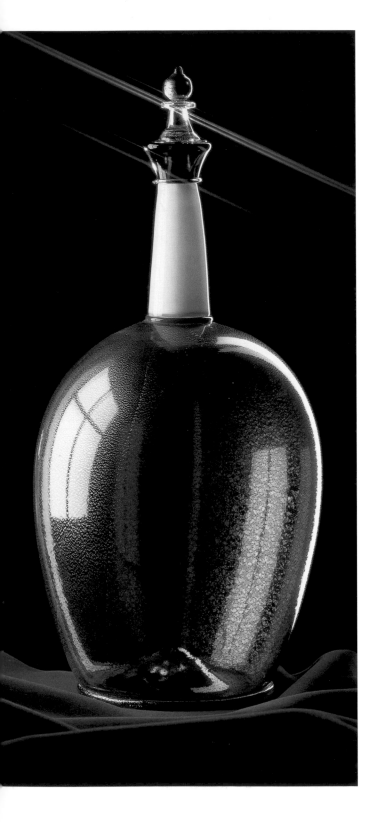

Yoichi Ohira achieved recognition as a glass artist only after leaving his native Japan in 1973 and going to Venice, where he took a sculpture course at the Accademia delle Belle Arti, graduating with a thesis entitled *The Aesthetics of Glass*. Although he exhibits in Japan every year, his home has been in Venice ever since he first went there. He not only fell in love with the place, but became so enamoured with the Venetian way of making glass that he learned to understand it intimately and to use it for his own artistic ends.

Ohira's style evolved over a number of years as he worked in a variety of Venetian techniques and with different glass masters. In the 1970s he collaborated with Egidio Costantini at Fucina degli Angeli, a glass company that produced designs in glass by such artists as Picasso, Cocteau, and Lucio Fontana. It was not until the late 1980s that Ohira started making his own designs, attending to every detail. Every curve, every rim, every goblet or vessel shape had to be exactly as he intended it to be. He was satisfied with nothing less than absolute perfection.

In 1987 Ohira began a collaboration with the de Majo glass company on Murano, designing a series of ethereally elegant thin blown bottles and goblets, for which he received instant acclaim when they were exhibited in the exhibition *Divine Glass* in Venice in 1990. Their colouring, with its sharp chromatic accents more commonly found in Japanese enamels or porcelain, also came as a surprise in the context of Venetian glass.

In 1990 Ohira freed himself from the restraints of designing for the Venetian glass industry and began life as an independent artist. He decided to collaborate with two *maestri*, one versed in the techniques of

Left *'Torre di Avorio' (Ivory Tower), 1987.*
h 37 cm (14⅝ in), w 14.5 cm (5¾ in).
Blown bottle with stopper.
While showing profound respect for
Venetian glass tradition, forms, and
techniques, Ohira has created his
own sensitive language in glass.

Left *Metamorfosi* (Metamorphosis), 2000.
h 17.5cm (6⅞in), w 16.5cm (6½in).
Blown glass with inserted murrine.
Ohira's work is small in scale and
jewel-like, meticulously worked
with no detail left unfinished.

Below "Laguna" (Lagoon), 1998.
h 31cm (12¼in).
Thin blown glass, polychrome canes,
ground. Made with maestro Livio
Serena. By working with the best
masters in Venice Ohira came to
understand the artistic possibilities
of the techniques they used.

murrine glass, the other a glass-blower of consummate skill. Whether his vessels are made of *murrine* or blown, their scale is small, usually under 20cm (7in) in height, and they are always perfectly formed. Since 1993 Ohira's main body of work has been carried out in conjunction with Livio Serena (known in Venice as "Maisisio"), a virtuoso when it comes to making blown pieces that incorporate *murrine*. Ohira delivers exact drawings to Serena, which are discussed and executed in the presence of the artist. The body of the glass is usually brightly coloured and richly textured, using intense primary colours or rich browns and sometimes black. The *murrine* canes are prepared by Ohira himself and incorporated into the body of a vessel by the *maestro* while blowing, in horizontal, vertical, or diagonal lines or in patchwork arrangements. They are part opaque and part transparent, the transparent parts shining and making the vessels appear lit from within. The other great Murano *maestro* with whom Ohira collaborates is Carlo Tosi, known on Murano as "Caramea". This body of work consists of glass vessels and bottles, sometimes with stoppers and curly finials, Neo-Classical in inspiration and Japanese in their elegant simplicity. In his work Ohira combines Western traditions with a sensitivity and delicacy that he owes to his Japanese origins, a fusion that could not be more pleasing or more perfect.

Pala & Palová

STÉPÁN PALA BORN 1944, ZLIN, CZECHOSLOVAKIA NATIONALITY CZECH

ZORA PALOVÁ BORN 1947, BRATISLAVA, CZECHOSLOVAKIA NATIONALITY CZECH

Stépán Pala and Zora Palová depend on each other as artists and their work is complementary, although they do not always work together as a team. Both of them are abstract thinkers, concerned with concepts such as constructivism, system structures, minimalism, and geometry in art. Pala's way of working is to design a basic module which is replicated or multiplied, taking on a sculptural identity in the process. He plays games with three-dimensional geometry. In his work there is a search for some sort of universal order. He is a brilliant technician, particularly in cold-cutting techniques. Palová's abstract thinking is more associative and linked to physical subjects. Autumn leaves, bridges, or vaulted spaces leave a more visual imprint on her way of thinking, which is clearly reflected in the imagery she creates. It remains abstract but has emotional content, in contrast with Pala's more cerebral mode of expression. Palová's technical speciality is large-scale casting. Her sculptures are of coloured glass, red, amethyst, blue, topaz, or green.

Both artists studied at the Academy of Fine Arts in Bratislava under Václav Cigler, whose extraordinary understanding of the way light can transmit feeling into glass had a great influence. Zora Palová has been professor of glass at the University of Sunderland in northern England since 1996, and divides her time between her home and studio in Bratislava and her teaching commitments in Britain. Stépán Pala also spends time in England and has been generous in sharing his skills with the students at Sunderland. Pala uses drawing as a way of clearing his mind, and his drawings are both finished work and preparation for his glass sculptures. Palová does sketches and also likes to work in glass on a small scale as a preliminary to large-scale casting. She has created some beautiful glass jewellery in the process, mostly pendants or brooches made of cut and polished optical glass.

The two artists are busy with exhibitions as well as large commissions. Their most ambitious projects to date have been one in The Hague (1996) and one in Sunderland (1998). In The Hague each was commissioned to do a work for the Verbond van Verzekeraars (Association of

Top "Thorn Crown", 1996.
Solo work, Pala.
h 32cm (12½in), diam. 200cm (79in).
Cast, ground, polished, glued optical glass, 96 separate pieces glued together.

Above "Gardens", 1985.
Solo work, Palová.
h 4cm (1½in), w 15cm (6in), d 20cm (7½in).
Cut and polished optical glass in nine sections. Although this is a solo work, it is evidence of the strong influence of these two artists on each other.

Insurers). Pala's contribution was "Thorn Crown" (also called "Glass Circle"), a dazzling floor sculpture for the lobby made of 96 brilliant-cut optical glass elements, resembling a giant diamond necklace. Palová's "Guardian" is a tapering triangular-section column of topaz-coloured glass that stands 8m (26ft) high in the central stairwell. Both works are impressive partly because of their scale, partly for the way in which their commanding presence enhances the interior space they occupy. In Sunderland Pala and Palová won an international competition to create a work to stand at the entrance of the National Glass Centre. Their winning entry, which "captures the dramatic light characteristic of the north-east of England", is the largest outdoor glass sculpture ever made, measuring 4.9m (16ft) across and 1.8m (6ft) high; in three sections, it weighs a total of more than 860kg (nearly 1,900lb). The sculpture, cast in their home town of Bratislava in grey glass, is destined to become a local landmark.

Above "Fissure". Solo work, Palová, 1997.
d 10cm (4 in), diam. 52cm (20¼in).
Cast, partially cut, and acid-polished blue glass. Palová's sculptural style often features bold geometric forms cut or distressed by less orderly intrusions into their symmetry.

Left "Time Transformer". Solo work, Pala, 1996.
d 18cm (7 in), diam. 42cm (16½in).
Cast optical glass and blue glass, ground, polished, and glued. Four blue glass rectangles seen through optically cut glass discs have a kinetic effect, distorting the rectangles and creating an illusion of movement.

Tom Patti

BORN 1943, PITTSFIELD, MASSACHUSETTS, USA NATIONALITY AMERICAN

From the beginning Tom Patti's work has stood out as an arresting statement in glass. Already at the time of his first public showings in the mid-1970s his work gave credibility to glass as a material for artistic expression. He shot to fame when a piece of his was used as the front cover of the epoch-making exhibition *New Glass* (1979), staged by the Corning Museum of Glass. At a time when the vocabulary of contemporary glass was still in its formative stages, Tom Patti defined some of the artistic possibilities achievable through innovative technical processes. A Patti piece was clearly something extraordinary, and the first question was always, "How is this achieved?". The "wow factor" was characteristic of the new wave of glass-makers in the 1970s, who reacted against Harvey Littleton's famous claim that "technique is cheap" and found that in fact technique was the key to beauty in glass.

Above "Banded Flair", 1976.
h 17.5cm (6⅞in), w 12.5cm (5in),
diam. 12.5cm (5in).
*Fused, hand-shaped, ground,
and polished glass. One of two
pieces by Patti in the collection
of the Metropolitan Museum of Art,
New York. Patti says that one of the
roles an artist should play is "to test
thinking against new materials".*

Right "Red Echo Lumina Echo
With Blue", 1992.
h 8.75cm (3⅞in), w 13.75cm (5⅜in),
d 10cm (4in).
*Fused, hand-shaped, ground,
and polished glass.
By fusing differently shaped layers
of glass Patti gives his glass forms
a busy inner life, with inner shapes
seen through outer forms, and
colours permeating one another
with diaphanous effect.*

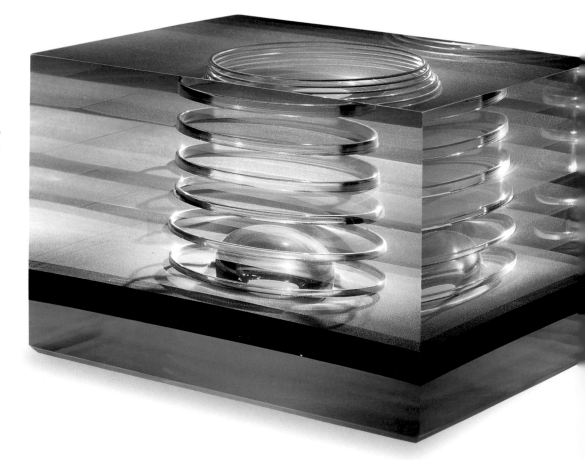

From 1963 to 1969 Patti studied industrial design at the Pratt Institute in Brooklyn, New York. He began his professional life as an industrial designer. Glass became a hobby, and much in the spirit of the pioneers of the contemporary glass movement he invented his first bits of machinery out of found objects. He found a laboratory glass-melting furnace in a scrapyard. An insulating brick cut in half and fitted with the element from a rotisserie became his crucible. These determined the way he was to work. Like a child experimenting with his own invented chemistry set, Patti treated glass without preconceived ideas and as a modern material, paying no heed to its history. He stacked thin plate glass, then heated it and blew it into a mould. It was an original concept and the resulting visual effect like nothing ever seen before in glass.

It is clear from his own words how Patti felt about working in glass: "The role of the artist... is to test thinking against new materials. When you make a piece you automatically give the material a certain credibility. But at the same time you have to deny the possibilities, even the existence, of the material, and if the material can justify its presence in the object and you can see its beauty, then you've given it a right to exist. But the material must always be subsidiary to the idea."

Patti's inventive technical processes are always visible and "on show" in his work. One gets the sense from looking at a piece that the material has undergone an interesting process, a process providing it with biographical data that become its life and soul. He creates internal spaces in glass in ways that nobody else does – a bubble contained within a cube formed of laminated sheets; or a series of bubbles forming a rhythmic internal pattern. The eye is led inward. Sometimes there are metal inclusions in the form of thin wires seemingly suspended inside a piece. Shapes have the precision of machine parts. He builds his pieces like an architect, conscious of inner space and outer shape.

Patti has not changed his style over the years. He works very slowly and each piece takes a long time to evolve. He can start a piece, leave it, and come back to it, taking up to two years to finish it, to resolve the problems created on the journey between start and finish. Abstract ideas are gathered together in his work and contained within the vessel form. He has brought new techniques to the glass world and uses them to help us make sense of the abstract.

Below "Azurlite Split Riser With Clear", 1994–95. h 15cm (6in), w 11cm (4¼in), d 6cm (2¼in).
Fused, hand-shaped, ground, and polished glass. Patti's imagination, both technical and artistic, has allowed him to use glass to create some unusual and surprising optical effects.

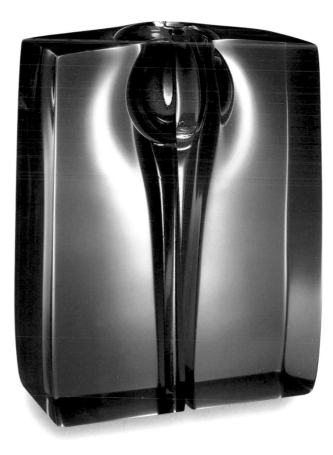

Mark Peiser

BORN 1938, CHICAGO, ILLINOIS, USA NATIONALITY AMERICAN

Below "Side Road", 1980.
h 17cm (6¾in), diam.12cm (4¾in).
*Blown-glass vase, flameworked
application. Peiser's flamework
draws the eye into the glass,
creating a* trompe l'oeil *illusion
of depth and distance.*

When Mark Peiser enrolled in 1967 in a glass-blowing class at Penland School of Crafts, North Carolina, he entered a preserve of natural beauty he has not since left. Penland is high on the rippling flank of the Blue Ridge Mountains, and Peiser's studio stands on the doorstep of nature, influencing his thoughts and his work. In his first years of experimentation Peiser, like all his contemporaries, experimented with the glass bubble. His first major series of work comprised his "paper-weight vases" (1975–81) – Tiffany vases incorporating lamp-worked elements, which were commonly referred to by that name although there is in fact little similarity between the way a paperweight is made and the complex process involved in making one of Peiser's landscape pieces, where detailed coloured imagery seems suspended between layers of glass. They are masterpieces of their genre.

The detail on these paperweight vases is extraordinary: leaves on the trees clearly visible, wisteria blossom completely realistic. The technique involved in making these pieces requires accurately informed guesswork gained through painstaking experience. A detailed pattern is laid out in miniature at an early stage of blowing the bubble: this micro version requires total accuracy so that it will retain its proportions when the bubble becomes expanded through blowing to its final size and shape. Peiser achieves not only accurate imagery, but a sense of perspective and mood rarely seen in imagery on glass. Panoramic landscapes imprisoned between layers of glass seem to stretch far into the distance, an effect achieved by working the imagery in the round, or in other words positioning it carefully on both the front and the back of the vase. The imagery thus takes on a three-dimensional effect.

While working on the landscape pieces Peiser explored the possibilities of abstraction and of constructing coloured imagery in a different way. He became fascinated with the idea of imagery changing as one moved around a piece, changing with the light, taking on a new mood when seen from a new angle. The imagery remained suggestive of landscape, but without the specific detail that characterized his earlier work. Imaginary suns and moons seemed to light interior spaces. Globular

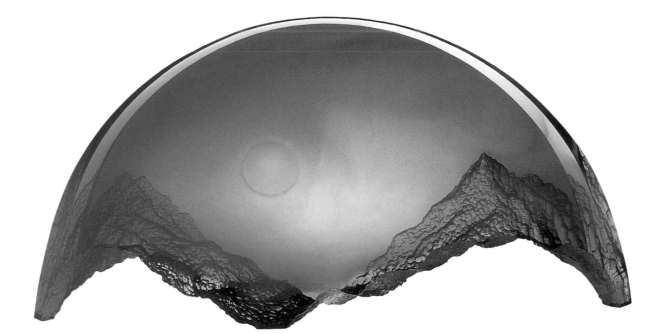

Above "Mountain Skyscape", 1997.
h 42cm (16¼in), w 21cm (8¼in),
d 7cm (2¾in).
Cast glass, cut and polished
In cast glass, Peiser's work
changed from detailed landscape
drawing to mood imagery.

Right "Armored Lips", 1999.
h 40cm (15½in), w 15cm (6in),
d 19cm (7½in).
Cast glass and copper, electroforming
A more sculptural idiom including
the use of moulds has opened
up new sculptural possibilities.

forms gave way to more prismatic shapes in his "Inner Space" series, made by pouring glass into a mould and polishing surfaces to have sharp edges after the glass had cooled. The effect is kaleidoscopic and produces a unique kind of internal colour effect that has the lightness of watercolour and a luminous transparency. The result is an original and emotive poetic language in glass.

In the 1990s Peiser's work changed again, as he says: "Virtually every conceptual aspect was affected, as well as the processes, materials and feeling." He began to use glass in a very different way, no longer using its transparency for effect but using the material as if it were solid and opaque, almost as if he were working in bronze. It led him, in fact, to casting some shapes both in bronze and in glass. His new work, he states, "concerns human nature… All of the pieces are intended as portraits. Not portraits of individuals, but portraits of consciousness itself."

Ronald Pennell

BORN 1935, BIRMINGHAM, ENGLAND NATIONALITY BRITISH

Above *"Strange Voyage"*, 1997.
h 17.5cm (6⅞in), diam. 13cm (5in).
*Sage over-cased glass, wheel-
engraved. Sturdy little characters
populate Pennell's romantic
fantasy world.*

Below *"Toe to Toe"*, 1999.
h 25cm (9⅞in), w 30cm (11¾in),
d 30cm (11¾in).
*Kiln-cast, wheel-engraved, carved
figures on a cut and polished base.*

Ronald Pennell has perfected his art form to suit his lifestyle, living with his wife Betty and his Jack Russell Bruno in a cottage so near the River Wye in Herefordshire that the winding river landscape seems to come in through the window. There, away from the real world and yet very much a part of it, Pennell has worked for most of his professional life designing and making bronze or silver medallions, working on glass using gem-engraving techniques (in which the *intaglio* engraving is done in reverse, resulting in the image being magnifed by the lens-like glass), and more recently making cast-glass sculptures.

Pennell's formal training was as a metalsmith at Birmingham College of Art, after which he studied gem-engraving at Idar Oberstein, the heartland of the German precious gem industry. From 1959 to 1964 he taught at Birmingham College of Art. It was not until the mid-1970s, after a decade and a half of working as an engraver on metal, that he thought of transferring the techniques to glass. The idea came to him in 1974 after he had done a series of rock crystal engravings that were exhibited at the Crafts Council in London; in 1977 he began to use his expert techniques on glass. At first he used commercial vessels, but as he grew into the world of contemporary glass-making, he turned to master glass-blowers in Britain to create vessels to his own design.

The larger surface of glass vessels allowed more room for narrative, and Ronald Pennell is above all a raconteur. "Life is a story. Reality is a confusion of memory and images and the only difference between narrative and actuality is perception." Pennell is both observer and commentator. He understands British eccentricity and uses the eccentric characters that populate his imagery to deliver urgent messages about topics such as global warming and the extinction of endangered species. He is serious about such matters but uses humour to convey his message. The brave but ridiculous Major Egmont Brodie Williams, one of his favourite characters, who hunts crocodiles in the company of his dog, epitomizes Pennell's mix of real concern for burning issues and amused tolerance of man at his most ridiculous.

In 1997 Pennell was invited by the University of Wolverhampton to be visiting professor of glass studies. That invitation coincided with another, to stage a retrospective exhibition at Wolverhampton Art Gallery. Pennell's invitation to become guest lecturer led him to experiment with a new technique, that of glass-casting. He learned quickly, and succeeded in completing a series of cast-glass sculptures in time for the retrospective in 1999. This is the first time that Pennell's figures have left their medallic or vessel environment. In three dimensions his cast figures (which are growing in scale all the time) have a muscular energy that has translated well into the new skills he is using. He is young at heart and feels that he still has a long way to go. "Life is a constant road to nowhere and it's always interesting to see what happens next," he says. "I don't have targets. Life is a target."

Below "The Triumph of the Sheila Na Gigs" (detail), 2000. h 46cm (18in), w 61cm (24in). Painted, engraved, etched, and laminated glass in stainless steel frame on ash and steel base. Whether engraving or sculpting in glass or bronze Pennell's ideas are always based on drawing. Drawing is his way of thinking and developing ideas.

Stephen Procter

BORN 1946, BOGNOR REGIS, ENGLAND NATIONALITY BRITISH

Above "Opposite & Equal 4 –
Bullseye Glass – Latitudes Series",
1999. h 8.5cm (3¼in), diam.
27.5cm (10⅞in).
*Fused, blown, cut, and
engraved bowl, black/orange.
Before becoming involved with
Bullseye glass Procter had never
ventured beyond black, white,
or transparent. In colour too
he is concerned mainly with
harmony, balance, and the
attraction of opposites.*

In 1992 Stephen Procter was appointed head of the Glass Workshop at the Australian National University's Canberra School of Art. Before that he lived and taught in England, eventually heading the Glass Department at West Surrey College of Art in Farnham. Procter is as persuasive as an artist as he has been as a teacher. He began working in glass in 1970 as an engraver, stipple-engraving much in the British tradition of Laurence Whistler. Then as now his imagery was about the landscape and light, treated as allegory. Glass is for him a magical way of gathering light. He feels a close affinity to the land, to plants, trees, and flowers, their growth, fruitfulness, and beauty. Of a goblet he made in 1976 in which light streams over a waterfall he says, "The theme... is an allegory, illustrating the path of the soul striving ever upwards."

By the end of the 1970s Procter had completely changed his way of working in glass. He blew his own forms, in order to obtain the correct "thickness, balance and flow", then cut them on a lathe to achieve the final shape, cutting so as to best allow them to capture light. He had travelled to Austria and to the United States in order to learn how to blow glass. In this new way of working the engraving is minimalist, bearing no resemblance to his earlier work. He describes how the transformation happened. "One day, after working on a series of drawings reflecting on the movement of elements through a landscape, I cut a corresponding rhythmic line into a piece of glass. The interaction of this line with sunlight and the shadow it cast, showed me a direct relationship with form."

As he became more interested in form he began thinking of it in terms of balance. Rounded forms were poised so as to rock if there was a breeze in what he refers to as "a state of stillness delicately poised on the edge of movement". Very often the rounded forms sat on simple rectangular or circular single or double sheet-glass bases, raising them so that their contours could be most clearly visible at the point of contact. Stillness is the counterpoint of rhythm, and both are features in Procter's work. He also contemplates sound within the spherical shapes he creates, believing it to be there. "The forms focus on the quality of silence, and yet I regard them also as structures of sound, like a shell held to the ear, to

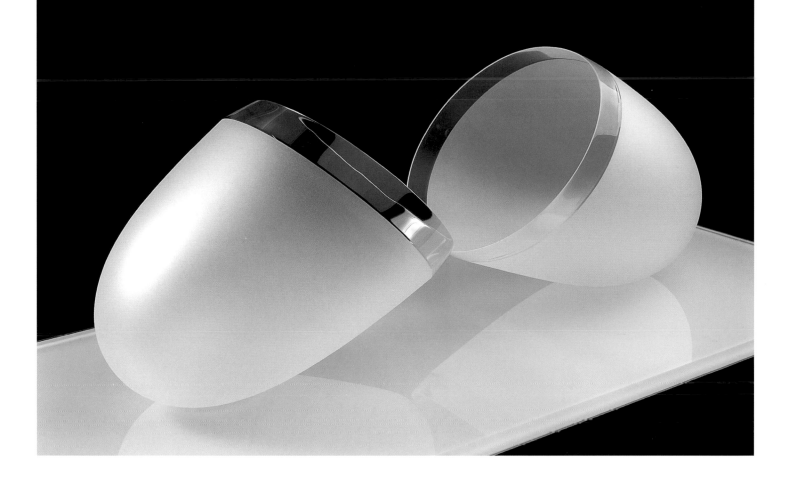

Above "Dialogue", 1995.
h 23cm (9in), (base) w 35.5cm (14in)
d 73.5cm (29in).
Blown, cut, sand-blasted glass
forms, resting on sandblasted glass
base. Carefully controlled forms in
a dialogue about opposing forces.

Below "Time Turner III", 2000.
h 25.5cm (10in), diam. 18cm (7in).
Blown, cut, and engraved
dark glass form.
The form is constructed to lie
still, although it will rock gently
at the slightest touch.

hear the rhythm of the sea." The idea of trapping light and sound in his forms plays an important role in their creation.

Until recently Procter has worked mostly in colourless glass, although in its cut edges the colours of the rainbow exist through the prismatic cutting he uses to finish rims. Recently, perhaps unable to resist the lure of the colours during the Bullseye Glass Workshop at Canberra in 1998, Procter has experimented with colour in some vessel forms. But in his sculpture he sticks to colourless glass, with occasional trips into black and white and very rarely into other monochrome colours. He has also experimented with deeper, more aggressive cutting in the recent past. In essence, despite nearly ten years in Australia, he remains the pastoral poet of his early work, very Wordsworthian, very British.

David Reekie

BORN 1947, LONDON, ENGLAND NATIONALITY BRITISH

David Reekie is a social satirist who works predominantly in glass, commenting with great insight on the absurdities of self-importance and other human qualities that have their funny side. He has a light touch and a typically dry but compassionate "British" sense of humour. He ridicules with the deepest affection. His cast of characters – orators, judges, jugglers, demagogues, and people with strange occupations (which they take far too seriously) – invariably find themselves in difficult or impossible situations of their own making. The viewer is encouraged to laugh at their self-inflicted troubles, which are absurd rather than tragic. A "King Juggler", for example, spins a plate with his arms folded; the top of his head is as flat (and empty) as the plate he is spinning. Two engineers with inane grins mindlessly tug at pulleys attached to small red buckets – an absolutely pointless exercise, but one in which they look delighted to be engaged.

David Reekie's work is in mixed media, including wood, metal, enamel paints, and found objects, but the main ingredient is always *pâte de verre*. Over the years, his skill in lost-wax casting has allowed his figures to become larger and the groupings have grown in number, resulting in increasingly complex scenarios. In lost-wax casting, a wax model is enclosed in a plaster mould; the wax is steamed out and replaced with molten glass. The glass he uses for head and hands is opaque and looks white. Bodies are made of glass too, but are often clad in enamel paint. The pieces are

Below "Curious Man", 1986.
h 23cm (9in), w 28cm (11in),
d 14cm (5½in).
Laminated and kiln-formed plate-glass with a lost-wax cast pink soda glass figure. "Work of this period is important because I started to use the figure in a very theatrical way and developed a sense of humour and the narrative in the work."

Left "Disturbing News", 1990.
h 47cm (18½in), w 38cm (15in),
d 17cm (6¾in).
Two lost-wax cast lead-glass
figures set into cast lead-glass
panels coloured with ceramic
enamels in the glass. Set
into a painted wooden base.
Reekie's titles are both
humorous and explicit.

Below "Observer V", 1992,
h 47cm (18½in), w 27cm (10¾in),
d 16cm (6¼in).
A lost-wax cast lead-glass figure
set on top of a cast lead glass
block. The figure has a sheet
lead mask with a copper strap,
is acid-polished, and has brass
retaining pins. One of a series
of masked figures.

figurative, and the figures have faces and gestures that convey a sense of absurd urgency. Often their mouths are open (showing a good set of teeth), and they gesticulate and point to attract our attention. Faces, hands, body posture, and gestures are all carefully modelled. The faces are always masculine and belong to men of a certain age with strong (and rather similar) features. Hands are pawlike and always busy. Expressions tend towards the enigmatic or the quizzical, inviting us to consider what the problem might be – Reekie feels that such expressions demand the viewer's regard. He creates actors who compel the attention of their audience as they act out the theatre of the absurd.

Being able to control expression so accurately in *pâte de verre* requires enormous skill in modelling and casting, the basics of which David

Reekie learned at Stourbridge College of Art, where he studied glass from 1967 to 1970. He drifted into the Glass Department more or less by mistake. "I just gradually worked my way into glass. It wasn't a preconceived thing." He enjoys sharing his knowledge and has given master-classes at schools and conferences all over the world. For ten years, from 1976 to 1986, he was lecturer in glass at North Staffordshire Polytechnic, but he now lives in Norwich, where his studio is a converted garage. He no longer has a full-time teaching position and is able to sustain himself by exhibiting the artistic work he makes.

Reekie works his way through a group of characters until he is ready to move on. Sometimes he says what he has to say using a single figure, but very often the work is about the complexity and absurdity of human relationships, the theatre of life with its mix of comedy and tragedy. For this kind of work figures are grouped together communicating (or more often failing to communicate) with each other. He may stay with one type of figure for a year or more. In the 1980s he created a series of masked figures. In the 1990s he made a series called "Observers", figures that sit perched on columns, often wearing grotesque masks (made of copper or lead). They are watchers, and we in turn are curious to guess what they might be seeing. In his most recent work Reekie expresses his concerns about cloning. In one work a group of identical figures shuffles along in close army-like formation, except for one solitary anxious figure at the back, whose head is turned sideways. Reekie is himself a keen observer, drawing inspiration both from the happenings of everyday life and from the work of other artists, Leger and Magritte being among his favourite. He feels, especially, an affinity with Magritte's surrealist world.

Much of what he sees is first captured in drawings. It is a help for him to put his thoughts down on paper in this way and he enjoys drawing, seeing it as a kind of relaxation and a temporary rest from the labours of kiln work and casting. He likes the immediacy of drawing, particularly when compared to the laborious processes of glass-casting. But in the end the drawings remain preparatory work: glass is his chosen medium. "The quality I like about glass is actually introducing mystery to it. There's a little bit of translucency there, little places where it's quite transparent but then you'll go through a very dense area. When the light comes through it, it is transparent so you get this thing about mystery." It has been fascinating to watch Reekie's expressive talents grow along with his

technical skills over 20 years. A sense of adventure challenges him to work with new materials (lead, wood), to find new colours, and new situations.

When he began lost-wax casting he made miniature vessels that sat on top of columns, giving them an overblown sense of importance. It was not until he was able to produce figures in cast glass (in the early 1980s) that Reekie could express himself fully. His figures are victims of weakness or of ambition. The situations he creates for them touch a nerve within us. We recognize a part of ourselves in Reekie's portrayals of the social, political, and personal risks to which we are all exposed.

Above *"Dancer VI", 1996.*
h 40cm (15¾in), w 44cm (17¼in),
d 21cm (8¼in).
*Cast in lead glass from a model
made of a combination of wax and
clay with enamel colours in the
glass. The figure is hand-polished
and has brass retaining pins.*

Colin Reid

BORN 1953, POYNTON, ENGLAND NATIONALITY BRITISH

Colin Reid is a master of the art of lost-wax casting, the medium in which he has responded to his artistic calling. Yet Reid found his way into the world of glass more or less by default. After various attempts to "find himself", which involved helping to set up a spiritual community in Israel, and later travelling and working with children, he chanced upon a government training course in scientific glass-blowing. Eventually he had the good fortune to end up studying for a Bachelor of Arts degree in glass at Stourbridge College of Art under Professor Keith Cummings, a world-renowned authority on glass-casting techniques.

Starting out on a career after leaving Stourbridge Colin Reid was able to combine his scientific glass-making skills with lost-wax casting, using the former to produce a range of lampworked perfume bottles, which sold well and earned him his bread and butter. The success of his production work allowed him to spend time on lost-wax pieces, the forms of which were loosely related to the idea of stoppered perfume containers. Reid was inspired by the coloured striations of rock formations or earth masses, which were revisited as frosted and coloured veiling inside his transparent glass sculptures. The sculptural arches or flattened pyramid forms he chose early on in his career were usually composed of two parts that looked as if they had been rent asunder by some earth-shattering force, but fitted together perfectly to form a single piece.

In 1991 Colin Reid went to New Zealand, where he spent two years as artist in residence at Carrington Polytechnic, Auckland. The break coincides with dramatic developments in his work, which became larger and more monumental. The change was brought about by the change of environment and exposure to an altogether new and more dramatic landscape. His forms and colours are a response to nature but, as he says, "there's no overt message".

As the pieces became more ambitious in scale a gallery environment was less appropriate and Reid found himself working on much larger-scale work in the form of commissions, including ones for the East India Company and Standard Life in London and one for Shanghai Library. In

Above Untitled, 1987.
h 52 cm (20⅞in), w 51.5 cm (20¾in).
Lost-wax cast glass, ground,
polished, and sandblasted.
Reid's sculpture grows out of a
physical and emotional reaction to
nature that is not language-based.
"I don't look at the meanings...
there's no overt message."

Right Untitled, 1997.
h 250 cm (98in), w 250 cm (98in),
d 250 cm (98in).
Kiln-cast optical glass; laminated
ash, ground, polished, assembled.
One of a number of commissions
executed during the 1990s,
this was commissioned by the
Standard Life Company and
installed at their offices in
Cutler's Green, London.

his commissioned work he combines cast-glass elements with other materials, such as wood or concrete. He also began using ideas developed in the larger work for new table-sized sculptures, which are, however, completely different from his earlier work. In the early work roughness was confined to edges, contrasting with smooth surfaces. In the later work the roughness becomes the subject matter. In his more recent large cast vessel forms the emphasis is on outer surface rather than inner space. The movement of earth and sea is felt in roughly textured surfaces, while small hollowed-out areas, often perfectly symmetrical, serve to introduce a note of calm. They are luxuriously finished in gold leaf or in some other, similar, sumptuous finish. The glass often rests on wood or slate, chosen to provide textural contrast.

Colin Reid's work has always moved forward and shown exciting development. The more he learns about this earth and the better he understands glass techniques, the richer his artistic offering becomes.

Below *Untitled, 1984.*
h 24 cm (9½ in), w 35 cm (13¾ in).
Lost-wax cast glass.
The piece is in two sections which fit together perfectly to form a whole.

Ann Robinson

BORN 1944, AUCKLAND, NEW ZEALAND NATIONALITY NEW ZEALAND

Below *"Nikau"*, *1991*.
h 84 cm (33 in), w 20 cm (7⅞ in),
d 20 cm (7⅞ in).
*24 per cent crystal, pâte de verre cast
glass. A feeling for symmetry and balance
in various colours give Robinson's
vessel forms an assertive presence.*

The wave of new ideas in glass that swept across the United States from the early 1960s was slow to arrive in New Zealand; until recently the glass community in New Zealand was small and isolated. Ann Robinson, like many New Zealand glass artists, is largely self-taught as a glass-maker, having taken a Fine Arts diploma at Auckland University and specialized in bronze casting. Lost-wax casting processes in bronze and in glass bear distinct similarities. Being far removed from other artists working in *pâte de verre*, the casting processes evolved by Ann Robinson make use of trial and error. A combination of isolation and imagination has resulted in some daring vessel forms distinguished by deeply carved surface patterning. Ann Robinson is dedicated to vessel-making, and to continuing the tradition in her own language.

Glass behaves temperamentally and it was only after endless research into glass batches and laborious experiments with different kinds of equipment that Ann Robinson was able to make some breakthroughs in glass-casting. She spent a whole year early in her career when everything she made broke. From 1980 to 1989, she worked at the Sunbeam Glass Works in Auckland, a collaborative studio set up by herself and two other New Zealand glass artists, Gary Nash and John Croucher. Since 1989 she has lived in Karekare on the west coast of North Island.

Material processes and the solving of technical problems have been a vital part of Ann Robinson's work. Finding a way of executing her artistic ideas has been inextricably linked with artistic content in her evolution as an artist. Risk-taking and problem-solving, with all their inherent emotional stress, have formed her as an artist. It is for her something of a triumph that she has learned to control cooling processes, which in her larger pieces can take as long as three weeks. Her art is entirely vessel-based, and her vessels have become larger and more confident with increasing technical control. Each vessel is related to the one made before it and a logical sequence is visible in her work. She says, "The bowl… is a form made throughout history, for thousands of years, by craftspeople. They have wrestled with the same thoughts that I have. I feel connected to human history through the working of the bowl."

Sometimes the vessels, especially the larger ones, are unique pieces; or they may be produced as a limited edition series, with pieces varying in colour. The work is highly decorative and has taken on a more sculptural feel as it has grown in scale. The control Robinson can now exercise in casting allows for a variation in the thickness of the glass, which provides a carefully considered play of light and shade. The vessels change as the light changes, giving them a sort of inner life that adds to their magic. Additional effects are achieved by surface treatment, often through finely etched rhythmic linear patterning.

The power of Ann Robinson's work comes from its bold simplicity, its vivid colouring, its controlled forms. She admits to being seduced by the material itself and declares her aim is "to make stunning things in glass".

Below left *"Large Wide Bowl"*, 1997.
h 18cm (7in), w 55cm (21¾in).
45 per cent crystal, pâte de verre cast glass. A beautifully crafted large ruby-red bowl, simple, strong, cast in a mould, and cold-finished with polishing.

Below *"Twisted Flax Pods"*, 1999.
Each: h 14cm (5½in), w 12.5cm (5in).
l 107cm (42in).
Three 45 por cent crystal forms. More recently Robinson has been exploring organic forms, which has also led her to mixing colours.

René Roubíček

BORN 1922, PRAGUE, CZECHOSLOVAKIA NATIONALITY CZECH

Above *"Two Heads: Dialogue"*, 1980.
h 89cm (35 in) & 82.5cm (32½ in).
*Two mould-blown clear and white
opaline glass sculptures in the
form of two abstract heads on clear
bases. This piece was awarded
1st prize for glass sculpture at
the Central Schweizer Glaspreis,
Lucerne, Switzerland in 1980.*

In 1958 René Roubíček was chosen as one of the artists to represent his country at the Brussels Expo. He did so with an installation composed of glass and metal, discs, bottle forms, a variety of glass bits and pieces, and a forest of metal rods. The piece was considered avant-garde for this medium – it was early in the history of contemporary glass for such individuality of expression, which so flouted the long-established traditions of the Czech glass industry. In 1967, at the Montreal Expo, Roubíček again caused shockwaves, with a huge object in the form of a pair of columns with shards of glass wrapped around them. For the Osaka Expo in 1970 he made a gigantic installation (8m [26ft] tall), called "Cloud, Water, and Fountain of Life". As yet the American glass artists had not made much of an impact, while in Czechoslovakia such freedom of thought had by this time become commonplace among glass artists, partly owing to restrictions forced on the industry by the Communist régime. With no home market for luxury products such as glass and little to occupy them, glass-makers looked to their inner selves for survival.

After 1970 René Roubíček was one of the artists punished by the régime for his artistic excesses, considered anti-establishment. Punishment did not stop him from exploring the expressive qualities of glass, although it had to be a more private occupation for a decade until he was again in favour, under a less totalitarian régime. Whether thinking big or small in scale, Roubíček has used hot glass techniques to create a range of strange imaginary objects, familiar yet unfamiliar, his own concept of animal, vegetable, and mineral. A globular form might have legs and horns, recalling something on this earth but clearly not of it. Clarinet-type objects in coloured and mottled glass might have cups hanging from them. Featureless busts are wrapped in glass threads. Delicious-looking cakes are made of glass. It is all cheerful work, expressing enjoyment of colour and form. Even though he lives in a country where glass is taken seriously and much discussed in art school circles, René Roubíček has managed to be a pioneer without being part of the glass inner circle, and despite having taught at the Prague's Academy of Applied Arts until 1968 (when he left to become a freelance artist). He and his wife Miluse Roubíčková, an artist who works in a similar style to his, live away from

the mainstream, despite residing partly in Kamenický Šenov, the heart
of the glass-making area of the Czech Republic, and partly in Prague.

Roubíček has exhibited his work widely and with success, particularly in
Europe and more recently in Japan. In his newer work he explores colour
and rhythm. Slabs of sheet glass set at an angle are studded with
carefully shaped clear glass shards or coloured tubes. The effect is of a
rectangular dartboard embedded with cheerful missile-like objects.
These are three-dimensional abstract paintings, made of glass. Roubíček
feels that his mission is to allow glass to speak for itself, to intervene as
little as possible; glass has a will of its own. "Glass always wants to be
free. I therefore usually think to liberate the glass and not to restrain it."

Jaromír Rybák

BORN 1952, PLZEŇ, CZECHOSLOVAKIA NATIONALITY CZECH

Jaromír Rybák's work has a certain quality of science fiction to it, seeming to inhabit some unfamiliar world where there is no clear distinction between animal, vegetable, and mineral. Do these works represent living beings with odd teeth and eyes where least expected, or are they strange structures invented by an altogether different type of being? They are at the same time utterly precise and completely obscure. Their distinctive colouring suggests that some life force other than blood inhabits them. They have an inner life of swirling bubbles and veiling. Colour seems to flow through them. Weird and wonderful, like living organisms from another planet, they fit uneasily into the sculptural pigeonhole where artistic convention would tend to park them.

Like so many Czech glass artists of his generation Jaromír Rybák received a thorough grounding in all aspects of glass-making by attending the Specialized School for Glassmaking in Zelezný Brod from 1967 to 1971. This generation of artists in glass started out to train for a career in the glass industry. But in the late 1960s or early 1970s those with talent found themselves in a new and exciting glass environment if they were able to continue their studies at the Academy of Applied Arts in Prague under Stanislav Libenský. Here they were encouraged to become artists rather than practitioners or designers in glass. Libenský urged his pupils to let glass have an inner life, inner meaning. Rybák, as well as many other Libenský pupils, decided that his artistic language was to centre around large-scale glass-casting, or, as the Czechs expressively call it, glass-melting. This technique allows much room for expression in terms of colour, form, surface decoration, and inner and outer structure.

After the training he had had, Rybák's decision as an artist to express himself in glass was a natural choice. He is an immensely gifted glass technician, able to translate his wildest imaginings into glass. As well as being an expert in casting he knows how to add a range of cold techniques, such as etching, engraving, and grinding. He is a man who seeks the elusive: "I'm searching for truth, which ought not to be found. Therefore I create my personal certainties, which make me happy, and I hope that I impart this to my friends as well." Rybák's sculptures seem to

Right "Silver Fish", 1997.
h 25cm (9⅞in), diam. 47cm (18½in).
Cast glass on metal support.
In the 1990s Rybák broke away
from the more formal Libenský-
inspired Czech tradition of abstract
forms in cast glass, to create
a menagerie of strange objects
and small monster-like creatures.

Below "Golden Gate", 1984.
h 32cm (12½in), w 32cm (12½in),
d 11cm (4¼in).
Cast glass, cut, polished, and
painted. In this early work, Rybák
is still exploring technique. His early
architectonic forms give no clue
to the wilder imagery that would
characterize his later work.

have an intense inner life. Voiling, bubbles, and bleeding colours inhabit the strange and precisely imagined shapes he creates.

In the Czech Republic glass commissions are perhaps more common than anywhere else in the world. A glass sculpture in a public place is a symbol of civic pride. Rybák has received his share of commissions for public buildings or restaurants in Prague and in his home town of Plzeń; internationally he is best known for his distinctive sculptures, which vary in size from table-size to life-size.

In the body of work he has built up Rybák seems to have created a family of cult figures, other-worldly yet somehow rooted in a European antiquity. Although there are references to creatures we recognize, particularly the fish, and shapes related to civilizations with which we are acquainted, overall the effect is one of an unfamiliar world. Rybák pushes both his imagination and glass technology to its limits, with exciting results.

Above "Headed Fish", 1997
h 19cm (7¼in), w 58cm (22¾in),
d 42cm (16½in).
Cast glass. Fish of all sorts have been used in a series of Rybák sculptures, their lens-like eyes, sharp teeth, and multitudinous forms used to evoke the essence of life and of nature.

Markku Salo

BORN 1954, NOKIA, FINLAND NATIONALITY FINNISH

Above *"Lighthouse", 1987.*
h 25cm (9¾in), diam. 25cm (9¾in).
Blown clear glass, metal
mesh construction.
Markku Salo plays around with
glass, using it to realize all the
fantasy of his fertile imagination.
The common factors that connect
his seemingly disparate ideas
are humour and clarity of thought.

Markku Salo combines a career as industrial designer for glass- and tableware at Nuutajärvi glassworks in Finland with making unique pieces for gallery exhibitions and museum shows. This is in keeping with the 20th-century tradition of Scandinavian studio glass, where artists employed as industrial designers also have the freedom to make their own work. At Nuutajärvi, where he has been since 1992, Salo has his own studio. Although he exhibits mainly in Finland, he has an international reputation and is regularly included in important group shows such as *World Glass Now* in Japan (1994) and *Venezia Aperto Vetro* (1996 and 1998).

Salo has a vivid imagination; his ideas are endlessly playful and the child in him is often at the forefront of his work. Sometimes the humour makes one laugh out loud, but usually it amounts to good-natured fun, both in his ideas and in the choice of the materials he combines. The ideas are simple and clear, making his glass an enjoyable experience. He says, "Glass is really not that serious. It is a very fast material. In just a few minutes you can materialize an idea and see if it turns out the way you want it to. Also, glass in itself is vivid, since it is always at play with light, looking different all the time."

Both the production work and the art he creates are important to Salo and he enjoys the contrasting environments of each. "Utility glass is more or less teamwork and you are always forced to compromise... It feels good not to be that selfish, to try to understand consumers' needs. At the other end of the line you have artwork, purely selfish and uninhibited." Salo reacts spontaneously to the world around him, to people's feelings and their lives, to nature, and the stark Finnish landscape. His work is very varied and he has not stuck to one technical process. He is an artist who does not need to shock, but his attitudes are unorthodox. At Nuutajärvi there are endless possibilities and he likes exploring them. He plays with colour, with blown glass, cast glass, pressed glass, glass of many colours, and with mixed media. He uses a variety of metal frames, and likes to blow glass into wire nets. Sometimes the frame is used to hold a single piece, but more often his work is a composition made up of bits and pieces, a series of connected ideas held within a metal frame.

Right "X-File", 1998.
h 30cm (11¾in), w 20cm (7⅞in),
d 20cm (7⅞in).
Pâte de verre. *Salo's work is
often characterized by his playful
coupling of forms or symbols, or
his combination of solid and fragile.*

In Salo's artistic work the tendency is to make work that covers a significant area, and it is not unusual for a piece to be 4m (13ft) high or wide. It is, however, usually made up of small individual elements. For *Venezia Aperto Vetro* in 1996 he made a series of crazy bottles that stood on a roughly constructed white-painted table that was plugged into electricity and vibrated. The bottles were different shapes, sizes, and colours but conceived as a homogenous crowd. For the 1998 exhibition Salo made a huge, shaped curtain that looked like a screen made of frost and was inspired by the icy landscape of the Finnish winter. It was composed of small segments held together with nylon wire. The construction was ingenious but so perfectly suited to the artistic idea that it was hardly noticeable. His own words best sum up this engaging work: "I like to have fun when I'm working and think you are also much more productive when you are having a good time."

Below "Spring", 1999.
h 10cm (4in), w 170cm (67in),
d 120cm (47in).
Pâte de verre. *The ice, frost, and
snow of the Finnish landscape are
often an inspiration. A simple poetic
image evokes winter turning to spring.*

Timo Sarpaneva

BORN 1926, HELSINKI, FINLAND NATIONALITY FINNISH

Timo Sarpaneva, artist in glass, designer in clay, metal, fibre, and wood, visionary, and living legend, has always risen above the obstacles in his path, be they economic decline within the glass industry, changes in fashion, or the risk of artistic burnout. He has worked in glass for more than half a century and still has dreams he needs to fulfil. He has always been an innovator and, long before American intervention in glass art, had aspirations as a sculptor and independent thinker in glass. He won acclaim and became famous in the mid-1950s with his spectacular successes at the Milan Triennales, which included a Grand Prix award there in 1954. In the same year the American magazine *House Beautiful* named a vase of his their "most beautiful object of the year". In a slightly modified version, that vase is still in production at the Iittala glassworks:

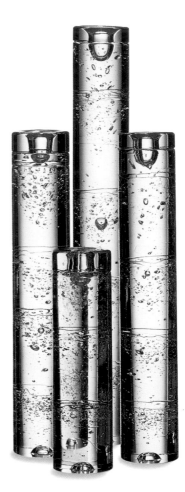

Above "Archipelago", 1978.
h 20cm (7¾in), 45cm (17¾in), and 60cm (23¾in).
Solid glass with internal air bubbles. A new manufacturing method was devised for the "Archipelago" series, which was used for both sculpture and stemware.

Left "Wild Apple", 1996.
h 40cm (15¾in).
Blown glass. Made in collaboration with Lino Tagliapietra. Sarpaneva is as capable of enigmatic sculptures as he is of utter simplicity.

while it looks beautiful as a vase for a single orchid, it is usually referred to simply as a glass sculpture because it is so much more than just a vase, its transcendental qualities setting it apart. Sarpaneva went on to make a number of pieces in the same vein – "Kayak", the "Lancet" vases, and "Sleeping Bird" among them – and they too are considered classics.

Throughout his career Sarpaneva has been inspired by the rugged Finnish landscape with its extreme weather conditions, endless day in the summer months, and in the winter the transformation of lakes and forests by snow and ice. He brought nature into the glass industry with brilliant inventions such as the carved and charred wooden moulds that he used for a series of sculptures, some of them up to a metre high, known as the "Finlandia Sculptures". The moulds were prepared so as to leave an impression of scored bark on the surface: a texture never before seen on glass. It is typical of Sarpaneva that he thought of adapting this technique for industrial applications, using it to produce a "frosted" surface on a vodka bottle and schnaps glasses.

During the 1980s Sarpaneva produced his "Claritas" vases, a series comprising 66 different basic types. These can best be described as bubbles of air surrounded by glass, sometimes clear, sometimes white, sometimes black. "I wanted to seal bands of eternity onto the silence of glass. I wanted to deposit this fast-fading present moment there, in all its fragile beauty." Also in the 1980s came his "Glass Age" collection, sculptures weighing hundreds of kilos in clear or green tinted glass. The rock-like sculptures, sitting on granite bases, look as if they came into being as a result of some primeval explosion. With evocative titles such as "Demons", "Panther", "Winds", and "Memory", they are restless works full of energy, described by Sarpaneva as "art that gives us space inside the mind and breaks the fetters of dogmatic thinking".

Still bursting with creative energy in his seventies, Sarpaneva renewed himself by preparing an exhibition in Helsinki for the year 2000, which he called *Millennium Meum*. In it he revisited some of his old ideas, this time working together with Venetian glass *maestri*, in particular Pino Signoretto. In collaboration with this other great master Sarpaneva's aesthetic ideas yet again take on a new beauty and a fresh sensitivity.

Below "Liber Mundi", 2000.
h 63cm (24¾in).
Hot formed glass. Made in collaboration with the Pino Signoretto Studio. Throughout his career Sarpaneva has remained a pioneer, always ready to brave the new, whether it be working within a new team or delving into his own imagination. In this piece, colour flows inside the glass with the liquidity of water.

Mary Shaffer

BORN 1947, WALTERBORO, SOUTH CAROLINA, USA NATIONALITY AMERICAN

Left *"Nail Pillow"*, 1974.
h 41cm (16in), w 41cm (16in),
d 26cm (10⅛in).
Slumped glass and nails. By
slumping glass Shaffer creates
the illusion of glass as a soft,
pliable material like a textile. The
hardness of the nails against
the apparent softness of the
glass adds a touch of surrealism.

Below *"Maquette Mamoure"*, 1986.
h 31cm (12⅛in), w 6cm (2¼in),
d 8cm (3in).
Slumped fused glass and iron.
Once again hard and "soft" make
a suggestive contrast that has
sexual and sensual connotations.

Mary Shaffer has been working as an artist in glass since the 1970s and has stayed with the pioneering technique that first attracted her to the material. Her work is instantly recognizable and has an integrity born of remaining faithful to the particular process she chose at the start of her career as an artist in glass: the technique of slumping glass, or letting it assume a shape dictated by gravity and force of circumstance while still warm. She majored in fine art at Rhode Island School of Design, but like all students there at the time, must have been aware of the excitement in the glass workshop under the leadership of Dale Chihuly.

Fritz Dreisbach, another member of the glass department, suggested the idea of slumping glass to Shaffer, a suggestion probably inspired both by Shaffer's attraction to glass and by her desire to add a third dimension to her work as a painter. Before Shaffer used slumped glass in an artistic context, it had been used by other American artists or glass designers during the 1970s (Frances and Michael Higgins, Edris Eckhardt, Maurice Heaton), using moulds into which they slumped glass to create vessel

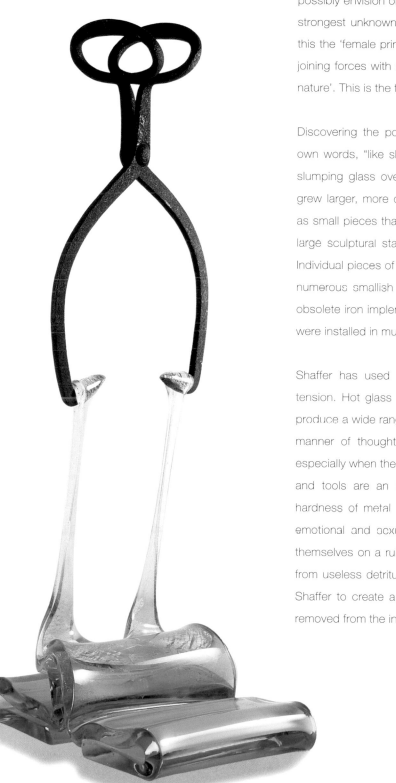

forms or small figures. Shaffer developed a process that she calls "mid-air slumping". She describes her work thus: "The structural system I create allows the glass to move with a fluidity and freedom you can't possibly envision or create with a mould. Because I work with gravity, the strongest unknown force in the universe, I say I work with nature. I call this the 'female principle' in the Jungian sense – the idea of yielding and joining forces with nature, versus the 19th-century attitude of 'man over nature'. This is the fundamental philosophy behind my work."

Discovering the possibilities of slumping glass was for Shaffer, in her own words, "like skiing down a virgin slope". Her experiments involved slumping glass over objects in all sorts of materials. The work quickly grew larger, more confident, and more ambitious in scale. What began as small pieces that acted as maquettes, or test pieces, developed into large sculptural statements or wall pieces that covered an entire wall. Individual pieces of sculpture went to make up "Tool Walls", consisting of numerous smallish pieces in which slumped glass was combined with obsolete iron implements picked up in scrapyards. Shaffer's "Tool-Walls" were installed in museum and gallery shows throughout the 1990s.

Shaffer has used slumping as a means of expressing emotion and tension. Hot glass arrested in its natural state of flux by slumping can produce a wide range of sculptural shapes. These can in turn suggest all manner of thoughts about movement, mood, relationships, tensions, especially when the glass is used in dialogue with other materials. Pulleys and tools are an important part of Shaffer's artistic vocabulary. The hardness of metal against the softness of slumped glass has obvious emotional and sexual connotations. Remnants that might have found themselves on a rubbish tip take on a new life in her work, transformed from useless detritus into artistic devices. The slumping process allows Shaffer to create a new existence for these nearly forgotten items, far removed from the industrial environment from which they came.

Left "Fragile Ice Tong", 1996.
h 76cm (30in), w 51cm (20in).
Slumped glass and metal.
Shaffer combines old tools with
glass in her mixed-media work, in a
way that gives their original function
a further symbolic significance.

Ryoji Shibuya

BORN 1956, SAITAMA, JAPAN NATIONALITY JAPANESE

Above *"Memory Of Time '90-V",*
1990. h 41 cm (16 in), w 44.5 cm
(17½in), d 43 cm (17 in).
Cast pâte de verre, *polished,*
engraved on the side.
Shibuya uses glass to give material
presence to his thoughts about
the cosmic and the metaphysical.

Ryoji Shibuya works in *pâte de verre*, creating imaginary scenes in smoky colours, usually set within the glass mass. These are quiet, deserted places, often with a flight of stairs leading the eye inward and upward, and disappearing into the distance. There is a ghostly feeling about the dimly lit interior spaces he creates in this way. Sometimes the stairs are on the outside, climbing to a shrine or monument with pillars. Whatever his subject, the mood is one of something half-remembered, a dream-like vision, a mysterious journey. The monuments are always some sort of shrine, as indicated by titles such as "The Shrine of the Sea" and "The Shrine of the Stone". His work can be quite large in scale, sometimes measuring up to a metre in height. Shibuya's inspiration comes from classical ruins seen in Greece and Italy, where he was moved by the way these had survived and lived on to tell of past civilizations. His own work draws its strength from the heroism of those structures.

Shibuya trained as a sculptor and graduated in 1981 from the faculty of sculpture at Tama Art University in Tokyo, going on from there to do a graduate course at the Tokyo Glass Art Institute, Kanagawa (1981–84). Further graduate studies were in Europe at the Gerrit Rietveld Akademie in Amsterdam, a school with an international flavour, where the leaders of the glass course, Richard Meitner and Mieke Groot, were used to dealing with the strict formality of students trained in Japan. On returning to Japan after two years Shibuya began teaching at his old school in Kanagawa; in 1990 he moved to Toyama City, where he was one of the founders of the Toyama City Institute of Glass Art. During the decade that he has been at Toyama, where he is now a full professor in glass, the glass course has become one of the most respected in the eastern hemisphere, with basic and advanced courses in every possible glass technique. It is one of the few educational establishments in Japan that encourage conceptual exploration in glass, and visiting artists from the West are invited to give master-classes or work as artists in residence.

Shibuya has done a great deal to further the art of glass in Japan. He is a recognized master in his own area of kiln work and *pâte de verre*. Under his influence the idea of creating abstract forms in glass has developed

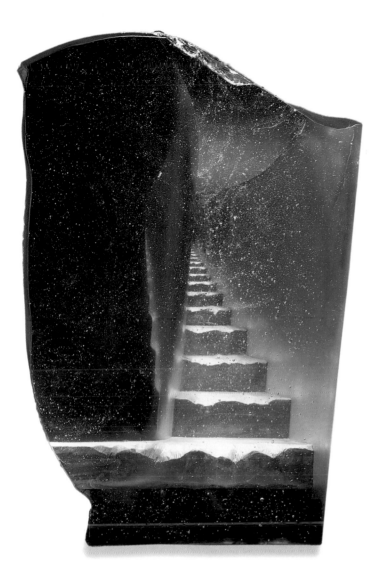

greatly among Japanese glass-makers. He has encouraged his students to think in three dimensions and to express themselves freely, in a bid to introduce a new mood into this area of the decorative arts in his native country. Students are encouraged to develop their ideas by drawing, clay-modelling, discussion, and writing research papers, a process based on his own student years, particularly in Amsterdam. Shibuya himself uses a variety of techniques in his work, including polishing and engraving. His aim is that his students learn as much about technique as they can while at the same time developing their creative forces.

For Shibuya teaching is an important part of the learning process. It has enabled him to meet a group of internationally renowned artists on home ground, and in working with them he has been able both to introduce them to Japanese tradition and to absorb some of their own culture.

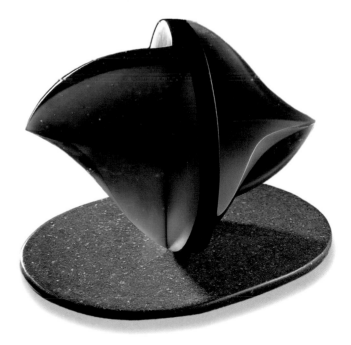

Anna Skibska

BORN 1959, KLUCZBORK, POLAND NATIONALITY POLISH

Above "Tornado", 2000.
h 270 cm (106 in), diam. 60 cm (24 in).
Lampworked transparent glass.
Dogged persistence and a
never-ending sense of fun make
Anna Skibska the unusual artist
in glass that she is. One longs
to see what cage-like constructions
in lampworked glass she will
think of next.

Anna Skibska graduated from the State College of Fine Arts in Wroclaw in 1983 with a diploma in painting, glass design, and graphic arts, and she returned to the state college to teach design, fine art, and architecture. After graduating she made stained glass for a while, before discovering a way to work that has made her the internationally acclaimed artist she is today. In a completely original and personal way she uses essentially a simple traditional flameworking technique to make clear glass sculptures that look as if they have been knitted or woven. They are sometimes monumental (up to 12m [40ft] high), despite the delicate fabric of which they are made. This is strong work, but with a fragility that is touching.

The technique used by Anna Skibska has traditionally been used to make small pieces such as little glass animals or glass flowers although, in the recent history of glass, flameworking has become much more varied and artistically ambitious. The way Skibska uses a blowtorch requires endless patience and a knowledge of how far she can go technically without the piece breaking into a thousand bits. At first she made small pictures that poked good-natured fun at totalitarianism. Her humour has always been free-spirited. "I was always free," she says. "Glass breaks in America as it breaks in Poland."

Ordinary things, animal, vegetable, or mineral, attract Skibska's attention and become the subject matter of her work. She takes the mundane and with wit, humour, and intelligence gives it a new spin. Irony is never far from her treatment of the simple things she portrays – a sunbeam, a dream, an encounter with a friend. Her exposure to an audience outside Poland occurred with the liberalization that took place in Eastern Europe after the fall of the Berlin Wall. Her first visits to the United States in the early 1990s meant the discovery of a new world. The visual impact of skyscrapers, the skyline of New York, the mix of cultures delighted her. The freedom of expression that she found among American glass artists opened up a new vista of conceptual possibilities for her. Glass moved from being what she calls "on the borders of art", to mainstream artistic endeavour. She has made Seattle her second home.

Skibska's work is pure construction and her lampworked glass resembles very delicate architectural parts almost too fragile to handle. They weigh practically nothing, but because of their large scale that fact is difficult to take in. Wherever light hits these loosely knit structures there is sparkle; the light literally dances off them. This is like no other glass sculpture; nor does it imitate any other form of sculpture. It is a completely original concept and one that could only be effective in clear glass. Large panels, or columns, or spire-like shapes recall moments in her life, as their titles suggest – "Two Sunbeams", "Ginny R. with Studley the cat". One gets the feeling that Anna Skibska likes to tickle our senses: "With this thread I shall build my empire," she says.

Paul Stankard

BORN 1943, ATTLEBORO, MASSACHUSETTS, USA NATIONALITY AMERICAN

Below "Crown Imperial Lily Botanical",
1988. h 15cm (6in), w 7.5cm (3in).
*Flameworked soda lime glass
paperweight. The heart and soul
of Stankard's work is flameworking,
a technique that dates back
to Roman times or earlier.
Individual (sometimes minute)
flameworked parts are worked
into a sculptural whole.*

During his long career Paul Stankard has brought the art of the floral paperweight to new heights with a degree of botanical detail hitherto unparalleled in this art form, which was once considered to have peaked in 19th-century France at Clichy, Saint-Louis, and Baccarat. Stankard is almost alone among contemporary American paperweight makers to be considered a serious glass artist. Making a floral paperweight involves botanical drawing in miniature using an oxyacetylene torch to melt and shape thin canes of coloured glass. Flameworking requires untold patience, a high degree of technical skill, and a poetic eye that revels in detail. The artist's tools consist of a humble array of home-made instruments, tweezers or scissors adapted to manipulate canes sometimes no thicker than a thread. Flameworked compositions are embedded in a block of clear crystal, providing a dramatic *trompe l'oeil* effect and drawing the eye into the body of the glass. The clear crystal also creates an illusion of flora and fauna suspended in space.

In the world of contemporary glass, where scale has become larger and larger, Stankard's work is distinguished by its smallness. His shapes are essentially those that have always been prevalent for paperweights: spheres, hemispheres, and cubes. He started out as a glass-blower in the scientific glass industry and began making paperweights as a diversion, in 1980 beginning the "Botanical Series" for which he is known. His art is the art of hyper-realism, being true to nature but without being pure imitation. Sometimes Stankard likes to trick us, with flora that look real but are pure invention, a parallel fantasy world of his own creation. He is a religious man and brings a very personal love and understanding of the botanical world to the medium in which he works.

The Art Nouveau master in glass Gallé also drew on the natural world as his chief source of inspiration. Gallé's symbolism is directly related to a tradition set by the 19th-century symbolist painters; Stankard's symbolism belongs to a private world of his own creation. Where he incorporates roots or the subterranean world of plants into his work, the intention is to highlight the differences and the connections between light and dark. The downward thrust of roots digs deep into the earth in order

to feed and sustain the world of colour and light above. These two worlds, one dark and arcane, the other sunny and bright, are drawn with equal verisimilitude, representing the opposing forces of nature together.

Stankard also makes combination pieces with a series of separate unrelated images creating what he calls "botanical mosaics". In these, different flameworked floral or insect clusters are arranged in a patchwork composition inside the body of the glass. In the early 1980s Stankard introduced his "root people". These tiny, pale, monochromatic male and female figures dance among the roots, life-giving humanoid symbols. Sometimes cane-worked words ("wet", "seeds", "fertile", "light") in tiny letters, barely legible to the naked eye, are "secretly" incorporated into the work. Stankard's impressive body of work places him among the best-loved and most popular of American glass artists working today.

Above "Sunflower Banded Botanical Block", 1995. h 7.75cm (3in). Flameworked and laminated soda lime glass paperweight. Stankard takes care to see that his creations, while not biologically perfect, achieve what he calls "organic credibility". He works in glass in the same way that a botanical artist might work in another medium, allowing himself some degree of artistic licence.

Right "Coronet & Blueberry Paperweight with Damselfly", 1997. Diam. 8cm (3in). Flameworked soda lime glass paperweight. Different members of Stankard's team now work on their individual specialities, one a specialist in fashioning insects' wings, another in flower petals or berried fruit. In the beginning Stankard did all this detailed work by himself.

Lino Tagliapietra

BORN 1934, VENICE, ITALY NATIONALITY ITALIAN

Above *"Noce dell'Amore"*
(Night of Love), 1982.
h 30cm (11¾in), w 15cm (6in),
d 16.5cm (6½in).
Free-blown black opaque glass
overlaid with brown opaque
glass. A lifetime of perfecting
the techniques that he began
learning as a teenager has earned
Tagliapietra a reputation as the best
Venetian glass-blower in the world.

The language of glass as spoken on Murano gives a name to every conceivable trick or technique of Venetian glass-making. It has grown over many centuries, with each new generation of Venetian glass-blowers adding a term or phrase that corresponds to a new development or a new idea. Lino Tagliapietra, born and bred in the "closed shop" environment of the Venetian glass fraternity on Murano, learned the complex language of glass-making as a matter of course from an early age. Apprentices on Murano begin by sweeping the factory floor. The journey from such humble origins to the position of one of the world's leading glass artists has required courage, determination, and patience. Tagliapietra had no special advantages at the outset; he worked his way to the top making the most of the opportunities that came his way. In the process he has been largely responsible for the adoption by glass artists worldwide of the Venetian way of making glass, or *façon de Venise*.

By his own admission, Lino Tagliapietra showed no special talents in the beginning. The goal to which every glass-maker on Murano aspires is to become a *maestro vetraio* – a title given in recognition of the ability to perform a huge variety of glass-making skills well enough to head a team. Tagliapietra took longer than some to achieve this recognition, but believes that this allowed him to learn processes more thoroughly than some of those who achieved success earlier. His greatest skill has always been blowing glass, forming it by filling the glass bubble with breath. It is an art form where endless practice and an innate artistic understanding of the medium are basic essentials.

The first opportunity that Tagliapietra had to show his talents was at the exhibition of San Niccolo (the patron saint of glass-makers). This annual event in Venice was practically the only showcase for Murano glass-makers, who otherwise spent their lives in the service of the industry. On this occasion Tagliapietra made the first of his "Saturno" pieces. The name refers to the planet Saturn; the piece was a perfect sphere dissected by a wide ring collar. To create this he invented a special technique, which left his Venetian colleagues mystified. Their puzzlement was his first great success; the piece also showed that he had an appetite

for technical invention. He has since blown this shape many hundreds of times and it is one of his "party-pieces", a sort of signature tune. Its colour, size, and decoration change with time, each successful piece in the series demonstrating a new technical and artistic variation.

Lino Tagliapietra's first real chance to develop his own artistry came after 1976, when he was appointed artistic director of Effetre International, a glass company on Murano. Before that, as part of his long apprenticeship, he had worked in several glass factories, including Archimede Seguso, Galliano Ferro, and Venini (1966–67). At Venini he had watched some of the greatest designers at work, including Tapio Wirkkala from Finland and the renowned Venetian architect Carlo Scarpa, and was overwhelmed both by their imaginative ideas and by the way in which it was possible to realize new ideas in glass at Venini. He says the greatest single influence on him was the Dutch glass designer Andreas Dirk Copier, whom he first met in 1976. "He was the first to speak to me, perhaps a bit late, about how to look at a piece of glass as a work of art." They produced some beautiful objects together, which were exhibited at the Gemeentemuseum in The Hague in 1982.

Above "Saturno" (Saturn), 1990. h 27cm (10¾in), w 27cm (10¾in), d 27cm (10¾in)
Free-blown glass, the two sections joined by the incalmo technique. The perfect hot fusion of two glass shapes is a tour de force of glass-blowing and one that Tagliapietra has enjoyed repeating in various colours and sizes since he first mastered the skills required to make it.

Left "Saturno", 1995. h 74cm (29in), w 84cm (33in), d 13cm (5in).
Free-blown clear glass and coloured glass joined by the incalmo technique and including canes with a double spiral pattern, the surface cold-worked. The many different techniques, both hot and cold, involved in making this piece form the basis of the aesthetic pleasure derived from it.

Above "Feomina", 1997.
h 42 cm (16⅛ in), w 35.5 cm (14 in),
d 20 cm (7⅞ in).
Free-blown red glass with red
canes, cold-worked on the surface.

Lino Tagliapietra left Venice for the first time in 1979, when he gave the first of his many classes at the Pilchuck Glass School in Seattle. This was an experience that changed his life. He fell in love with the open-minded attitudes of the Americans involved in glass-making. In the United States there were no secrets. The mystery and magic of glass were something to be shared by all, unlike in Venice, where sharing technical knowledge was generally considered gross disloyalty. Tagliapietra was amused by the way his students, and even some of the teachers, made glass. They were doing it all wrong and he helped them to do it right. He was working with some of the greatest talents in America (among them Dale Chihuly, Dan Dailey, and Dante Marioni, with whom he would eventually establish a close working relationship) blowing or teaching them to blow glass shapes that they could not have made without his help.

In 1986 Tagliapietra quit his job with the Venetian glass industry to devote his time to collaborating with others and working on his own creations in glass. He was in great demand all over the world, both as a teacher and as an interpreter of artistic ideas, fully attuned to the spirit of independence that had swept through the glass world. This was beginning to influence his own work, which until then had been very much confined to responding to industrial convention with vases, carafes, bowls, or lamps. He was no longer obliged to respect commercial considerations. His palette became richer, with dramatic swirling colour

Left "Batman", 1998.
h 20 cm (7⅞ in), w 43 cm (17 in),
d 8 cm (3 in).
Free-blown opaque coloured glass
with superimposed two-colour
canes, cold-worked on the surface.

effects, though always based on more or less traditional Venetian techniques. The decorative designs were based on different techniques for combining colour, either by using glass threads or broader bands of contrasting colours, or by joining two different coloured bubbles of glass, a technique known as *incalmo*, requiring great technical expertise. He felt free to introduce bold variations into his designs, which would have

been disallowed in the industry as too time-consuming and perhaps too expensive for series production work. The vessel shapes loosened up, with the *Saturno* leitmotif appearing in unexpected places, wide folded collar rims, and occasionally a touch of asymmetry. Working with leading American artists was having an effect on him, although he never copied their ideas.

In July 1988, after they had known one another for nearly ten years, Chihuly asked Tagliapietra to collaborate with him on a series inspired by 1930s' Venetian glass. Tagliapietra headed a stellar team of American *maestri vetrai*, many of whom had learned from him. Working with Chihuly liberated him further. He saw what could happen when such an artist, with love for Venetian tradition but not necessarily too much respect, let his imagination wander. Chihuly's "Venetians" were outrageous exaggerations of a more respectful Venetian style. Tagliapietra saw that breaking the rules and artistic licence were the way forward for him too.

In the late 1960s glass blown the irreverent American way with no respect for its history had reflected fine art trends and showed the influence of the American Abstract Expressionist painters. This had its limitations and from the mid-1970s to the late 1980s technical exploration went a hundred different ways. Tagliapietra's influence brought hot glass back to the forefront. The Venetian way of making glass became the fashion of the 1990s, with Tagliapietra hailed as its most brilliant exponent. He was overwhelmed with invitations to do exhibitions, especially in the United States, and Americans went wild for his work as "the genuine article".

Pressure to produce his own work for exhibitions encouraged Tagliapietra to broaden his horizons. He invented a range of new shapes that are recognizably his own, and his vessels grew in scale. One favourite basic shape was a tall teardrop shape, very narrow at the base, with a broad shoulder near the rim, narrowing to a tiny neck. The tiny narrow neck became a feature and was repeated in other, fatter forms. In homage to his Venetian origins Tagliapietra also experimented with gondola shapes. Using coloured glass threads to create filigree and patterns, he extended his *zanfirico* range of patterns beyond all recognition. His work became much more expressive, and titles such as "Cathedral Window", "Venus of Lino", "Autumn", "Piume" (Feathers), and "Eden" are indicative of his desire to capture a wider range of impressions in glass.

In a further bid for freedom Tagliapietra built his own studio on Murano, enabling him to produce exactly what he wanted. Heeding advice to make bigger, bolder statements, he began making groups of work with family associations and whose relationship to each other extended his concept of composition. In 1998 for the second *Venezia Aperto Vetro* glass biennial, he made a series of long gondola shapes arranged in suspended groups. The effect was a riot of colour and, in this setting – a room in the Ducal Palace – a poignant statement in glass.

Tagliapietra's enthusiasm, his great love of glass, and his generosity to fellow artists have made him one of the most loved personalities in his field. He has left an indelible mark on the course of late 20th-century glass and a body of work that has given new meaning and new life to the world of Venetian glass.

Below *"Concerto di Primavera"*
(Spring Concert), 2000.
h 210cm (82in), w 244cm (96in),
d 56cm (22in).
Assembly of hand-blown coloured glass with black canes, some with partially and some with wholly cold-worked surfaces, the cuts varying from piece to piece, on metal stand. As the title suggests, this piece is intended as a symphony of spring colours.

Bertil Vallien

BORN 1938, STOCKHOLM, SWEDEN NATIONALITY SWEDISH

Bertil Vallien's work has been a narrative about what goes through his mind on a daily basis, more detailed and visual than a diary could ever be, more expressive than words. He thinks about the technicalities of glass production and creation, in particular the technique of sand-casting, which he has made into one of the most expressive and original glass techniques. Over 40 years Vallien and his associates at the glass firm Kosta Boda have built an entirely new language in glass. As an artist Vallien has wanted to record his thoughts about man and his world. He has always used symbols to encapsulate and shape his thoughts, and they have been key elements in putting his message across. In his early work he acted as a story-teller in glass, making bowls and vases busy with imagery. With the passing of years, narrative has given way to introspection and deeper thoughts.

Vallien graduated with honours from the School of Arts, Crafts and Design in Stockholm, and then spent two years travelling and learning in the United States and Mexico. In 1963 he began designing for Kosta Boda glassworks at Åfors in southern Sweden making tableware, decorative household objects, vases, and bowls. By the 1970s Vallien had become one of the best-known glass designers in Scandinavia. He also worked in Kosta Boda's studio glass department. Eventually it became necessary to devote a whole glassworks to his artistic output because of the innovative sand-casting techniques he had introduced and the demand for his increasingly large-scale artistic work. The sand-casting division of Kosta Boda has been custom-built to suit his requirements.

The early studio glass pieces were cased glass bowls and vases, where the outer layer was often iridescent and the decoration a sandblasted cast of figures and symbols that could tell a story. The key character was often a flying male figure wearing a top hat, alone or in the clutches of a bird of prey. There were imaginary buildings, churches, and hilly landscapes with animals and starry skies. It was a romantic account of the artist's setting out on his voyage through life. In the mid-1960s he began using his symbols to create sand-cast sculptures. He had been searching for a simple method of creating sculpture in glass which would allow him

Below *"Captivity"*, 1978.
h 20.5cm (8in).
Sand-blown and sandblasted layered glass, iridescent colour. In his early work Vallien's landscapes and figures are those of fairytales or dreams. The main recurring (autobiographical) Icarus-like figure, nude and wearing a hat, is seen winging his way through an imaginary landscape with ladders, doors, and stairs.

Below "Vaso Donna", 1986.
h 55cm (21¾in).
Sand-cast glass with coloured
glass threads. Mounted on stone
with a metal rod. The female
form can also be seen as Vallien's
boat form upended. There is
a timelessness about the vase
sculptures, with their antique
finish and amphora shapes.

Right "I lead 9", 1996.
h 20cm (7⅞in), diam.
28.5cm (11¼in).
Sand-cast glass, coloured
oxides. A head with devil-like
horns and symbolic red marks
conveys the artist's anxiety and
fear, his concerns for the survival
of the human race and of the earth
itself in the face of opposing forces.

ample artistic freedom. In sand-casting, negative shapes are carved or incised into a bed of sand; hot glass from a ladle is then poured into the bed of sand, which acts as a mould. While the glass is still hot it can be manipulated further. After annealing it is lifted out and can be cold-worked. Vallien has invented many refinements to this process.

What began as an experiment has developed in many different ways. A whole range of tools has been developed for manipulating the hot glass. Vallien devised ways of embedding objects in the glass and of varying surface texture. One of his best-known sayings is "Glass eats light", referring to the way in which light is contained within the glass mass. In his work, where glass has been in contact with sand, the surface is matt and does not let light in. But where the surface roughness has been polished smooth, the light pours in, creating the illusion that it is trapped inside the glass and is shining out from within. Vallien is a master of controlling this inner light, which for him adds to the spiritual and symbolic content of his work.

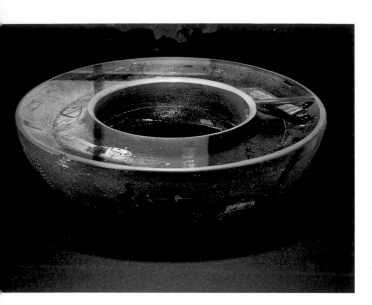

In the early sculptures a collage of symbols delivered the message. At the start of the 1980s Vallien's work changed, basic geometric forms becoming the framework for his sculpture. For a body of work he chooses a (usually English) title that represents a basic idea. The idea takes shape, evolves, ends; it is then time to go on to the next. In the series, "Houses and Bridges", he explored the many associated spiritual and social concepts. Geometric forms expressed opposing forces, while symbols acted as the key to more specific subject matter, a way of bringing metaphysical ideas down to earth.

In 1984 the idea of casting a boat form came to him. It was the perfect vehicle for his kind of symbolism. In itself the boat has a great many symbolic associations. In Viking tradition it represents the passage from life to death. It is a carrier, a vehicle that can go on voyages to unknown lands or back home, voyages of discovery, self-discovery, or escape. It is a vessel, a container of human beings, of cargo, of thought, and of light. The thematic possibilities are endless. It also opened up new technical challenges, particularly in two areas, the first being colour, the second the possibility of creating an inner world of symbols by embedding objects in the molten glass. Colour could be added to the surface of the glass by adding a thin layer of coloured powders to the bed of sand. Objects embedded in the glass act like words: "I choose some words, after which I shuffle in almost any order. They then present a meaning which I could never in my wildest fantasy ever think of. The circumstances contribute immensely." Vallien implies that the process of making itself directs and orders his thoughts. The vocabulary he builds up in this way contains favourite words or symbols, among which are the ladder, the ring, the cross, the staff, a wire-wrapped glass mummy, symbols of life, death, travel, discovery.

During the "boat" period, the boats became more complex in symbolic content and larger in size until they were enormous. The boat was turned on its end and became a standing stone, opening up a new range of symbolic possibilities. This new vertical form spread out into cruciform sculptures and also took on a human shape, becoming a torso. The torsos became masks and led the way to a new body of work. In 1989 Vallien took a year's sabbatical from Kosta, using the time to free up his thinking and become fully creative. A major breakthrough came in 1991 with the exhibition *Area II*, an installation in the ruins of Borgholms Castle

in Öland. The colour blue predominated, a cobalt blue, the colour of a midnight sky, creating a more sombre and reflective mood.

The exhibition acted as a catalyst for the next body of work, the "Map" series, the "Findings" and "Watchers" series, and a series of heads, masks, and faces. In each of these a simple exterior, its form inspired by the basic geometry of Modernism, contained an anxious inner life made of a growing language of symbols that widened the scope of his subject matter to incorporate references to history and archaeology. These connect past and present, symbolizing man's journey through history and the human condition now. The faces and masks are expressionless but they suggest fear or longing, love or hate. Sometimes the mask is the sculptural form, sometimes it peers out from another form, a trapped soul. There was also a move towards total abstraction during the 1990s, although references to the human figure were never altogether absent. Recently Vallien has used mixed media, particularly granite or metal. With

Below "Sleep", 2000.
h 32cm (12¾in), l 53cm (20¾in).
*Sand-cast crystal, wooden base.
A mysterious light glows from
within the form, the inner light
of our dreams. Vallien talks of
imprisoning light within the glass
mass, hence his description
of "glass eating light".*

the "boat" series, wires suspended the forms in space, to give an impression of floating. Long slender granite bases, sometimes inscribed with hieroglyphs, act both as supports and as bodies for glass heads.

By the turn of the century Vallien had reached a point where he could draw on the vocabulary of a lifetime to create ever more powerful imagery, with dramatic statements replacing questioning narratives. Despite the darker subject matter Vallien remains the most cheerful and convivial of human beings. He has been a team member always willing to recognize the contribution of others at Kosta Boda. As a teacher he has spread the word about the art of casting in glass, both in his own country and at numerous schools throughout the world. As an artist his contribution has been to create a new language in glass that will be used for centuries to come. The exploration into sand-casting has only just begun and yet it is difficult to imagine anybody being able to express themselves more imaginatively or more fully in this medium than Bertil Vallien.

Mary Van Cline

BORN 1954, DALLAS, TEXAS, USA NATIONALITY AMERICAN

Below *"The Enigma of Time"*, 1982.
h.56cm (22in), w.32cm (12½in),
d.26cm (10¼in).
*Photosensitive glass, cut and
laminated plate and cast glass.
By incorporating photography
into the artistic framework of
contemporary glass, Mary
Van Cline has added a new
dimension to the art form.*

Mary Van Cline combines cast glass with photographs printed on photo-sensitive glass in her installations, in which other materials such as wood and patinated copper or bronze can also feature. The combination is both unusual and effective. To a certain extent the flat imagery of the photography influences Van Cline's treatment of all the other materials. Her free-standing installation work has the flattened quality of cut-outs. Sometimes the flat imagery of a photograph extends beyond the photograph in three-dimensional form: the impact of flatness thus becoming three-dimensional is both a visual and a sensory trick. Pieces stand a metre or more high, their flatness further emphasized by their verticality. The work is beautifully crafted with a precise, machine-like finish and no areas of indecision. This kind of perfect execution gives the same kind of pleasure as might be derived from a well-designed precision instrument, yet the work is in no way mechanical; rather, it is full of thought-provoking imagery and spiritual symbolism.

Van Cline spent ten years pursuing various kinds of study, much of it art-related, first taking a Fine Art degree at North Texas State University, then studying at Texas Women's University (1971–77). This was followed by further studies at Penland School of Crafts (1979–80) and a Master of Fine Art at Massachusetts College of Art (1980–82). In 1988 she spent six months in Crete, taking the photographs that she would later incorporate in her glass constructions. She then settled in Seattle, where she has lived ever since, teaching from time to time at the Pilchuck Glass School (as well as at many American and foreign universities).

In her own artist's statement, in which she refers to herself in the third person, she says: "Van Cline's work is rich in symbols which work on many levels… The figures in her photographs span the ages in their anonymity, while the very process of photography stops time altogether. [The work] invites us to find our own balance within the piece, both visually and spiritually. The architectural aspects… give us a familiar point of departure. However, we are quickly asked to accept the work on a metaphysical rather than a literal level." The landscape photography in Van Cline's work (taken on her Hasselblad camera) often incorporates a

Left "Installation", 1989.
h.186cm (73in), w.372cm (146in),
d.310cm (122in).
Sandblasted glass, neon, painted
wood. A rich combination of
different materials makes for
a three-dimensional narrative.

Below "The Curve of Time", 1997.
h.66cm (26in), w.41cm (16in),
d.15cm (6in).
Photosensitive glass, cut and
polished, pâte de verre, copper
patina, sandblasted writing. The
flattened cut-out overall form makes
the photographic content of this work
stand out all the more.

carefully posed nude or semi-nude figure, usually herself or her brother. The figures are anonymous, either because their backs are turned to us, or because they are shrouded in drapery, suggesting timeless sculpture. The photography raises questions about time and mortality. It is taken on her travels in Crete, Japan, Peru, and areas of the United States, where the landscape serves her purpose.

Very often photographic parts are shaped to fit into a glass composition that suggests classical (Mediterranean) vessel shapes (in flattened form), which for Van Cline evoke memories of the past. The photography is used in many different ways; sometimes negative imagery is used, sometimes the photography is reflected in the glass, creating a double image. She also uses words, repeated like mantras, as part of the imagery. Antiquity, whether Greek or Buddhist, is often recalled in one way or another. Her brand of neo-classicism evokes the past and the lapse of time between past and present. Mary Van Cline looks for participatory response from the viewer, and her work asks us "to let go of preconception, and to be, for a little while, in another space where time does not just stand still, it does not exist at all".

Vincent van Ginneke

BORN 1956, ROTTERDAM, THE NETHERLANDS NATIONALITY DUTCH

Below "Certificate Holder", 1989.
h 30 cm (11¾ in), w 19 cm (7½ in),
d 13 cm (5 in).
*Cast clear crystal, foundry-made
cast iron, steel plate, gold leaf.
The piece evokes the kind of often
ridiculous ceremony attached
to the awarding of a certificate.
Knowing the artist's fascination
with junkyards, it is clear where the
inspiration for this piece came from.*

Vincent van Ginneke's studio is in the heart of Amsterdam and he revels in the urban landscape around him – the machinery that makes the city function; the scrapyards to which it is relegated when it has outlived its working life. His work is as precise and ordered as the junkyards are disorganized and chaotic. From them he selects treasures as if they were archaeological finds, mechanical parts that reflect the ingenuity of their inventors. Grids and gear levers, cogwheels and turbine technology are transformed and dignified by his selective translation of them into cast-glass sculptures. He personalizes machinery in his thinking: "Engines from Germany, Italy or England not only look different, but they also make different noises and function in a different manner. These engines all have their own rhythm, their own faces."

From childhood van Ginneke has been fascinated by machinery. He and his father tinkered with old motorcycles, and he developed a love of the shiny metal, which engendered dreams of speed, adventure, and dynamism. It was hardly surprising that he chose to concentrate on metal-smithing. He attended a vocational high school, where he learned about gold- and silversmithing. A desire for further study led him to the Rietveld Akademie in Amsterdam, one of the freer art schools in Europe, where conceptual thinking was encouraged and students left to develop without fitting into any particular artistic mould. The international atmosphere and the mix of foreign cultures among the students were a liberating influence on a young Dutchman.

At the Rietveld Akademie, where he made his first contact with glass, van Ginneke explored the possibility of making vessels that were not vessel-like. His love of precision engineering meant that his vessels were always well formed and impressive for their machine-like finish, retaining the urgency if not the purpose of machinery. They resemble small constructions and are invariably made up of different parts. In his early work the colours are lively and the forms experimental. Shapes range from the classical to the bizarre. One senses the influence of Memphis designers at this stage in his career. He was as interested in blown glass as in cast glass and was skilled enough in both disciplines to combine them.

More recently van Ginneke's sculptural work, often combining metal and glass, has lost its early exuberance. Form has become more important than colour. Shapes are now more considered. Vessel form seems to have been left behind, as if earlier on it had been simply a prop. As a mature artist, he has found his way into a sculptural idiom in which the direct references to machinery have been toned down as if now a distant memory. Precision and the need for perfection are still there, but the sculptural language has become more abstract. The work is sleek without being streamlined. Van Ginneke is a romantic even when he is at his most precise, and the ideas that come across are related to the aesthetics of order. There is a clarity of thought about all he does that results in a self-sufficient abstraction. He has understood the magic of glass and the pleasure to be derived from controlling form. Once the link to the machine aesthetic was important, but it is no longer necessary. His sculptural idiom carries its own momentum and leaves the viewer with a sense of fulfilment and satisfaction. Vincent van Ginneke's work is always elegant and attractive, but it is also intellectually challenging, in that it demands a degree of sophistication from the viewer without which it touches no nerve.

Above "Bend Gear", 1992.
h 14 cm (5½ in), diam. 65 cm (25½ in).
Twice-cast clear crystal: first static casting, second time slump firing. This re-invented machine part recalls the artist's words: "A saw-toothed cogwheel can laugh too."

Below "Body Shapes", 1999.
Each: h 28 cm (11 in), w 25 cm (9¾ in), diam. 21 cm (8¼ in).
Cast yellow crystal. Machine-inspired parts have taken on muscular body forms; setting up a kind of bodily dialogue.

Frantisek Vízner

BORN 1936, PRAGUE, CZECHOSLOVAKIA NATIONALITY CZECH

Above "Plate", 1983.
diam. 45cm (17¾in).
Blue cut glass. Utter simplicity,
geometric precision, colour, and
light are the ingredients of Vízner's
art. However simple the idea,
the magic of his work lies in the
exactitude of technical detail,
in particular the cutting and
polishing of the glass mass.

Frantisek Vízner has been an independent artist in glass since 1976, although he was already making unique pieces ten years before while still employed in the glass industry. There is no superfluous detail in his work. The forms are pure geometry: cylinders, hemispheres, and cubes, basic shapes that are worked on with cutting and polishing. The cutting serves to add further geometrical interplay, holes cut into cubes, hemispheres gently hollowed out leaving a sharp central point, rectangles with raised tapering sides, columns with a section sliced away. Colours are warm, glowing, and usually monochrome. If there is more than one colour it is where layers of different coloured glass have been laminated together. Acid treatment to the surface leaves it matt and silky, giving an impression that it is soft to the touch. The cutting is masterful, decisive, and immensely subtle, and the overall effect is one of effortless simplicity. The finished work leaves one with the satisfying feeling that an idea has been fully realized. The result is perfect harmony in glass.

As a student at the Prague Academy of Applied Arts (where he studied from 1956 to 1962 after the customary initial training in basic skills at the

Specialized Glassmaking School of Nový Bor), Vízner's main interests were in pressed glass and cut glass. Pressed glass has a long history, and is a process ideally suited to mass production. In order to be cost-effective its design has to remain simple, and this economy of design spilled over into the artistic work that Vízner found he was attracted to when he began working as an artist rather than an industrial designer. To create so distinctive a style by reducing rather than adding decorative content is a remarkable feat. The shapes that Vízner has created are entirely original, unconventional, and so convincing that it seems surprising that they had never been seen before in the long history of glass. They are compact and stable, like good architecture. Vízner has an infallible sense of shape, and is capable of turning geometry into sculpture. His artistic work met with instant success.

If Vízner exploits the qualities of his medium, it is by varying the thickness of the glass, which constitutes part of his basic design process. By doing this he creates light and shade within the glass mass. While Liberský and his pupils work to create a similar effect in cast glass, Vízner uses his masterful cutting skills to illuminate his glass and make it vibrate from within. He sculpts using a quality of light and shade that only cut glass can provide, and exploits these possibilities in a unique way. A great deal of thought goes into every piece. Each one is carefully considered, and every angle, every incision, every cut is calculated down to the last detail, in terms of both form and light. Nothing is left to chance. Every idea is worked through to its logical conclusion. Yet the finished result never looks cold and calculated. It simply looks as if it had to be that way, perfectly natural, predestined.

Vízner's glass is a mixture between velvet and gemstone, and it is perhaps this unique textural quality that is its most effective "secret ingredient". He works within a very narrow aesthetic range, but finds plenty there to challenge him as a sculptor and as a glass-maker. All his work is very similar but there is no repetition. It is as if every new idea stems from exactly the same place in the artist's entirely focused brain, where the concentration is so disciplined and sharp that it is mirrored in every one of his artistic creations.

Above "Vase", 1992.
h 17cm (6¾in), w 17cm (6¾in), d 17cm (6¾in).
Colourless cut glass. Four identical precisely positioned holes create a ghostly pattern of interior shadows.

Below "Bowl", 1998.
diam. 45cm (17¾in).
Green cut glass. The interplay of concave and convex, enhanced by a sharp linear division, gives a theatrical effect.

James Watkins

BORN 1955, NEW IBERIA, LOUISIANA, USA NATIONALITY AMERICAN

James Watkins set his style early on in his career, using recognizable forms and imagery, but moulding them into a distinctive and easily identifiable language of his own, in which flattened forms maintain three-dimensionality. The metamorphosis has both poetic and dramatic appeal. Familiar objects take on a new identity in this sculptural idiom, becoming sometimes humanoid, sometimes architectural in their new guise. Colours are limited to black, grey, and white but most commonly the hues are those of opaque glass, tending towards white where transparency is diminished. Even within this reduced spectrum Watkins makes colour tonalities vary considerably by controlling the density of his glass and thus creating light and shade. Some work is mixed media and when

Below "Construction Grouping", 1980. h 82 cm (32¼ in).
Six-part installation, blown glass, sandblasted and assembled.
This set piece of different cylindrical, conical, and open vessel forms has the effect of a choreographed tableau lit by its own devices.

that is the case painted wood is among his favourite materials. Wood complements the raw and carved effect of the glass.

Watkins grew up in a small town in Louisiana, influenced by his grandfathers and their love of objects: "They had a lot to do with where I'm at today... One of them was an insurance salesman, but his passion was junk-collecting and making furniture out of things he found." The objects that Watkins portrays – vases, violins, water pitchers, fruit – tend to be small, almost as if his eye had picked them out on a flea-market stall. The subject matter is junky rather than rare or precious, but in his treatment of them objects become dignified and intelligent in their bearing and in the way they relate to one another.

After high school, in a bid to broaden his horizons, Watkins attended Eisenhower College in upstate New York, a small liberal arts college, where he received a grounding in art history. Like so many American art students in the mid 1970s, he wanted to try his hand at glass and returned to school in 1980 to do a Master of Fine Arts degree at the Rhode Island School of Design.

After a series of experiments as a student, some of them large-scale, Watkins settled on the still life in glass as his subject matter. At first he blew his creations in glass, but moved on to *pâte de verre* glass casting during the mid-1980s. He brings to mind the Italian painter Giorgio Morandi and the grainy paintings of bottles that occupied him for a lifetime, and Watkins admits his fascination for this artist. He says his aim was to "reduce the pieces to a silhouette, as in the photographic image, and to create implications of volume rather than actual volume". The flattening of forms has its own appeal, demanding that viewers adjust their vision and moving them into a fictional world. Watkins uses his world of mannered objects and simplified forms to explore relationships. His still lives are like essays or short stories. Like Morandi, Watkins has been content to remain with the same language of objects and sees no problem in using them over and over again. "I don't feel like I'm being repetitive, or if I am, I'm being repetitive with a purpose." The purpose is to go on asking questions about the world and its inhabitants. The answers he provides delight an ever-growing audience that is drawn into his world, looking forward to the next episode as one might look forward to a developing scenario in a favourite literary or television serial.

Above "Ewer with Squash and a Fiddle Head", 1999.
h 38cm (15in), w 26cm (10¼in), d 12cm (4¾in).
Double piece, pâte de verre. Watkins creates a relationship between two complementary but unrelated forms, an unexpected juxtaposition that turns familiar into unfamiliar with pleasing results.

Jack Wax

BORN 1954, TARRYTOWN, NEW YORK, USA NATIONALITY AMERICAN

Above "Shiro Annular", 1992.
h 40cm (15½in), d 40cm (15½in).
*Cast glass. A cluster of half-
recognized forms becomes
a new organic whole that belongs
to an imagined world, a world
related to what we know but
extending our thoughts towards
the region of the unknown.*

Glass, like water, is a fluid and ever-changing substance. The Roman philosopher Lucretius, in his *On the Nature of Things,* addressed the concept of change, of how nothing remains the same. Lucretius was inspired by the early Greek philosophers, in particular Epicurus and his famous saying, "Everything flows, nothing stays". Jack Wax continues to ponder such issues and to encapsulate in his work the concept of change and its effects. Sometimes his subject matter is taken from things we recognize – a head, a hand, a wig. By association and by implication they address his concerns. A human head lies decaying but rendered beautiful; a monkey's head serves as the point of departure in a series of self-portraits. The cupped hand in a piece entitled "Beholden" (1997) is inspired by a wood-carved hand seen in a Japanese museum, the only remaining piece of a statue of the Buddha. Sometimes strange grape-like or egg-like clusters suggest alternative visceral organisms related to those we know from images of minutiae greatly magnified under a microscope, but allowing for a degree of poetic licence. They are organisms that hint at change, decay, destruction, and death, universal themes that occupy us all. They are frightening and sometimes revolting to think about and yet the pieces are strangely beautiful to look at.

Jack Wax first handled glass at Pilchuck School during the 1970s, having earlier attended the Archaeological Field School at Northwestern University in Illinois. He returned to Illinois in 1998 as associate professor and head of the glass programme. In the interim he had taken a Master of Fine Arts course at Rhode Island School of Design (1981–83), taught at various American universities, and spent five years in Japan (1991–96) as professor at Toyama City Institute of Glass Art in Japan. Japanese culture and philosophy mix with Western thought in his work. There is a formality about his work that suggests Japanese influence, together with a respect for objects not necessarily evident in the West.

Colourless glass is the base material of Jack Wax's work, but it is treated with surface finishes that obscure its glassiness, although the fragility and feel of the material never become obscured. Unusual substances are rubbed into glass surfaces to give them their dark patinas: walnut ink,

Sumi inks, wood stains, graphite, and charcoal are among the curious treatments that provide a unique depth to the work. The forms are strange and unfamiliar but utterly convincing. They are simple and uncluttered. One senses that in their creation the artist is trying to delve deep into areas of his own subconscious which seem related to our own. Dark secrets emerge which we are invited to share.

Wax uses glass to see things in a new way and creates imagery that touches a sympathetic nerve in us, although it is difficult to pinpoint why or how. His work seems to live and breathe like the organisms to which it refers. Enormous skill and a wide range of mould-blown hot-glass techniques as well as cold techniques (cutting, polishing, pigmenting) go into making these objects, but process is somehow forgotten in the finished work. It is what it is, and one tends not to reflect on how it came to be. This in itself is a distinguishing feature of Wax's work. Usually part of the fascination of glass is that it invites technical questions from the viewer. Wax's work goes beyond those questions. The material itself takes on secondary rather than primary importance. Jack Wax says: "I just begin and work to cut my thinking off from my composing, to let the words write themselves and have the poem lead me to its conclusion."

Above "Pleat", 1998.
h 17.5cm (6⅞in), w 52.5cm (20¾in),
d 12.5cm (5in).
Cast glass, pigment.
The quality of Wax's glass has
a distinctive presence, smooth
and oily but also brittle and fragile.

Below "Beholden", 1997.
h 25cm (9⅞in), w 37cm (14½in),
l 57cm (22½in).
Cast glass, pigment. An image
borrowed from a traditional
sculptural representation of
the Buddha, presented in this
unfamiliar material, is transformed.

Ann Wolff

BORN 1937, LÜBECK, GERMANY NATIONALITY GERMAN

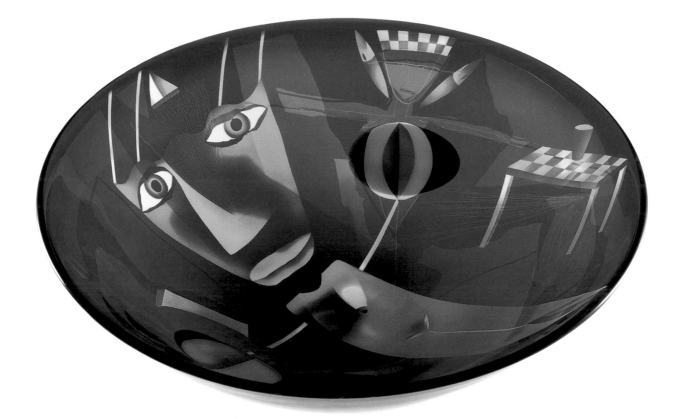

Ann Wolff has struggled all her life not be classed as an artist in contemporary glass, trying to avoid being labelled as anything at all. Although she has been an important figure on the glass scene, she does not "belong" to the world of glass but rather to a group of artists and thinkers who are concerned about the emancipation of women, expressing themselves in whatever medium is most fit. Yet Wolff is a skilled technician, learning new techniques with a versatility that has enabled her, during a career that to date spans 40 years, to work as an engraver, a vessel-maker, a sculptor, a stained-glass artist, a watercolourist, and a designer for industry. She has had a battle with glass, fighting its obvious attributes but at the same time using them to create some of her most notable successes.

At the beginning of her career Wolff used her married name. But it is typical of her bid to assert her own personality and her identity as a

Above "Blue Goddess", 1985.
diam. 40cm (15½in).
*Cased glass, etched and sand-
blasted. In the earlier part of her
career Ann Wolff made vases,
plates, and other vessel forms
using a technique that allowed her
to present her narrative almost as if
she was painting in watercolours.*

Right "Maisan", 1988.
h 85cm (33½in).
*Cased glass, etched and
sandblasted, wooden body.
The head and face have always
been an important feature for
Ann Wolff. The sculptural element
added by the wooden body
marks a transition from vessel
form to sculpture in her work.*

woman that, following a divorce, she changed her name to Ann Wolff after her maternal grandmother, like herself a woman of some personality and strength. Typically, this was a decision born of great contemplation.

Ann Wolff's first encounter with glass, after design studies at the Design High School in Ulm, came as a result of her marriage to the Swedish glass artist Goran Wärff. Accompanying him to Sweden, she worked in the glass industry for ten years as a designer of decorative and household wares, first for Pukebergs Glasbruk (1960–64) and then for Kosta Boda (1964–70). During this time, largely through trial and error, she taught herself the techniques of etching and sandblasting. After her divorce in 1970 she established Studio Stenhytta, a glass studio in the grounds of her home in Transjö, which she set up with Wilke Adolfsson, a master glass-blower who had been at the Orrefors glass factory.

During the 1970s – early in her career as an independent artist in glass – Wolff built up an image language of shapes, symbols, and colours, seeking to express her thoughts about fate and emotion. Her shapes were predominantly vessel forms, bowls, cups, milk churns, and teapots, which were clearly, in part at least, symbolic of her household responsibilities. These were multilayered glass vessels which she sandblasted and etched with narratives of her favourite subjects, revolving around woman's dependence on man; woman as home-maker and childbearer; and the need for freedom. The figures were mostly female, and the stories, though autobiographical, were intended as allegories. Wolff's many successes in the 1970s included winning the first Coburg glass prize in 1977, then one of the most prestigious prizes available.

Ann Wolff has moved fearlessly from one idea to the next during her life as a glass-maker. In the 1980s she began to make large circular glass chargers, decorated using the same techniques as before; it was mainly

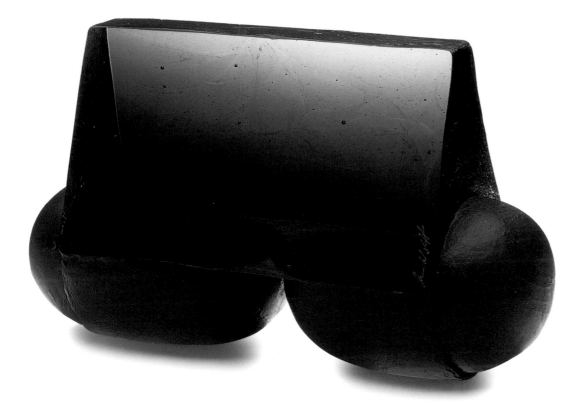

the nature of the subject matter that changed. The more garrulous narrative drawing gave way to a series of heads – contemplative female faces, triangular in shape with large questioning eyes and sensuous lips. As her skills evolved she brought more painterly qualities into glass, the sandblasting and acid-etching on glass made from the mid-1980s onward often imitating brush strokes.

From the mid-1980s to the mid-1990s, Ann Wolff turned to drawing and making in a variety of media, as well as teaching (at the High School for Applied Arts in Hamburg, where she was professor of design from 1993 to 1998), seeking inspiration and relaxation in other means of expression and freedom from the inevitable constraints of working in glass. This was a period of disenchantment with, but never outright rejection of, glass, when she felt that the way in which she was working the medium was just too limiting. It took her nearly ten years to discover that the most fulfilling way of combining her talents was as a sculptor, and it was not until she moved from cold-working techniques to glass-casting that she felt herself coming alive again as an artist. She is now in the place where she belongs and it has taken her the best part of a lifetime to get there. Her decision to work as a sculptor in glass has undoubtedly been

influenced by the incredible cast work of Stanislav Libenský and Jaroslava Brychtová; no doubt too the work of Brancusi has been in her mind. As a sculptor she can be bolder than ever before.

There is great calm about Ann Wolff's most recent sculptural work. Although it does not always take up more space than some of her earlier work, what she now makes is much grander, more heroic. Colour has changed from polychrome to monochrome as her statements in glass have become more monolithic. Body parts still play an important role, more often than not the head: this has become a container of mood, just as the vessel was once a container of narrative. When she started her monumental castings she made them in the Czech Republic, but the complex inner structures and grainy outer surfaces that she wanted caused some technical problems. These have been resolved and the casting is done at her home in Transjö. She has learned to create areas of inner luminosity that draw one into the heart of the piece, allowing a glimpse into arcane spaces as if enabling the viewer to penetrate thought.

Hiroshi Yamano

BORN 1956, FUKUOKA, JAPAN NATIONALITY JAPANESE

Above *"From East to West – Fish on the Stone", 1994.*
h 65 cm (25½ in), w 25 cm (9⅞ in),
d 10 cm (4 in).
Blown glass, silver foil, engraved detail, glue. The rich silvered decoration calls to mind the Japanese art of lacquer.

From his earliest years Hiroshi Yamano wanted to be an artist, but owing to family pressure he studied history at the Chuo University in Tokyo. After three years he took a break in order to travel in Europe and the United States. He returned to Japan to finish his studies, but went back to the United States in 1982, becoming a student at California College of Arts and Crafts under Marvin Lipofsky. Two years later he was able to attend the recently opened Tokyo Glass Art Institute. In the United States Lipofsky had taught his Japanese students about freedom of expression; back in Japan the emphasis was on technical perfection.

During the 1980s it was difficult to survive as a glass artist in Japan. Since then, glass courses and institutes have been inaugurated, but in the 1980s artistry in glass had advanced far more rapidly in the United States, where galleries specializing in contemporary glass had been launched and where the first generation of a new breed of glass artist was attracting attention from museums. Yamano, encouraged by friends in California, returned to the United States, where he worked as an assistant in various glass studios and also continued his studies, taking a graduate glass course at Rochester Institute of Technology. While he was there he began his series of decorative vessels, "From East to West".

These are heavy blown-glass vessel forms with applied silver-leaf designs. Yamano admired heavy-walled blown Scandinavian glass and as a student spent time in Scandinavia learning their glass skills. The heavy glass body is rolled in silver foil which adheres to the hot glass. On some areas of the glass the silver foil is applied so as to have a crackled effect, while in other areas it is smooth. These different effects depend on the thickness of the foil and the heat of the glass, and achieving them requires tremendous technical skill. A recurring motif in Yamano's work is fish, usually depicted in groups and swimming in the same direction; a single fish, often in the form of a finial, may swim the other way. Details are scratched into the silver foil with a sharp instrument. The silver areas that are to become the fish decoration are covered in a protective resin and areas of the vase are coated in copper. The resin-covered areas do not react to the copper coating. The glass is then soaked in verdigris

to add patina to the copper. Some pieces are also engraved and electroplated. The metal techniques that Yamano employs are essentially Japanese in origin, used in the decoration of swords.

This kind of work has occupied Yamano since the late 1980s. The fish with their open mouths and keen little eyes swim busily towards some unknown destination, representing the artist's own journey from East to West. The work is exquisitely crafted and finished, expressing the respect for the art of the object that is so deeply ingrained in Japanese culture. The mixture of Scandinavian-style precision glass-blowing and traditional Japanese metalwork techniques gives this work its flavour of combined cultures. It has earned Yamano as much of a reputation in the United States as in Japan, and he exhibits in both countries with equal success. In 1990 Yamano returned to live in Japan, although he travels frequently to the West. In 1991 he opened his Ezra Glass Studio in Sakai gun, Fukui, Japan, where he has also established a glass school.

Above "From East to West – Fish Catcher", 2000.
h 40cm (15½in), w 40cm (15½in), d 40cm (15½in).
Blown glass, engraved, cut, and polished. Although the decorative subject matter is similar in the pieces in this series, Yamano has experimented with a variety of different glass forms, using heavy-walled vessels as his point of departure.

Right "From East to West – Scene of Celt", 1999.
h 50cm (19¾in), w 45cm (17¾in), d 35cm (13¾in).
Blown kiln-formed glass, engraved. Fish, depicted either singly or swimming in shoals, is the main theme of the "From East to West" series. The title makes allusion to the two different worlds where Yamano learned his craft skills.

Dana Zámecníková

BORN 1945, PRAGUE, CZECHOSLOVAKIA NATIONALITY CZECH

Above *"Theatrum Mundi", 1993–94.*
h 1,100cm (433in), w 1,100cm
(433in), d 310cm (122in).
Painted and laminated glass, metal,
mixed media. Her background as
a painter and theatre designer is
evident in all of Zámecníková's work,
where a graphic scene is set for
the viewer to interpret.

Dana Zámecníková graduated from the School of Architecture at the Czech Technical University in 1968 and for a while worked in an architectural practice. From 1969 to 1972 she studied stage design at the Academy of Applied Arts in Prague. It is unusual for a Czech artist whose chosen medium is glass not to have been through the conventional glass course at the Prague Academy, and much is left over from the world of theatre design in Zámecníková's work as a glass artist.

Sometimes she makes figural pieces in glass that could well have been stage props cut out of cardboard or wood; instead they are cut out of sheet glass, which she draws on and colours with enamel paint. The paint is applied in drips and splashes, giving the work its tense and nervous quality. The drawing is a series of linear scribbles and this too adds nervous energy. The technique that she has made her own is brilliant though simple. It allows her a degree of freedom and flexibility not enjoyed by glass artists who work using more conventional glass techniques. Dana Zámecníková is a painter and sculptor of great skill, using glass as her canvas, and the fragility and vulnerability of the material serve to highlight the emotional subject matter of her work.

Although she is not a naive painter, her works, because they have somewhat rugged edges, like paper cutouts where the scissors have not properly followed the dotted lines, have a naive quality that makes them very approachable. They demand the viewer's engagement. One wants to walk towards them as if they were alive. Even though sheet glass is flat, once it is shaped and painted and free standing it becomes totally three-dimensional. Zámecníková chooses dramatic poses for her cutout figures and the painting gives them great expression. Her people are emotional even when they are in reflective mood. They are not quiet or inactive; they shout or dance or run, and there is always movement.

Dana Zámecníková's work is narrative, almost like a diary, and contains recurring leitmotifs. One of her favourite themes is a dog, sitting contentedly by its master or sometimes angry and growling. The female figure is a central theme in her work. The work is also about human relationships,

or the lack of them. Puppets and masked figures speak of difficulties in addressing reality. Scenes are moments observed or remembered, recording her concern at what she has seen or lived through. We recognize from our own lives the everyday experiences she describes and are curious as to the spin that she puts on them. The imagery is a mixture of dream, nightmare, and reality – the dreams and nightmares and realities that we all share.

In 1978 Dana Zámecníková created the first of the compositions in which she uses layers of glass, a technique that again harks back to her training as a stage designer. The compositions are like a series of flats painted for a stage set, but the fact that they are in glass provides opportunities for interaction between the layers that cannot apply in any other material, giving the narrative a unique depth of perspective. Over the years Zámecníková has grown more secure, more complex in her imagery, and more technically ambitious in her chosen medium. She has become an artist of considerable standing in her own country as well as abroad.

Above "My Family", 1997.
h 210cm (82in), w 120cm (47in),
d 150cm (59in).
Painted glass and wooden chair, mixed media. There are frequent allusions to domestic life in Zámecníková's work, either in the painted imagery or through the introduction of found objects, whose dramatic presence can make an even more direct impact.

Left "Devil Versus Angels", 2000.
h 73cm (28¾in), w 80cm (31½in),
d 16cm (6¼in).
Patinated glass, metal, acid-etched, digital print. Zámecniková's work is charged with nervous energy, in an impulsive fusion of colours and imagery. The use of digital imagery is a recent development.

Mary Ann Toots Zynsky

BORN 1951, BOSTON, MASSACHUSETTS, USA NATIONALITY AMERICAN

Below *"Waterspout #9", 1979–94.*
h 49cm (19in), w 22.5cm (8⅞in),
d 22.5cm (8⅞in).
Blown glass, applied threads.
Zynsky used glass thread at first as
in this piece to wrap a vessel form,
giving it an unfamiliar appearance.

Toots Zynsky's work stands out from all other contemporary glass because of the way it is formed from coloured threads of glass to build a vessel, a technique that must surely have been inspired by nest-building. Her work is instantly recognizable not only because of its physical structure, but because of its exuberant colour palette which has been compared to the plumage of exotic birds. Although Toots Zynsky now lives in the United States, she has spent a good deal of her life in Europe, mostly in Amsterdam and Paris, where she maintained homes and a studio simultaneously for many years.

Her unique way of making glass owes a lot to the invention of a "thread-pulling machine" that was developed in 1982 in conjunction with Mathijs Teunissen van Manen, a jeweller and product designer. This thread-pulling device enables Zynsky to create long thin strands of glass, similar to optic fibres. These are layered, heated, and slumped over a series of moulds to achieve the desired effect. Toots Zynsky has used this method of making glass for nearly 20 years now, working through one idea after another, each idea contained within a graphically titled series, including "Tierra del Fuego" (1989), "Winged Chaos" (1995), "Chaotic Fusion" (1998), and "Serata" (2000). In fact, the idea of working with glass threads predates the machinery that was developed in the 1980s; before it was invented Zynsky wrapped vessel forms with irregular strands pulled from a molten mass. The idea was original and the effect eyecatching.

In the early stages of both her education and her career during the 1970s Toots Zynsky enjoyed the free-spirited mood of experimentalism that characterized the world of American pioneers in glass. She experimented with light and sounds: slumped glass was only one of the materials that she used, in combination with bricks, barbed wire, or cheesecloth, in her early "performance-installations". Gradually, however, glass became her preferred artist's material. "It's really amazing, you can do everything with it. You can pour it and cast it like metal. You can stretch it, carve it, saw it, you can stick it together. It's the only material you can melt and blow. It's such a strange and plastic thing. I think that's what keeps drawing me back to it."

Below Untitled, 1979.
Left: h 15 cm (6 in), w 13 cm (5 in),
d 13 cm (5 in); right: h 9 cm (3½ in),
w 10 cm (4 in), d 10 cm (4 in).
Blown glass, applied threads.

Toots Zynsky took a Bachelor of Fine Arts Course at the Rhode Island School of Design, although she had not intended to experiment with glass when she went there originally. At the end of her freshman year, having already decided to quit, she chanced upon the glass studio. "I saw all this hot glass swirling through the air. It was nuts." She completed the course and in 1971, as one of Dale Chihuly's first students, she also became involved in the birth of the Pilchuck Glass School as one of its founding student members.

During a career already spanning more than two decades Zynsky has designed for industry (including for Venini), lectured, and taught. Most of her time is taken up, however, in preparing work for exhibitions in galleries throughout the world. Her exotic and beautifully crafted vessels have instant appeal. What she does can best be described as drawing or painting in glass with coloured threads. Coloured glass rods 10–14mm (⅜–⅝in) thick are pulled into hairlike threads which are laid out flat in a coloured arrangement. They are then heated until they are supple enough to be lifted with spatulas into a mould. This process can be repeated up

Below Untitled ("African Dream" series), 1983.
h 13 cm (5 in), w 34 cm (13¾ in),
d 34 cm (13¾ in).
Fused glass threads. Glass threads are allowed to slump into a mould in the kiln.

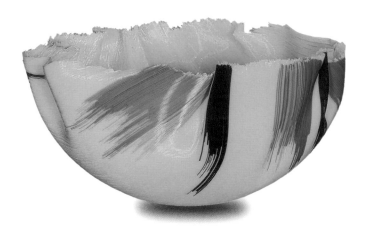

Above Untitled ("Bird of
Paradise" series), 1985.
h 11.5cm (4½in), w 20cm (7⅞in),
d 20cm (7⅞in).
Fused glass threads.
As suggested by the title,
the colouring of this and many
other works by Zynsky is inspired
by the plumage of exotic birds.

Below "Snowbird", 1990.
h 13cm (5in), w 45cm (17¾in),
d 20cm (7⅞in).
Fused glass threads.
The transference of imagery
is subtle and very effective, and
the reduction of colour to black
and white as emotive as in
Zynsky's more highly coloured work.

to six times, adding colour and shape each time. The thread-like quality of the strands draws attention to the fragility of the glass. The glass threads protrude beyond the edges, so that a Zynsky piece requires special handling, adding to one's sense of having a precious object in one's hands. Although the vessels are quite solid in themselves, the handling they demand makes them seem vulnerable, almost alive. It gives their physical presence a tactile quality. One wants to run a hand over the surface to see what these glass threads feel like and yet one knows one has to approach them with care.

"It's really like painting," Toots Zynsky says. "It's an identical thought process – the way you build up a painting or drawing and then the other layers go on really to hold together so it's actually about 30 layers of thread. They are very solid, they look more fragile than they are." She works in glass, but her inspiration comes from elsewhere, and she cites birds and the sea in particular. Her forms set colours in motion, creating an almost kinetic effect. The threads of which the vessels are composed give the glass the vibrant quality of taut wire. The effect is one of arrested movement; the threads were once flexible and their rhythm remains present though frozen. Through the slumping process folds are created that belie the customary stiffness of glass. They provide kaleidoscopic movement, making the colours rock and roll within their forms. One feels movement where there is none, hears music where there is silence.

When it comes to colour, Toots Zynsky knows no shame. She understands better than anybody how to use the luminosity of colour. Hers is a very

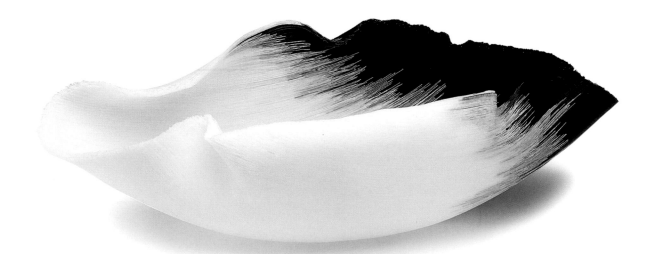

personal colour idiom, without the transparent qualities normally associated with glass. Zynsky's colours do not absorb light, they bounce it back at you. She creates the illusion of having applied colours with brush strokes. She uses colours to stir the senses, so vivid that the eye alone cannot absorb their intensity and brightness. They vibrate and so evoke a response that is more than simply visual. Colours do have emotional force, but in the normal course of life that force can go unnoticed. No Toots Zynsky colour combination goes unnoticed. She reawakens our sensitivity to colour with her exotic palette. Before becoming aware of the cleverness of the technique she uses to make her work, it is a burst of colour that stops one in one's tracks. Toots Zynsky's colours are a tonic that lifts the spirits.

Below "Blue Moon Total Eclipse Isla Bella" ("Tierra Del Fuego" series, 1987. h 13cm (5in), w 30cm (11⅞in), d 30cm (11⅞in).
Fused glass threads.
Zynsky's technique allows for endless colour exploration, sometimes combining just one or two colours, sometimes the whole spectrum.

GALLERIES AND MUSEUMS

Albright-Knox Art Gallery. Buffalo (NY). USA.

American Craft Museum. New York (NY). USA.

Arkansas Arts Center Decorative Art Museum.
 Little Rock (AR).USA.

Art Gallery Of Northern Territory. Darwin (NT). AUS.

Art Gallery Of South Australia. Adelaide (SA). AUS.

Art Gallery Of Western Australia. Perth (WA). AUS.

Art Institute Of Chicago. Chicago (IL). USA.

Auckland City Art Gallery & Museum. Auckland. NZ.

Augustiner Museum. Freiburg. GER.

Australian National Gallery (inc. the Crafts Board of the Australia
 Council). Canberra (ACT). AUS.

Australian National University Art Collection. Acton (ACT). AUS.

Badisches Landesmuseum. Karlsruhe. GER.

Birmingham Museums & Art Gallery. Birmingham. UK.

Birmingham Museum Of Art. Birmingham (AL). USA.

Boca Raton Museum Of Art. Boca Raton (FL). USA.

Bremer Landesmuseum für Kunst und Kulturgeschichte.
 Bremen.GER.

Brisbane City Gallery. Brisbane (QLD). AUS.

Broadfield House Glass Museum (inc. Dudley Museum & Art Gallery
 Collection). Kingswinford. UK.

Brook Museum. Memphis (TN). USA.

Brooklyn Museum Of Art. Brooklyn (NY). USA.

Carnegie Institute, Museum Of Art. Pittsburgh (PA). USA.

Charles A Wastum Museum Of Fine Art. Racine (WI). USA.

Chase Manhattan Bank Art Collection. New York (NY). USA.

Chrysler Museum, Institute Of Glass. Norfolk (VA). USA.

Cincinnati Art Museum. Cincinnati (OH). USA.

Cleveland Museum Of Art. Cleveland (OH). USA.

Columbia Museum Of Art. Columbia (SC). USA.

Cooper Hewitt Museum. New York (NY). USA.

Corning Museum Of Glass. Corning (NY). USA.

Denver Art Museum. Denver (CO). USA.

Der Danske Kunstindustrimuseet. Copenhagen. DK.

Detroit Institute Of Art. Detroit (MI). USA.

Dowse Art Museum. Wellington. NZ.

Dundee Art Galleries & Museum, McManus Galleries. Dundee. UK.

Ebeltoft Glasmuseet. Ebeltoft. DK.

Fitzwilliam Museum. Cambridge. UK.

Förderkreis Wertheimer Glasmuseum e.V. Wertheim. GER.

Frans Halsmuseum. Haarlem. NL.

Gemeentemuseum Arnhem. Arnhem. NL.

Glasgow Museums & Art Galleries. Glasgow. UK.

Glasmuseum Ernsting Stiftung Alter Hof Herding.
 Coesfeld-Lette. GER.

Glasmuseum Frauenau. Frauenau. GER.

Glasmuseum Immenhausen. Immenhausen (Hess). GER.

The Glick Collection. Minneapolis Museum Of Art.
 Minnesota (MN). USA.

Göteborgs Museum. Göteborg. SWD.

Hessisches Landesmuseum Darmstadt. Darmstadt. GER.

High Museum Of Art. Atlanta (GA). USA.

Hiroshima Prefectural Museum Of Art. Hiroshima. JAP.

Hokkaido Museum Of Modern Art. Sapporo. JAP.

Hsinchu Cultural Centre Collection. Hsinchu. TW.

Hunter Museum Of American Art. Chattanooga (TN). USA.

Huntington Museum Of Art. Huntington (WV). USA.

Indianapolis Museum Of Art. Indianapolis (IN). USA.

International Glass Museum. Tacoma (WA). USA.

International Glass Symposium Collection. Crystalex.
 Novy Bor & Castle Lemberk. Lemberk. CZ.

Illinois State University Art Museum. Normal (IL). USA.

J & L Lobmeyr Collection. Vienna. AST.

JB Speed Museum. Louisville (KY). USA.

John Nelson Bergstrom Arts Center & Mahler Glass Museum.
 Neenah (WI). USA.

Kestner-Museum. Hannover. GER.

Kitazawa Glass Museum. Kitazawa. JAP.

Koganezaki Glass Museum. Shizuoka. JAP.

Kunstgewerbemuseum Bellerive. Zürich. SW.

Kunstgewerbemuseum Berlin. Berlin. GER.

Kunstgewerbemuseum Schloss Pillnitz. Dresden. GER.

Kunsthaus Am Museum. Carola Van Ham. Köln. GER.

Kunstindustrimuseet Oslo. Oslo. NOR.

Kunstmuseum Düsseldorf im Ehrenhof. Düsseldorf. GER.

Kunstsammlungen Der Veste Coburg. Rödental. GER.

Kurokabe Glass Museum. Nagahama. JAP.

Lannan Foundation Museum. West Palm Beach (FL). USA.

Leicestershire Museum, Art Galleries & Record Services.
 Leicester. UK.

Leigh Yawkey Woodson Art Museum. Wausau (WI). USA.

Liberty Museum. Philadelphia (PA). USA.

Los Angeles County Museum Of Art. Los Angeles (CA). USA.

Malmö Museum. Malmö. SWD.

Manchester City Art Gallery. Manchester. UK.

Metropolitan Museum Of Art. New York (NY). USA.

Milwaukee Art Museum. Milwaukee (WI). USA.

Mint Museum Of Art. Charlotte (NC). USA.

Moravská Gallery. Brno. CZ.

Morris Museum. Morristown (NJ). USA.

Moser A.G. Glass Collection. Karlovy Vary. CZ.

Musée Ariana. Geneva. SW.

Musée-Atelier du Verre de Sars-Poteries. Sars-Poteries. FR.

Musée d'Art Moderne & d'Art Contemporain. Nice. FR.

Musée d'Evreux, Ancien Evêché. Evreux. FR.

Musée des Beaux-Arts et de la Céramique. Rouen. FR.

Musée des Arts Décoratifs, Centre du Verre. Palais du Louvre.
 Paris. FR.

Musée des Arts Décoratifs de Montréal. Montreal (QBC). CAN.

Musée de Design & d'Arts Appliqués Contemporains
(formerly, Musée des Arts Décoratifs de la Ville de Lausanne).
Lausanne. SW.

Musée du Verre Charleroi. Charleroi. BEL.

Musée du Verre Liège. Liège. BEL.

Musée National de Céramique. Sèvres. FR.

Museo Contemporáneo del Vidrio Ciudad de Alcorcón. Madrid. SP.

Museo del Vidrio. Monterrey. MEX.

Museo Vetrario. Murano, Venice, IT.

Museu de Arte de São Paulo. São Paulo. BRZ.

Museum Boijmans Van Beuningen. Rotterdam. NL.

Museum für Kunst & Gewerbe. Hamburg. GER.

Museum für Kunsthandwerk. Frankfurt am Main. GER.

Museum Künstlerkolonie. Darmstadt. GER.

Museum Of Applied Arts. Budapest. HUN.

Museum Of Art, Rhode Island School Of Design.
Providence (RI). USA.

Museum Of Fine Art. Boston (MA). USA.

Museum Of Fine Art. Houston (TX). USA.

Museum Of Modern Art. New York (NY). USA.

Museum Van Der Togt. Amstelveen. NL.

Museum Voor Sierkunst. Gent. BEL.

Muzeum Skla a Bizuterie. Jablonec Nad Nisou. CZ.

Muzeum Skla Kamenický Senov. Kamenický Senov. CZ.

National Gallery Of Australia. Canberra (ACT). AUS.

National Gallery Of Victoria. Melbourne (VIC). AUS.

National Gallery In Prague. Prague. CZ.

National Museum Of American Art, Smithsonian Institute.
Washington (DC). USA.

National Museum Of Modern Art. Kyoto. JAP.

National Museum Of Modern Art. Tokyo. JAP.

National Museums Of Scotland. Edinburgh. UK.

Nationalmuseum, Avdelningen För Konsthanverk. Stockholm. SWD.

New Orleans Museum Of Art. New Orleans (LA). USA.

Newport Art Museum. Newport (RI). USA.

Niijima Glass Art Centre Museum. Tokyo. JAP.

Nordenfjeldske Kunstindustrimuseum. Trondheim. NOR.

Norton Museum Of Art. West Palm Beach (FL). USA.

Norwich Castle Museum. Norwich. UK.

Notojima Glass Art Museum. Ishikawa. JAP.

Nottingham Castle Museum. Nottingham. UK.

Nuutajärvi-Nötsjö Glasbruk. Nuutajärvi. FIN.

Oakland Art Museum. Oakland (CA). USA.

Oberglasmuseum. Bärnbach. AST.

Otago Museum. Dunedin. NZ.

Philadelphia Museum Of Art. Philadelphia (PA). USA.

Pilchuck Glass Collection. Stanwood (WA). USA.

Phoenix Art Museum. Phoenix (AZ). USA.

Portland Museum Of Art. Portland (OR). USA.

Portsmouth City Museum & Records Service. Portsmouth. UK.

Powerhouse Museum. Sydney (NSW). AUS.

Prescott Collection Of Pilchuck Glass. Pacific 1st Center/US Bank
Center. Seattle (WA). USA.

Queensland Art Gallery. Brisbane (QLD). AUS.

Renwick Gallery, National Museum Of American Art, Smithsonian
Institute. Washington (DC). USA.

Resource Finance Corporation Ltd. Glass Collection. Sydney
(NSW). AUS.

Rijksdienst Beeldende Kunst. The Hague. NL.

Rijksmuseum. Amsterdam. NL.

Röhsska Konstlöjdmuseet. Gothenburg. SWD.

Royal Ontario Museum. Toronto (ONT). CAN.

Rutgers, The State University Of New Jersey, The Jane Voorhees
Zimmerli Art Museum. New Brunswick (NJ). USA.

St. Louis Art Museum. St. Louis (MO). USA.

Saku Municipal Modern Art Museum. Saku, Nagano. JAP.

San Francisco Museum Of Modern Art. San Francisco (CA). USA.

Scottsdale Center For The Arts. Scottsdale (AZ). USA.

Seattle Art Museum. Seattle (WA). USA.

Severoceské Muzeum. Liberec. CZ.

Shimonoseki City Art Museum. Shimonoseki. JAP.

Shipley Art Gallery. Gateshead. UK.

Slovenské Národní Galerie V Bratislave. Bratislava. SL.

Smålands Museum. Växjö. SWD.

Stedelijk Museum. Amsterdam. NL.

Stichting Nationaal Glasmuseum. Leerdam. NL.

Suntory Museum Of Art. Tokyo. JAP.

Suomen Lasimuseo. Riihimäki. FIN.

Suwa Garasu No Sato Museum. Hiroshima. JAP.

Tasmanian Museum & Art Gallery. Hobart (TAS). AUS.

Toledo Museum Of Art. Toledo (OH). USA.

Toyama City Institute Of Glass Art. Toyama. JAP.

Turner Glass Museum, University Of Sheffield. Sheffield. UK.

Ulster Museum. Belfast. NI.

Umeleckoprumyslové Muzeum V Praze. Prague. CZ.

Usher Gallery. Lincolnshire County Council. Lincoln. UK.

Venetian Glass Art Museum. Otaru. JAP.

Victoria & Albert Museum. London. UK.

Victorian State Craft Collection. Melbourne (VIC). AUS.

Vitra Design Museum. Weil am Rhein. GER.

Wagga Wagga National Glass Collection. Wagga Wagga City Art
Gallery. Wagga Wagga (NSW). AUS.

Waikato Polytechnic Collection. Hamilton. NZ.

Wheaton Museum Of American Glass (Creative Glass Center Of
America). Millville (NJ). USA.

The World Of Glass (St. Helens) Ltd. (inc. Pilkington Museum Of
Glass). St. Helens. UK.

Württembergisches Landesmuseum Stuttgart. Stuttgart. GER.

Yokohama Museum Of Art. Yokohama. JAP.

GLOSSARY

acid-etching Cold decoration technique in which the surface of the glass is partially covered with a wax or resin resist, then submerged in acid which bites into the exposed areas

applications Decoration applied to the surface of the glass during the hot process

battuto Cold surface decoration in which a "hammered" pattern is cut into the glass with stone or diamond wheels

Bullseye glass Brand name for a type of glass developed by Bullseye in Portland, Oregon, making it possible to combine blowing and kiln-forming processes in the same piece

casing See overlay

craquelé A crackle effect achieved by dipping hot glass into cold water during the blowing process

electroforming Coating the glass with metal, which involves passing a direct electric current through a bath of plating solution in which electrodes are suspended

enamelling Enamel-painting on the glass surface using finely pulverized lead crystal mixed with metal oxides

façon de Venise Generic term given since the 17th century to glass made in the Venetian manner

flameworking (or lampworking) Shaping glass objects or vessels using a gas-oxygen burner or blowtorch to melt thin glass rods

float glass Glass formed by a process invented by Pilkington Glass in which sheet glass of virtually any size can be formed by being floated over a bed of molten tin

free-blown glass Glass that is free-formed or blown without the use of a mould

frit A glass batch material, such as lead oxide, which has previously been melted and then ground into the glass mixture

gather The gob of glass picked up from the furnace as it adheres to the end of a red-hot blowpipe

Glasfachschule Specialized school for learning the glass trade, which provided the traditional training curriculum in Germany and Czechoslovakia

incalmo Hot process in which different pieces of glass are joined and then worked together, the joining process involving pulling one coloured bubble over another

inciso Cold decorative technique in which thin vertical incisions are cut into the surface of the glass to form a linear pattern

inclusions Any kind of decoration inserted between layers of glass, which can include air bubbles, metallic foil, and coloured glass detail

intaglio Technique in which a glass surface is engraved deeply using a small rotating stone wheel

kiln-formed glass Glass poured or heaped into moulds and formed in a kiln

laminated glass Layers of glass that have been joined together either by fusing or by the use of adhesives

lampworking See flameworking

latticino Technique of incorporating threads of white and/or coloured opaque glass into blown forms

lip wrap An applied glass thread trailed around the rim of a vessel

lost-wax casting Casting technique used in metal and glass in which a wax model is encased in a mould and subsequently steamed out, leaving a void that can be filled with molten glass, replicating exactly the wax model

maestro Term, meaning "master" used in Venice to signify that someone has achieved virtuoso status as a glass-blower

marver Polished steel plate on which a gather of hot glass is rolled, shaped, and smoothed

mould-blown glass Glass blown into pre-formed moulds made of wood, metal, graphite, etc.

murrine Prefabricated mosaic tiles that can be embedded in a glass vessel, formed by fusing coloured glass threads in a long strip which is then sliced like salami, each slice retaining an almost identical pattern

optical glass Very high-quality glass with extreme clarity and great light-refracting capability, traditionally used in the manufacture of optical instruments

overlay/underlay Hot process in which a second layer of glass is laid either over or under a first layer; also referred to as "casing"

pâte de verre Glass paste used to form vessels or objects, made from crushed glass and binding agents laid in a refractory mould and formed in a kiln

plate glass/sheet glass Term used for glass sheets of varying thickness and strength, produced either industrially or by hand

plumbein glass Type of glass with a high lead content

sandblasting Method of surface decoration in which sand is propelled by air pressure, cutting a design into the body of the glass

sand-casting Using a wooden mould pressed into a bed of tightly packed moist sand to form a cavity into which hot glass is poured, assuming exactly the shape of the mould

sheet glass See plate glass

slumping Allowing sheet glass to slump into a mould when heated in a kiln

sommerso Technique that involves sinking layers of clear and coloured glass into one another by repeatedly dipping an object into different crucibles of melted glass during the hot process, producing a heavy-walled piece of significant weight or thickness

underlay See overlay

Vitrolite Brand name for a type of opalized flat coloured glass sheets produced in America

wheel-cutting, wheel-engraving Using an electrically driven stone, ceramic, or diamond rotating wheel to cut or engrave surface decoration

zanfirico Glass decorated with pre-formed differently coloured canes worked into complex intertwined spiralling or linear patterns

SAMPLE SIGNATURES

Hank Murta Adams

Philip Baldwin &
Monica Guggisberg

(the artist does not sign his work)
Howard Ben Tré

Giles Bettison

Cristiano Bianchin

Claudia Borella

Lucio Bubacco

Dale Chihuly

Václav Cigler

Tessa Clegg

(the artist does not sign her work)
Kéké Cribbs

Dan Dailey

(the artist does not sign his work)
Bernard Dejonghe

Isabel de Obaldía

Laura Diaz de Santillana

Anna Dickinson

Benjamin Edols & Kathy Elliott

Erwin Eisch

Bert Frijns

Irene Frolic

Kyohei Fujita

Michael Glancy

Mieke Groot

Jens Gussek

Jirí Harcuba

Brian Hirst

Franz-X. Höller

Toshio Iezumi

Marián Karel

Gerry King

Alison Kinnaird

Joey Kirkpatrick & Flora Mace

Vladimír Kopecký

Antoine Leperlier

Stanislav Libenský &
Jaroslava Brychtová

Marvin Lipofsky

Harvey Littleton

Mária Lugossy

Finn Lynggaard

Ivan Mareš

Dante Marioni

Richard Marquis

Richard Meitner

Klaus Moje

Isgard Moje-Wohlgemuth

William Morris

Joel Philip Myers

Matei Negreanu

Yoichi Ohira

Stépán Pala & Zora Palová

Tom Patti

Mark Peiser

Ronald Pennell

Stephen Procter

David Reekie

Colin Reid

Ann Robinson

René Roubícek

Jaromír Rybák

Markku Salo

Timo Sarpaneva

Mary Shaffer

Ryoji Shibuya

Anna Skibska

Paul Stankard

Lino Tagliapietra

Bertil Vallien

Mary Van Cline

Vincent van Ginneke

Frantisek Vízner

James Watkins

Jack Wax

Ann Wolff

Hiroshi Yamano

Dana Zámecníková

Mary Ann Toots Zynsky

SELECTED BIBLIOGRAPHY

Books

Bloch-Dermont, Janine, *Le Verre en France. Les Années 80*, Les Editions de l'Amateur, 1988

Borowsky, Ivin J, ed., *Artists Confronting The Inconceivable: Award Winning Glass Sculpture*, The American Interfaith Institute, Philadelphia, 1992

Bray, Charles, *Dictionary Of Glass: Materials And Techniques*, A & C Black (Publishers) Ltd, London, 1995

Frantz, Susanne K, *Contemporary Glass*, Harry N. Abrams Inc, New York, 1989

Goodearl, Tom & Marilyn, *Engraved Glass: International Contemporary Artists*, Antique Collectors' Club, Woodbridge, 1999

Groot, Mieke, ed., *Glassammlung Ernsting*, Ernsting Stiftung Alter Hof Herding, Glasmuseum, Coesfeld-Lette, 1996

Ioannou, Noris, *Australian Studio Glass: The Movement, Its Makers And Their Art*, Craftsman House G + B Arts International, Roseville East, 1995

Japan Glass Artcrafts Association, *Glass '99 In Japan*, Forward: Kyohei Fujita, Tokyo, 1999

Klein, Dan, Glass: *A Contemporary Art*, William Collins Sons & Co, Ltd, London, 1989

Layton, Peter, *Glass Art*, A & C Black (Publishers) Ltd, London, 1996

Littleton, Harvey, *Glassblowing, A Search For Form*, Van Nostrand Reinhold Co. (Litton Education Publishing Inc,) New York, 1980

Lynggaard, Finn, ed., *The Story Of Studio Glass*, Finn Lynggaard/The Authors/Rhodos, Copenhagen, 1998

Museum Bellerive Zürich, *Museum Bellerive Zürich: Glas Band I 1945-1991*, Zürich, 1992

Netzer, Susanne, *Museum Für Modernes Glas: Orangerie Schloss Rosenau*, Kunstsammlungen Der Veste Coburg, Coburg Landesstiftung, Coburg, 1989

Ricke, Helmut, *New Glass in Germany*, Kunst und Handwerk/ Verlagsanstalt, Düsseldorf, 1983

Takeda, Atsushi, *Expressions Of Contemporary Glass*, Yurindo Co. Ltd, 1999

Yelle, Richard Wilfred, *Glass Art From Urban Glass*, Schiffer Publishing Ltd, Atglen, 2000

Monographs

Anderland Verlagsgesellschaft mbH, *Franz-Xaver Höller: Glasobjekte Und Zeichnungen 1997-1990*, Forward: Helmut Ricke, Munich, 1990

Antique Collectors' Club Ltd, *Modern Myths: The Art Of Ronald Pennell In Glass And Bronze*, Forward: Julia Ellis, Intro: Dan Klein & others,Woodbridge, 1999

Blonston, Gary, *William Morris: Artifacts/Glass*, Abbeville Publishing Group, New York, 1996

Buechner, Thomas S; Susanne K Frantz; Sylva Petrová, & Jirí Setlík, *Stanislav Libensky, Jaroslava Brychtová: A 40-Year Collaboration In Glass*, The Corning Museum Of Glass, Corning/Prestel-Verlag, Munich, 1994

Cigler, Václav, *Václav Cigler*, Ministry Of Culture Of The Czech Republic & The Soros Center Of Contemporary Art, Prague, 1993

Claude, Herve; Dominique Narran, & Helmut Ricke, *Matei Negreanu*, Editions Vers Les Arts, Nérac, 1993

Dietz, Ulysses Grant, *Paul J Stankard: Homage To Nature*, Harry N Abrams Inc,, New York, 1996

Dorigato, Attilia, *Vetri Veneziani: Ohira*, Arsenale Editrice, Venice, 1998

Dowse Art Museum, *Light: Ann Robinson Casting light: A Survey Of Glass Casting 1981-1997*, Forward: Bob Maysmor, Lower Hutt, 1998

Edition Galerie Von Bartha, *Anna Dickinson*, Intro: Dan Klein, Basel, 1997

Edwards, Geoffrey, *Klaus Moje Glass*, National Gallery Of Victoria, Melbourne, 1995

Exeter Press, *Dan Dailey, Linda MacNeil: Art In Glass And Metal*, Intro: Karen Burgess Smith, 1999

Frantz, Susanne K, & Jean-Luc Olivié, *Philip Baldwin, Monica Guggisberg: In Search Of Clear Lines*, Editions Benteli SA, Berne, 1998

Glasmuseum Alter Hof Herding, *Glasmuseum Alter Hof Herding: Mieke Groot*, Preface: Lilly Ernsting, Ernsting Stiftung, Coesfeld/Lette, 1999

Guillot-Chêne, Gérard, *Antoine Leperlier: Trajectories*, HD Nick Editions, Aubais, 1999

Haags Gemeentemuseum, *Bert Frijns: Glas/Glass*, Forward: JL Locher & Titus Yocarini, The Hague, 1995

High Museum Of Art, *Harvey K Littleton: A Retrospective Exhibition*, Essay: Joan Falconer Byrd, Atlanta, 1984

Houghton, James R, Kiki Smith, Tina Oldknow, Stanislav Libensky, Susanne K Frantz, & Josef Svoboda, *Dana Zámecníková*, Josef Houdek, 2000

Kalin, Kaj, *Sarpaneva*, Octava Publishing Company, Helsinki, 1986

Kuspit, Donald B, *Chihuly*, Intro: Jack Cowart, Portland Press, Seattle, 1997

Lindqvist, Gunnar, *Bertil Vallien: Glas Äter Ljus, Glass Eats Light*, Translation: Angela Adegren, Carlsson Bokförlag, Stockholm, 1999

Lynggaard, Finn, *Joel Philip Myers*, Narran & Helmut Ricke, Editions Vers Les Arts, Nérac, 1993

Lynggaard, Finn, *Finn Lynggaard*, Introduction: Kyohei Fujita, Translation: Sandra Blach, Ebeltoft, 1994

Musée d'Art Contemporain, *Bernard Dejonghe: Dialogues C: Dialogues Céramiques*, Dunkerque, 1997

Oldknow, Tina, *Richard Marquis: Objects*, University Of Washington Press, Seattle 1997

Petrová, Sylva, *Stepán Pala*, Galerie Jaroslava Krále, Brna, 1994

Poskocilová, Eva, *Vladimír Kopecký*, Galerie Hlavního Mesta, Prague, 1999

Procter, Stephen, *Stephen Procter: Thoughts About Light*, Intro: Helmut Ricke, Glas-Galerie Luzern, 1986

Reekie, David, *David Reekie*, Intro: Jennifer Hawkins-Opie, Norwich, 2001

Roubícek, René, *René Roubícek – Liberated Glass*, Koganezaki Crystal Park, Shizuoka, 2000

Sarpellon, Giovanni, *Lino Tagliapietra: Vetri, Glass, Verres, Glas*, Arsenale Editrice, Venice, 1994

Suomen Lasimuseo, *Markku Salo Lasia Glass*, Forward: Dr Heikki Matiskainen, Riihimäki, 1991

Swann, Prof. Flavia; Sylva Petrová, & Dan Klein, *Amygdale*, School Of Arts, Design, & Media, University Of Sunderland, 1999

Takeda, Atsushi, *Kyohei Fujita: Glass*, Translation: Naoko Shoji, Ryutaro Adachi Kyuryudo Co, Ltd, Tokyo, 2000

Ulmer, Renate, *Sand & Light: Danny Lane*, Ateliers Im Museum Künstlerkolonie, Darmstadt, 1993

Von Bartha, Miklos; Dan Klein; Dale Chihuly, & Erik Gottschalk, *Constellations, An Alternative Galaxy: Glass By Michael Glancy*, Edition Galerie Von Bartha, Basel, 1995

Wacquez-Ermel, Christine, *Jaromir Rybak's World*, Transparence Gallery, Brussels, 1991

Waldkircher Verlagsgesellschaft mbH, *Jiri Harcuba: Porträtschnitte 1951-1990*, Forward: Eva Schmitt, Freiburg, 1990

Exhibition Catalogues

Artbureau-Artex, *New Hungarian Glass*, Forward: Ildiko Nagy, Budapest, 1983

The Art Gallery Of Western Australia & Australian Consolidated Industries Ltd, *International Directions In Glass Art*, Preface: Cedar Prest, Intro: Robert Bell, Perth, 1982

Brisbane City Council, *At The Edge – Australian Glass Art*, Intro: Peter Nickl, Brisbane 2000

Canberra School Of Art Gallery, *Latitudes: Bullseye Glass In Australia*, Forward: Prof. David Williams, The Australian National University, Acton, 1998

Corning Museum of Glass, *Glass 1959*, Corning, 1959

Frantz, Susanne K, Helmut Ricke, & Yoriko Mizuta, *The Glass Skin*, Organized by Hokkaido Museum of Modern Art, Kunstmuseum Düsseldorf, & Corning Museum of Glass, 1997/1998

Fukunaga, Shigeki, ed., *Contemporary Studio Glass: An International Collection*, National Museum Of Modern Art, Tokyo/Kyoto, 1982

Hokkaido Museum Of Modern Art, *World Glass Now '85*, Forward: Kimihiro Kurata & Shoji Wakui, Nakanishi Printing Co. Ltd, 1985

Hokkaido Museum Of Modern Art, *World Glass Now '88*, The Asahi Shimbun Publications, 1988

Hokkaido Museum Of Modern Art, *World Glass Now '91*, The Asahi Shimbun, Sapporo, 1991

Hokkaido Museum Of Modern Art, *World Glass Now '94*, Nakanishi Printing Co., Ltd, 1994

Kanazawa Museum, *The International Exhibition Of Glass Craft '88*, Kanazawa, 1988

Kanazawa Museum, *The International Exhibition Of Glass Kanazawa '90*, Kanazawa, 1990

Kanazawa Museum, *The International Exhibition Of Glass Kanazawa '92*, Kanazawa, 1992

Kanazawa Museum, *The International Exhibition Of Glass Kanazawa '95*, Kanazawa, 1995

Kanazawa Museum, *The International Exhibition Of Glass Kanazawa '98*, Kanazawa, 1998

Klein, Dan, & Attilia Dorigato, eds., *International New Glass: Venezia Aperto Vetro*, Arsenale Editrice, Venice, 1996

Klein, Dan, Attilia Dorigato & Barovier Mentstai, Rosa, eds.,

International New Glass 1998: Venezia Aperto Vetro, Electa, Milan, 1998

Koganezaki Crystal Park, *Vessels: The International Exhibition Of Glass: The Third Anniversary Of Koganezaki Crystal Park*, Forward: Masakazu Yamamoto, Shizuoka-ken, 2000

Kunstsammlungen der Veste Coburg, *Coburg Glaspreis 1977 für Moderne Glasgestaltung in Europa*, Forward: Heino Maedebach, Coburg Landesstiftung, Coburg, 1977

Kunstsammlungen Der Veste Coburg, *Zweiter Coburger Glaspreis für Moderne Glasgestaltung in Europa 1985*, Joachim Kruse, Coburg Landesstiftung, Coburg, 1985

Kunstgewerbemuseum Bellerive, *Museum Bellerive Zürich: Glas Heute – Kunst Oder Handwerk?*, Forward: Erika Billeter, Zurich, 1972

The Leigh Yawkey Woodson Art Museum, *Americans in Glass*, Wausau, 1984

Lippuner, Rose-Marie, ed., *Expressions on Verre II*, Musée des Arts Décoratifs de da Ville de Lausanne, Jean Genoud SA, Le Mont-Sur-Lausanne, 1989

The Metropolitan Museum of Art, *Studio Glass in the Metropolitan Museum of Art*, New York, 1996

Musée des Arts Décoratifs de la Ville de Lausanne, *Expressions en Verre*, Preface: Paul-René Martin, Intro: Rose Marie Lippuner, Jean Genoud S A., Lausanne, 1988

Musée National de Céramique, *Couleurs et Transparence: Chefs-d'œuvre du Verre Contemporain*, Sèvres, Éditions de la Réunion des Musées Nationaux, Paris, 1995,

National Museum Of Modern Art, Tokyo/Kyoto, *Contemporary Glass – Europe & Japan*, 1980

The Oakland Museum, *Contemporary American and European Glass from the Saxe Collection*, Oakland, 1986

Sahl-Madsen, Charlotte, & Sandra Blach, *Young Glass 1997*, Ebeltoft Glasmuseel, Glasmuseets Forlag, Ebeltoft, 1997

The Toledo Museum Of Art, *American Glass Now*, Intro: Otto Wittmann, Toledo, 1972

Magazines

Contemporary Glass Society: Glass Network, Contemporary Glass Society, Stoke-On-Trent

Crafts, Crafts Council Publication, London

Craft Arts International, Craft Art Pty, Ltd, Sydney

GAS News, The Glass Art Society, Seattle

Glass, UrbanGlass, New York

Glass Network, Newsletter of the Contemporary Glass Society, London

Neues Glas, Verlagsgesellschaft Ritterbach mbH, Frechen (including *New Glass: A Worldwide Survey*, an annual selection of new glass juried by the Corning Glass Museum, Corning)

Review, Rapid Publishing Offices, Prague

La Revue de la Céramique et du Verre, La Revue De La Céramique Et Du Verre, Vendin-Le-Vieil

Vetro, Centro Studio Vetro, Murano

INDEX

ACKNOWLEDGMENTS

The Author and Picture Researcher would like to thank the following for their kind permission to reproduce images for use in this book.

Key: b bottom, l left, r right, t top.

2 Terry Rishel; 5 Bill Truslow; 6 Dan Durrance – Littleton Studios Spruce Pine; 7 Erwin J Plokarz; 8 Russell Johnson; 9 Russell Johnson; 10 Gabriel Urbánek; 13 Robert Vinnedge; 14 Gören Örtegren; 16 Gary Gold; 17 t Rob Adams; 17 b Kate Elliott; 18,19 all Dan Kramer; 20 t Ch Lehmann; b Dan Kramer; 21 Ch Lehmann; 22, 23, 24 all Ric Murray; 25 Steve Myers; 26,27 all Ric Murray; 28 Stephen Procter; 29 t Eva Heyd; b Andrew Dunbar; 30 Francesco Barasciutti; 31 all Andrea Morucchio; 32 Claudia Borella; 33 all Damian McDonald; 34,35 all Norbert Heyl; 36 Theresa Batty; 37 t Dale Chihuly; b Claire Garoutte; 38 t Rob Whitworth; b Claire Garoutte; 39 Russell Johnson; 40 l Terry Rishel; r Claire Garoutte; 41 Mark McDonnell; 42 Jan Brodský; 43 Miroslav Vojtechovský; 44 Jan Brodský; 45 no credit required; 46 all Alan Tabor; 47 t David Cripps; b Alan Tabor; 48 Alan Tabor; 49 Paul Louis; 50 Erik Poulson; 51 all Rob Vinnedge; 52 t Susie Cushner; b Bill Truslow; 53, 54, 55, 56, 57 all Bill Truslow; 58 all François Goalec; 59 Muriel Hanssens; 60 Sarah Wells, Mary-Anne Martin/Fine Art New York; 61 t Sarah Wells, Mary-Anne Martin/Fine Art New York; b Robert Lorenzson, Mary-Anne Martin/Fine Art New York; 62 Fabio Zonta; 63 t Fabio Zonta; b Andrea Morucchio; 64 t Ian Dobbie; b Kevin Summers; 65 Rike Baetcke; 66 Paul Foster; 67 all Peter Scott; 68, 69, 70, 71 all Lisa Moser; 72, 73 all Van Niel; 74 Irene Frolic; 75 l Tommy Olof Elder r Heinz Hess; 76, 77, 78, 79 all Yuji Ohtsuka; 80, 81, 82, 83 all Gene Dwiggins; 84, 85, all Ron Zijlstra; 86 t Uwe Jacobshagen; b Helga Schulze; 87 Uwe Jacobshagen; 88 Jindrích Brok; 89 all Gabriel Urbánek; 90, 91 all Greg Piper; 92, 93 all Franz-Xaver Höller; 94 Tadao Kodaira; 95 t no credit required; b Toshio Iezumi; 96 no credit required; 97 no credit required; 98 no credit required; 99 no credit required; 100, 101 all Grant Hancock; 102, 103 all Ken Smith; 104, 105, 106, 107 all Rob Vinnedge; 108, 109 all Gabriel Urbánek; 110 Corning Museum Of Glass Corning; 111 Peter Wood;

112 Sam Lambrou; 113 all Kent Meares; 114 Eric Morin; 115 t Douglas Schaible; b Jalain; 116, 117 George Erml; 118 Ivo Gil; 119, 120 George Erml; 121 t Gabriel Urbánek; b George Erml; 122, 123, 124, 125 all M Lee Fatherree; 126 Dan Durrance – Littleton Studios, Spruce Pine; 127 t John Littleton; b Dan Durrance – Littleton Studios, Spruce Pine; 128, 129 all Zoltán Bohus; 130, 131 all Jan Friis; 132, 133 all Gabriel Urbánek; 134, 135, 136, 137 all Roger Schreiber; 138, 139, 140, 141 all Richard Marquis; 142 Alan Tarbor; 143 l Laurent Sully-Jaune; r Alan Tarbor; 144, 145 all Ron Zijlstra; 146, 147, 148, 149 all Klaus Moje; 150 Studio M; 151 t Klaus Moje; b Studio M; 152, 153, 154, 155 all Robert Vinnedge; 156 t Joel Philip Myers b Doug Schaible; 157 Chris Brown; 158 Matei Negreanu; 159 t Thomas Hennocque; b Paul Louis; 160 Lorenzo Trento; 161 t Francesco Ferruzzi; b Norbert Heyl; 162 t Dano Zachar; 162 b D & D Studio; 163 t Valika Zacharová; b Valika Zacharová; 164 t Paul Rocheleau; b George Erml; 165 George Erml; 166 Ann Hawthorne; 167 t Mark Peiser; b John Warner; 168, 169 all Cliff Guttridge; 170, 171 all Stephen Procter; 172, 173, 174, 175 all David Reekie; 176 Colin Reid; t no credit required; 177 b Colin Reid; 178 Museum Of New Zealand (Te Papa Tongarewa) Wellington (F4548/1); 179 t Studio La Gonda; b Rob Vinnedge; 180 Karel Kalivoda; 181 Lubomír Vána; 182, 183, all Gabriel Urbánek; 184 Gero Mylius; 185 all Timo Kauppila; 186 t Osmo Thiel; b Markku Luhtala; 187 Harri Kosonen; 188, 189 all George Erml; 190 Kojima Hirokazu; 191 t Mitio Matumoto; b Kazuo Miyahara; 192, 193 all Russell Johnson; 194, 195 all James Amos; 196, 197, 198, 199, 200, 201 all Russell Johnson; 202 Ola Terje; 203 t Gören Örtegren; b Robert Vinnedge; 204 Anders Qwarnström; 205, 206, 207 Gören Örtegren; 208, 209 all Robert Vinnedge; 210, 211 all Ron Zijlstra; 212 Gabriel Urbánek; 213 all Miroslav Vojtechovský; 214 James Watkins; 215 Jessica Marcotte; 216 Jack Wax; 217 t Russell Johnson; b Ted Diamond; 218, 219, 220 all Anders Qwarnström; 221 t Anders Qwarnström; b Thommy Durath; 222 Takashi Akiyama; 223 all Hiroshi Yamano; 224 No Credit Required; 225 t No Credit Required; b No Credit Required; 226 Rob Vinnedge; 227, 228, 229 all Toots Zynsky.

Author acknowledgments I would like to thank all those whose contribution made this book happen. The editorial, design, and production teams at Mitchell Beazley, in particular Mark Fletcher, Emily Asquith, Colin Goody and Kirsty Seymour-Ure have been a pleasure to work with. Alan Poole, in his role as picture researcher and adviser on many other aspects of the book, has been a great support from beginning to end of the project. Above all I would like to thank all the artists, first and foremost for their important contribution to contemporary glass, but also for so willingly interrupting their busy working lives to supply photographic material and background information.